ART OF THE AMUR

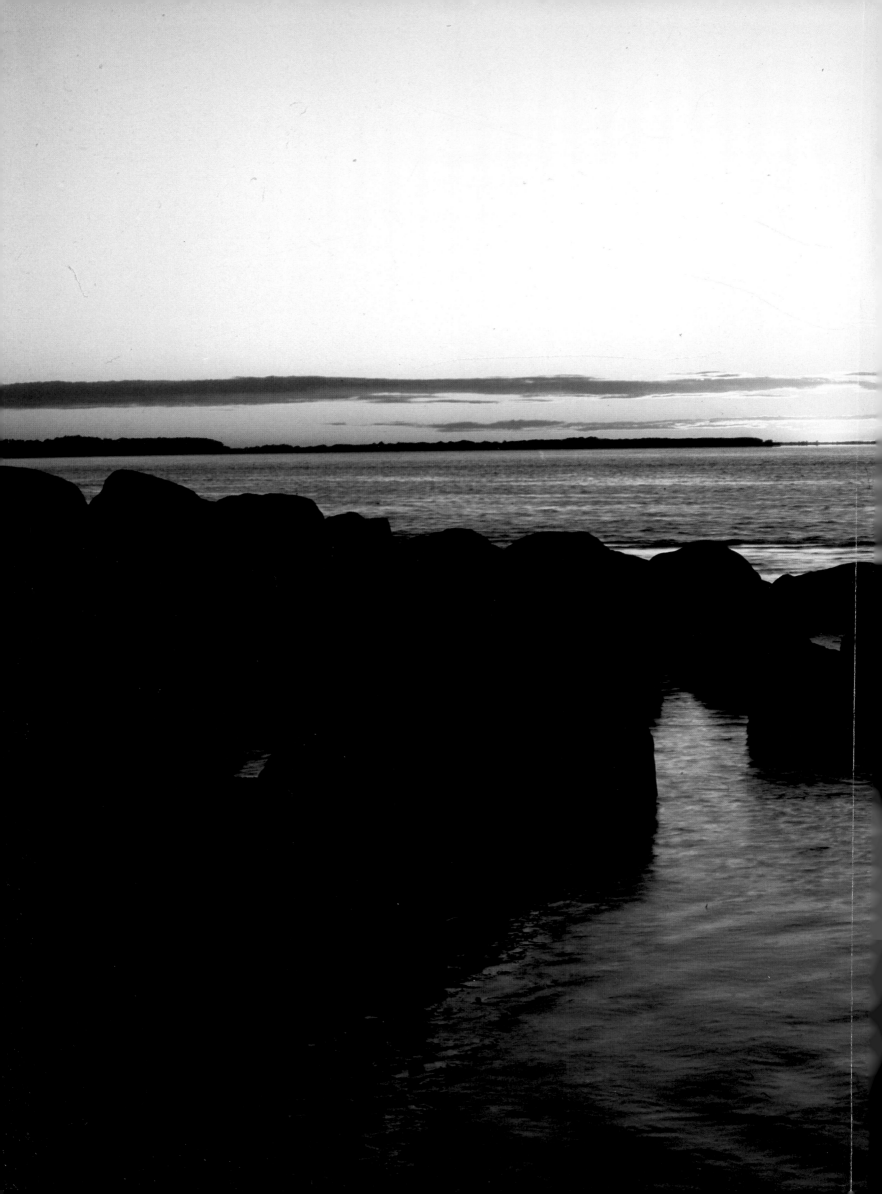

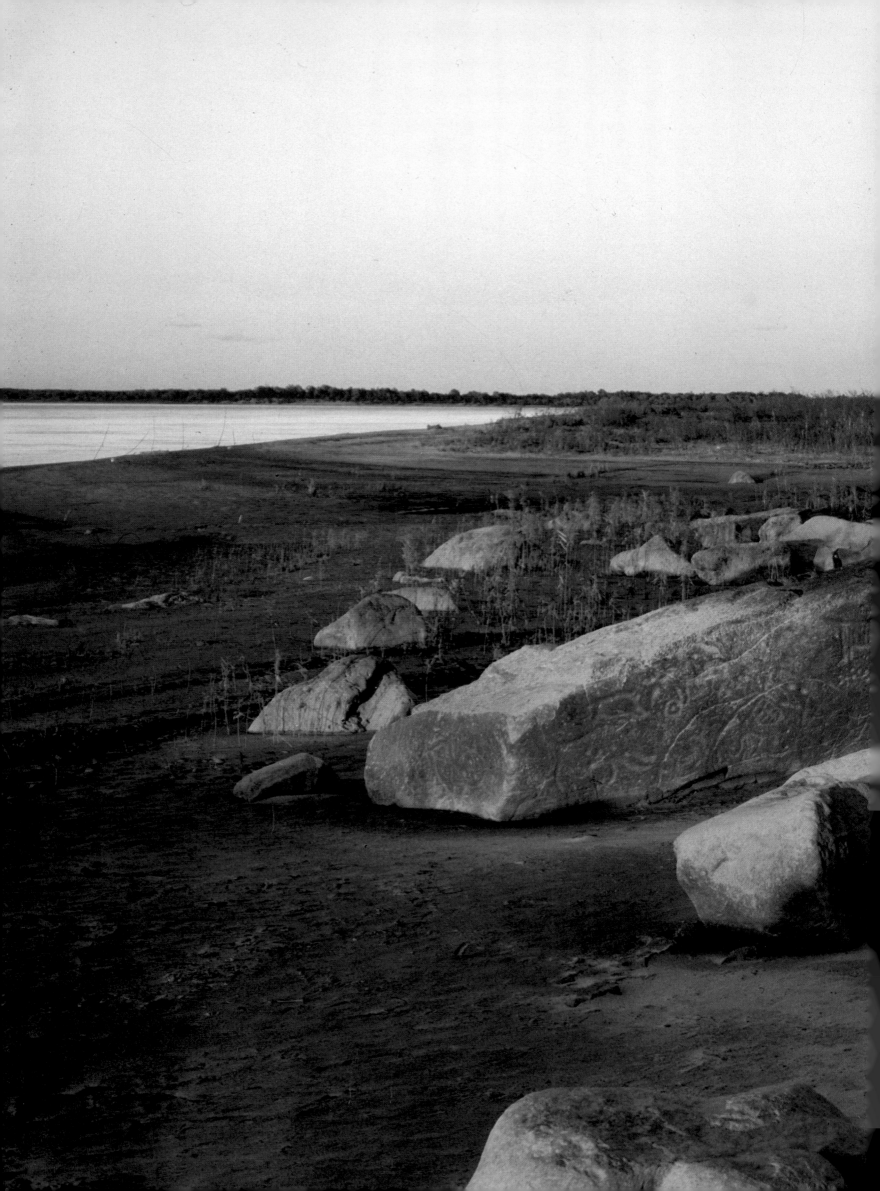

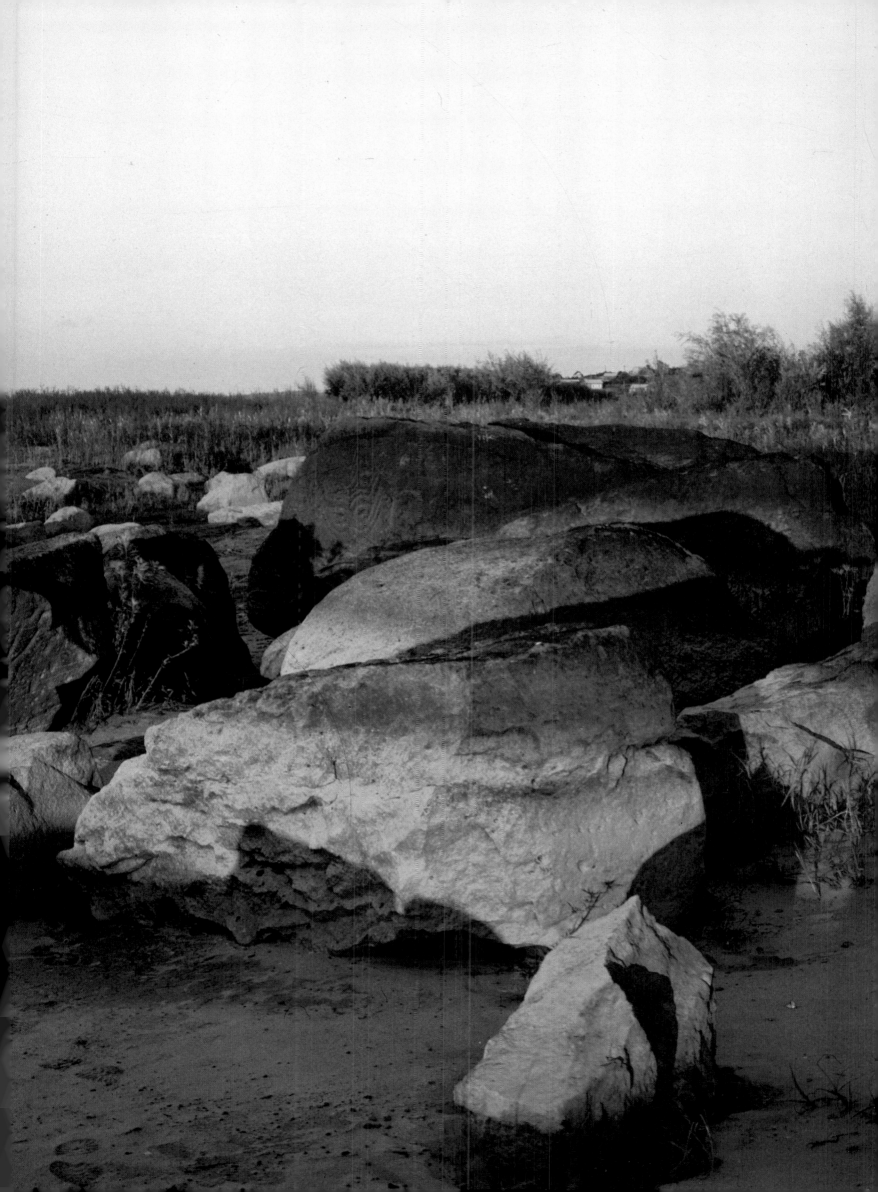

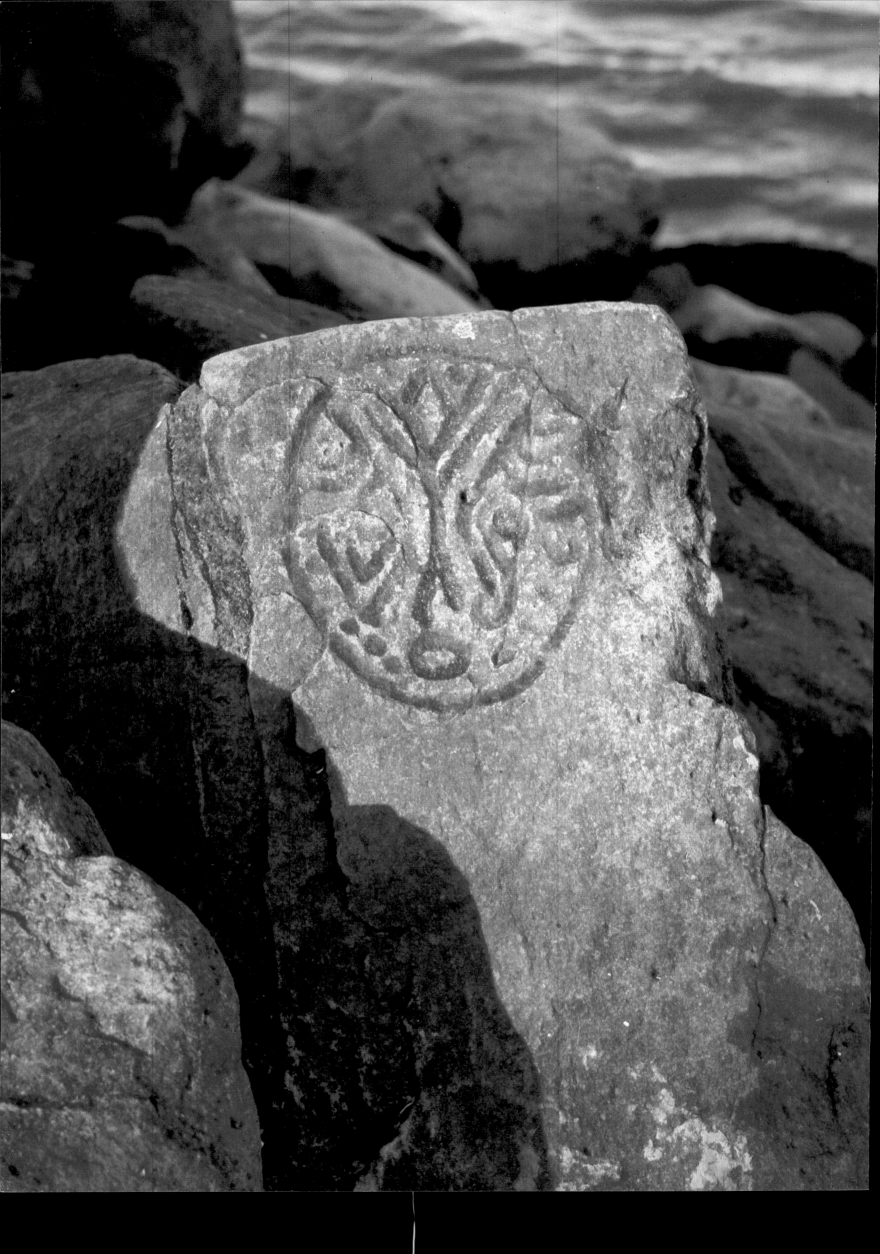

ART OF THE AMUR

ANCIENT ART
OF THE RUSSIAN FAR EAST

ALEXEI OKLADNIKOV

HARRY N. ABRAMS, INC., PUBLISHERS, NEW YORK

AURORA ART PUBLISHERS, LENINGRAD

Designed by Yevgeny Bolshakov
Photographs by Ferdinand Kuziumov

Translated from the Russian by
Stephen Whitehead and Alla Pegulevskaya

Library of Congress Cataloging in Publication Data

Okladnikov, Alexei Pavlovich.
 Art of the Amur.

 1. Ethnology — Russian Federation — Amur Valley.
2. Art — Russian Federation — Amur Valley. 3. Neolith-
ic period — Russian Federation — Amur Valley. 4. Man
Prehistoric — Russian Federation — Amur Valley. 5. Amur
Valley — Antiquities. 6. Russian Federation — Antiquities.
I. Title.
GN635. S5055 957'.7 80–13728
ISBN 0-8109-0681-3

Library of Congress Catalog Card Number: 80–13728

Created by Aurora Art Publishers, Leningrad, for joint
publication of Aurora and Harry N. Abrams, Incorporated,
New York.

Printed and bound in Hungary

CONTENTS

INTRODUCTION

This book is dedicated to the cultural heritage of the Soviet Far East, principally the Amur area and the Primorye (Maritime) territory. It sets out to describe the artistic treasures left by the distant ancestors of the Nanai, Olcha, and Nivkh peoples and to show how the modern culture of these nations has developed from their ancient traditions. It is genuinely remarkable that what were, in the not so distant past, small and backward nations should have possessed such creative power. Everyone who has come into contact with the art of the Lower Amur has been impressed by its creators' vivid originality and inexhaustible wealth of imagination. Researchers into the culture of the Amur tribes wrote enthusiastically about the works of these unknown craftsmen. Academician Leopold Schrenck, one of the first Russian researchers in the ethnography of the Far East, published a superb collection of artefacts which enables us to place the Nanai (Gold, as they were then called), Nivkh, and Olcha craftsmen of the first half of the nineteenth century among the greatest artists known to world ethnography. Richard Maack, another Russian investigator of the Far East at this time, was equally impressed by their work. Finally, Berthold Laufer, an outstanding nineteenth-century American ethnographer and sinologist, published a study specifically devoted to the traditional art of the Lower Amur.

Anyone who has studied the books of Schrenck, Maack, and Laufer, and another Russian ethnographer, Ivan Lopatin, has shared with them that feeling of elation which is aroused by all contact with the really beautiful. The nameless wood-carvers and sculptors of the Amur transformed into works of art the most everyday objects—plates for cutting fish, or the birch-bark or wickerwork boxes in which the women kept the implements of their heavy and exhausting domestic labor.

A simple auger- or a knife-handle became in their hands priceless treasures. The clothes of the Amur tribes—made not only of fur, but of such an unusual material, to us, as carefully treated fish-skin— were copiously decorated with intricate colored patterns. These peoples reached the heights of skill in religious art, which formerly played the main part in their spiritual life. The objects of the primitively naïve shaman ritual are most expressive. The fantastic, brightly colored masks personify the menacing and benevolent spirits, on whose disposition man's life was constantly dependent. Their mood is echoed by the ritual garments of the shamans—the intermediaries between the world of people and the world of spirits. Even modern connoisseurs of art are fascinated by the expressive power of these sculptured idols. Still more striking is the decoration of their buildings, including the burial huts, whose main function was to make the future life of their kinsmen in the *buni* (lower earth) as rich and even beautiful as possible—hence the luxurious decoration of the gables and walls of these huts. Their own houses were thought of as living beings: they were given eyes and inside was placed the spirit of the dwelling, its master—the *dzhulin*—most often presented in a female guise, that of the Mother-goddess. In the mind of the Nanai and Nivkh, boats too were living beings—they also had eyes, the windows of the soul.

Shamanism, with its ritual dances and drum music, has long since disappeared. The customs of the tribal patriarchy are forgotten. The smoky communal dwelling with rows of bunks has been replaced by light spacious homes. The people's everyday life has radically changed. But the ancient art and its traditions continue to live, and they find a new stimulus in the social demands of contemporary life. While carefully preserving their artistic inheritance, the peoples of the Amur are constantly enriching their culture.

There can hardly be any other place in the world where the art of the distant past is so closely interwoven with contemporary life, ancient culture with modern, and where, as a result, the connections between past and present can so easily be traced. As far as distant antiquity is concerned, the petroglyphs of the Amur and Ussuri have always aroused especial interest.

Everyone who sees these Far-Eastern petroglyphs for the first time feels that he is encountering something unusual and unexpected. For more than a hundred years the petroglyphs of the Lower Amur and the Ussuri have attracted the attention of researchers attempting to solve the riddle

of their origin and age. No less fascinating are the original style and inner meaning of these images, so much in contrast with all that is known of the early art of the neighboring territories of North and East Asia. When we compare the petroglyphs with the objects of Neolithic art, with ornamented earthenware vessels and clay statuary, we see that they form an integral whole, permeated by the same ideas and the same conception of life.

Moreover, the same patterns, images, and subjects that characterize the petroglyphs found at Sikachi-Alian on the Amur, Sheremetyevo on the Ussuri, and "Chortov Plios" (Devil's Reach) on the Kiya River, can also be traced in the remarkable folk art of these regions of the Far East. Thus the evidence of archaeology and ethnography shows the wealth and originality of the art of the Amur tribes over an enormous period of time—from the Neolithic (fourth to second millennia B.C.) or possibly Mesolithic period (eighth to sixth millennia B.C.) to the present. Most of the archaeological and ethnographical exhibits reproduced in this book belong to two chronological extremes—the Neolithic Age and the period of modern ethnography, which display close correspondences with one another in their art.

The final chapter of the book is devoted to artistic finds belonging to the period of transition from stone to metal, and to the succeeding Iron Age as far as the Jurchen period—to a time when, as a result of complex historical processes, new ethnic groups and new cultures were formed. In these cultures the age-old traditions can still be found, and they are strikingly visible in the nineteenth and twentieth centuries among the Nanai, Olcha, and Nivkh. The continuity of this culture and its traditions does not mean, of course, that it remains static and unchanged. On the contrary, like all nations, the peoples of the Amur have undergone a complex historical development, coming into contact with other nations and cultures. But, for all that, their art brings down to us something time-honored and immortal which has withstood the flow of centuries. Taken as a whole, these monuments testify to the fact that the vast territories of the Lower Amur and the Ussuri have for thousands of years, since time immemorial, been occupied by the ancestors of the present-day nations of the Amur region, and that they created an original, rich, and remarkably vigorous culture.

FACES OF THE AMUR

Sikachi-Alian in the Nanai language means "Boar's Hill." This small village, lost in the taiga, is familiar to scholars of various countries. The eminent American orientalist Berthold Laufer visited Sikachi-Alian at the end of the nineteenth century, and in the 1920s the Japanese professor Riuzo Torii, author of numerous books and studies on the archaeology and ethnography of Japan, Sakhalin, Manchuria, and Mongolia, also came here.

Sikachi-Alian is described in the works of the famous traveller Vladimir Arsenyev and of Lev Sternberg, the outstanding Russian scholar who is mentioned with respect by Friedrich Engels as the discoverer of a new form of group marriage.

In 1935 the first Soviet archaeological expedition was sent to Sikachi-Alian and had the good fortune to discover many previously unknown treasures of ancient art. Like the scholars who had preceded them, the archaeologists were fascinated by the huge basalt boulders piled up in long mounds along one bank of the Amur.

Millions of years ago, a current of molten lava flowed out of the depths of the earth, from the crater of a now non-existent volcano. It congealed, cracked, and finally, undermined by the river, disintegrated to form a multitude of boulders. On one of these massive fragments of rock, black and weather-worn, as old as the Amur itself, a relief drawing was discovered. An underwater monster, the "Black Dragon"—legendary master of the Amur—seemed to be emerging from the muddy water, from the silty bed of the river. The rough boulder, witness of the infancy of our planet, bore the imprint of creative thought and revealed the strange, mysterious world of prehistoric art.

pl. 4

Time has smoothed the sharp edges of the rock, polished its surface, but could not obliterate the deep grooves cut by the hand of an unknown artist.

Once you have seen this remarkable production of prehistoric art, it is impossible to forget it. It is striking for its laconic wisdom and simplicity, for the fantastic intricacy of the design, and finally for the keen sense of composition with which the primitive craftsman arranged the picture on the side of the rock.

The drawing and the rock form an indissoluble whole, also with all of the surrounding landscape —the Far-Eastern taiga, the limitless expanse of the great Asian river. When the water level rises, the waves lap against the monster's beard and its slanting eyes. Gradually the water rises higher and higher until the entire stone is hidden. In two or three months, the rock will once more appear above the mirror of the waters. And so year in, year out, through the centuries.

The image of the monster, carved on the stone of Sikachi-Alian, is as if born of the earth itself, formed by its elemental creative power, by the force that raises the vigorous spring sap from the depths of the earth and gives birth to all living things.

The drawing involuntarily brings to mind the ancient Greek myth of the infancy of the Universe and the gods, of the monstrous giants, the Titans with many arms and serpent legs born of the Earth goddess Gaea. It recalls also the battle of the Olympians with the sons of Earth, carved on the marble frieze of the Pergamon altar.

Was not this enigmatic monster-image on the Amur suggested by such a myth, or perhaps an even older one? In fact there does exist among the Nanai a myth about the first days of the Universe and the hero-demigods, a myth that may help to solve the problem of how these drawings appeared on the rocks of Sikachi-Alian.

It is no wonder that the Khabarovsk ethnographer Nikolai Kharlamov, fired by the romantic past of the Far East, imagined that these were the ruins of an ancient city with tall columns of hewn stone, as at Baalbek, covered with representations of unknown beings from a foreign world. He is the author of the first, although very short, description of the Sikachi-Alian petroglyphs in our literature. In it he mentions the "ruins of Galbu" and creates a striking picture of the former city. "On the territory of the Far East," writes Kharlamov, "are scattered a great number of monuments that testify that the region was formerly inhabited, and they are of enormous scientific interest. Among these the ruins of 'Galbu' on the right bank of the Amur, 75 km below Khabarovsk at the Nanai (Gold) encampment of 'Sanagi-Alyal' (in ancient times 'Galbu'), attract particular attention. Along the cliffs of 'Sanagi' and 'Gasya' drawings are cut into the rock, and these have for a long time excited the interest of travellers and scholars... In our opinion, the ancient ruins of 'Galbu' are the remains of an old city, the religious center for the inhabitants of the Far East at that time. This is proved by the regular construction of the stone embankment, the mud-paved square, the numerous rocks incised with ritual drawings, and what seem in places to be the stone walls of the city as well as moats and earthworks beyond the camp." In Kharlamov's view the town existed from the first millennium B.C. until almost the end of the first millennium A.D.

Needless to say, no ruins of a temple were found in Sikachi-Alian. The first thing that the archaeological expedition of 1935 discovered was the rock drawing that has already been described. Not far away, and also half covered by water, lay a second stone carved with a figure of an elk, and also another mask, without the same elaborate decoration around it. This face was of regular ovoid form; the slanting eyes with distinct round pupils, and the wide nose stood out sharply against it; on the cheeks and chin were parallel curved lines, possibly tattoos.

The drawings on the rocks of Sikachi-Alian also attracted the attention of Arsenyev. He saw them during his travels in the mountains of Sikhote Alin in 1908. "Near Sikachi-Alian on the bank of the Amur," writes Arsenyev, "there are stones carrying drawings that are covered over during the spring floods. On one stone is an outline representation of a human face. The eyes, nose, eyebrows, mouth, and cheeks can be clearly distinguished. On another stone are two human faces; the eyes, mouth, and even nose are shown by concentric circles, and on the forehead are a number

of undulating lines, which give an impression of surprise as though the eyebrows were raised."
There are many stones with drawings in Sikachi-Alian. Incised on the basalt boulders are not only fantastic masks, but also figures of animals and clusters of writhing snakes.

All along the steep right bank of the Amur, from the last houses of the Nanai hamlet of Sikachi-Alian as far as the old Russian village of Malyshevo and its jetty, there are piles of basalt rocks —the remains of fallen cliffs. This is the same mass of huge, rough-edged boulders that produced even on the restrained and unemotional Laufer the impression of a man-made defensive wall and that Kharlamov took for the remains of a fortress and temple. The ridge of boulders, becoming gradually lower and sparser, stretches out like a spit of land from the picturesque cliff, on the top of which in Moh-hoh times was built a small but powerful fortification. This is where most of the drawings are concentrated; the largest and most impressive of them are two elks and a boulder with a "radiant" mask.

pls. 41, 44

There is another large accumulation of basalt boulders at the lower end of Sikachi-Alian, beyond the deep inlet of the Amur (referred to as Lake Orda by Laufer), which separates one part of the village from the other. Here there are a number of rocks with representations, including a large, almost rectangular slab carved with huge figures of animals.

Rock carvings are found both at Malyshevo and further upstream. We must also mention a fourth place where petroglyphs have been found, in this case not on boulders but on the vertical surfaces of the cliffs along the river between the drawings of Sikachi-Alian and the petroglyphs of Malyshevo. These are incised line drawings, including a thin-line depiction of a *mudur*—dragon or serpent.

In short, this small region is a veritable museum of the primitive art of the Amur. The number of petroglyphs here (in all about 150) has been only approximately established, for most of the year the Amur overflows its banks and the ridges of basalt are covered over. The spring rush of ice, which in ancient times destroyed the cliffs, still continues to toss the heavy slabs of stone and break them into fragments. When this happens the drawings too are broken, and sometimes overturned and buried under piles of stones.

Could the drawings have been originally incised on the cliffs, and subsequently, when the cliffs collapsed, have fallen into the river and been carried downstream by the ice? In that case the surviving fragments of cliff would still carry drawings identical to those cut into the boulders. However, there is no sign of them. Moreover, the drawings are done in such a way as to fit the shape of the boulders which had broken away from the rock face. Thus it is most likely that the drawings were executed on the stones, and we should more properly call them boulder drawings rather than rock drawings. In style and subject matter, the drawings of Sikachi-Alian are divided into two sharply distinguished groups: the oldest, archaic drawings and the later ones of the Moh-hoh period. Most of them belong to the first group—archaic, purely primitive.

The oldest petroglyphs all use the same method of pecking or pressure retouching, characteristic of the Neolithic period. The craftsman worked on the drawings in the same way as on a stone axe: he struck stone against stone, chipping off small flakes one after another, until he had made tiny depressions in the surface, which merged into a single patch or line. The result was a high-relief image, sometimes almost three-dimensional. The drawings bear the marks of great antiquity. They are often worn so smooth that it is hard for the eye to follow the outlines of individual figures. In many cases the drawing can be found only by touch: the parts which were chipped away in ancient times are smoother than all the remaining surface of the rough stone untouched by human hands. Compared with all the other, similar, archaeological monuments known to us in Asia, the petroglyphs of Sikachi-Alian stand out as something unusual and exciting. What can we learn from these fantastic masks, these snakes and strange beasts, carved by the hand of an unknown sculptor?

Among the prehistoric drawings of Sikachi-Alian the enigmatic stylized anthropomorphous faces or masks occupy a central place. They are so varied that it is difficult to divide them into any definite groups: each mask represents a separate type, but all the same they show a certain unity of form and style and can be classified by certain definite features.

The most important common characteristic is that most of them depict not real human faces, but precisely masks. This is not because people of those times were unable to reproduce the features of the human face realistically in stone. One of the drawings of Sikachi-Alian depicts a human being with such warm and tender feeling that the stone may be said to have come alive under the hand of the craftsman. The outline of the face is deeply cut, the large slant eyes look out from under drooping heavy lids, the round depressions of the nostrils and the wide fleshy lips are finely modeled. More often, however, we find masks. These are strikingly laconic, conventionalized, abstract representations of the human face. Abstract does not mean simplified, reduced to the minimum of expressiveness. On the contrary, notwithstanding their overall unity of style each drawing has its own character, its distinguishing peculiarities and details. In other words, we see here one subject, but with endless variations, produced by the various and unexpected combinations of traditional artistic devices.

pls. 6, 7 Most of the masks have an elliptical or ovoid outline, but some are circular. Some are elliptical at the top and cut off horizontally at the bottom (truncated ovals). Apart from elliptical, ovoid, and circular masks, there are also cordate ones (with an indentation at the top). Some masks are very broad at the top and taper sharply at the bottom to a rounded or truncated chin. These masks suggest the face of an ape, and at the same time a skull. In some cases (as in the drawings on the Sheremetyevo rocks) the mouth is closely packed with teeth, which enhances the likeness to a skull. Thus we have another type of mask—skull-shaped. We may note that skull-worship is a genuinely primitive phenomenon, especially characteristic of the period of transition from matriarchy to patriarchy.

We find the same basic types of mask in several variants: it is clear that this is the result of the craftsman's individual creative approach, and that there is no obligatory standard type. Sometimes the primitive artist does not even attempt the outline of a face. He draws a mouth, a pair of eyes above it—and leaves it at that. To him it is already a mask (we may call these partial masks). The eyes and mouth are usually rendered by concentric ovals or circles. Alternatively the eyes are made not round but slanting, fish-shaped. The eyes are essential: the ancients believed that man's soul looked out through his eyes.

Besides, many of the masks show a nose, some form of tattooing, and also a splendid headdress or a kind of halo made up of lines arranged symmetrically around the face.

Ever since the discovery of the masks of Sikachi-Alian and Sheremetyevo, researchers have tried to find out when and by whom these strange faces were cut into the rock. The answer was found after the start of systematic excavations of the ancient settlements on the banks of the Amur, including some in the immediate vicinity of these basalt slabs with petroglyphs. In 1972, during work near the village of Voznesenskoye at the mouth of the Gur River, our archaeological expedition uncovered something quite unexpected and remarkable. We found fragments of an earthenware vessel, brilliant red and burnished, whose color and gloss called to mind the polished red-painted vases of the ancient Greeks. Of course it was covered not with lacquer, but with a type of slip-coating, a thin layer of specially prepared red ochre, which was then polished with an abrasive stone. Vessels of this type were first found in 1935 on the island of Suchu near Mariinsk and have already been encountered several times on the Amur. But this time something unusual was un-
pls. 18, 19 covered: round, human eyes looked at us from this fragment of Neolithic pottery. The nose with its distinct nostrils was executed in high relief. The mouth was clearly outlined by a deep incision in the soft clay. In a word, it was just such a mask as those of the Sikachi-Alian and Sheremetyevo rocks. The vessel carries the remains of other masks, which must have formed a continuous band, a kind of circle-dance, around its upper half. The creator of this remarkable piece of pottery depicted not only faces, but also arms raised in an attitude of prayer, like those of the famous Virgin Orans of the "Impregnable Wall" in Kiev. Admittedly, unlike the Virgin Orans, these creatures have not fingers and toes, but sharp animal claws. Their pose is also unusual: as far as we can tell from the potsherds, they are squatting on their haunches.

14

This strange, fantastic composition reflects a spiritual world that is unknown to us; it shows the unusual and imaginative artistic ideas of the ancient tribes.

Comparing the masks incised on the basalt of Sikachi-Alian with those drawn in the soft clay of the Voznesenskoye vessel, we can see how much these works of early Amur art have in common. The resemblance between the masks on the vessel and those of the petroglyphs is seen first of all in their similarity of outline. It is most significant that this resemblance extends to the manner in which the outlines are filled in. The eyes, for example, are represented either by regular circles, by commas, or fish-shapes. The fish-shapes on one of the masks of the vessel differ from those of the petroglyphs only in that they are inverted, with the narrow corners turned downwards. Over the eyes of the Voznesenskoye mask is a molded double arc, like the spread wings of a bird. We find just such arcs on the majority of the petroglyphic masks. It forms the top of the cordate oval mask of the clay vessel. These masks are done in low relief. They have protuberant, softly mod- elled noses and just as protuberant mouths. We can observe the same tendency towards sculptural treatment in the ones depicted on the rocks. A further similarity is probably non accidental: the anthropomorphous representations are placed on the rounded sides of the Voznesenskoye vessel, and the petroglyphic masks are carved on the convex face and sides of the basalt slabs. Another interesting feature is that each of the masks on the vessel, like those of Sikachi-Alian, is different from the neighboring ones and has its own unique character. One has round eyes, the next has eyes in the form of a half-spiral or comma. One mask is a regular cordate oval, and another is cleft at the top and has a cordate outline, like some of the heart-shaped Sikachi-Alian boulder drawings. All the wealth of decoration, all the typical features of the Sikachi-Alian masks are combined in the ornamentation of this one vessel.

As was to be expected, careful examination of the site and further excavation showed that the vessel had been deposited in a specific layer, corresponding to the Middle Neolithic period in the stratigraphy of the Voznesenskoye settlement. In the Amur pottery of that period, curvilinear ornamentation reached its full development. And the spiral was widely used: its tight curves, covering the vessel, were usually drawn against a stamped background of parallel vertical zigzags. The settlement of Voznesenskoye was in all respects similar to the famous settlement on the Lower Amur, on the island of Suchu. People of the same tribe, at the same period, built their deep pit-dwellings at Voznesenskoye and on Suchu, modelled identical clay pots, and were equally assiduous in decorating them with complicated, almost geometrically exact spirals and molded masks. The age of the Voznesenskoye vessel and the era to which it belongs is that phase of the Neolithic period which can be firmly dated by the modern radiocarbon method as the third millennium B.C.

Next came another new find, this time on the same bank of the Amur as the boulders carrying drawings, on the steep promontory between Malyshevo and Sikachi-Alian. During excavations of a Neolithic settlement, fragments of vessels decorated with anthropomorphous masks, together with polished stone axes and finely chipped flint arrowheads, were found among the remains of an ancient dwelling. Admittedly they are simpler than those on the Voznesenskoye vessel, and without the sumptuous purple or crimson background, but perhaps for that reason all the closer to the masks carved in the basalt slabs of Sikachi-Alian. These masks are oval, with rhomboid eyes. The surface of the masks, as with their counterparts at Voznesenskoye, is ornamented with comb impressions. Still more exciting was the discovery of a small fragment of a clay cup with a fine pattern of vertical zigzags made up of dotted comb-impressed lines, such as is found on hundreds of pot- sherds from Neolithic dwellings along the Amur and Ussuri rivers. What was completely unexpected was an apelike head in relief on the inner rim of the vessel, with huge round eyes and an oval mouth outlined with a fine groove: an exact repetition of the Sikachi-Alian masks. The cup, which can be dated by its vertical zigzag pattern, was found on the site of one of the Neolithic dwellings of Kondon, a large ancient fishing settlement on the Lower Amur, the second Neolithic "Pompeii" of the Far East (after the island of Suchu). Now there could be no doubt about the age of the majority of the Sikachi-Alian masks.

pl. 2

In short, masks played a dominant role in the art and constituted the major part of the rock drawings of the Neolithic culture of the Amur some five or six thousand years ago. They show with great distinctness their creators' unique artistic world. The enigmatic soul of an unknown culture, of mysterious and forgotten tribes, seems to look out at us through their huge, staring eyes. But are they so mysterious? Have they become entirely forgotten and lost in the haze of time? Here ethnography comes to the aid of archaeology.

pls. 20, 21

The ritual shaman masks of the Udeghe and Nanai of the Lower Amur (such as those in the Khabarovsk Museum of Local Studies), unique and remarkable for their decoration, almost fully reproduce the patterns and general appearance of the masks of Sikachi-Alian and of the Voznesenskoye vessel. The masks of the petroglyphs have also come down to us, although naturally with changes, in the ornaments of the present-day Amur peoples. Laufer in his time firmly denied the existence of anthropomorphous elements in the decorative art of the Amur tribes. He indicated as its characteristic features only zoomorphic and plant motifs, in the first place stylized drawings of fishes, cocks, and dragons. In his own terms he was, of course, absolutely right: it is true that the ornamentation of the Nanai, Olcha, and Nivkh contains no anthropomorphous representations which have the same degree of naturalism as the depictions of cocks and fishes. However, after careful study we have none the less come to the conclusion that it does contain simplified yet distinct masks. Moreover, they are not an exception, but its most widespread and indeed basic element. They include a simian mask with a broad, round upper half, within which huge eyes like those of the petroglyphs are represented by a double spiral. The wide apelike nostrils and massive chin stand out clearly. The broad ears are also rendered as spirals. Over the head we frequently find two raylike projections. Basically similar straight lines, projections or rays, are also characteristic of the anthropomorphous masks of the petroglyphs; they crown them at the top, and sometimes form a border around the sides. Similar patterns are found on the household articles and appliences made by Nanai women even now. Thus the masks of the Amur petroglyphs have not disappeared without trace, but, like other motifs (for example, birds or fishes) have been incorporated in later ornamentation, for which they served as a sort of building material; they have become elements of decorative patterns.

THE "NEFERTITI" OF THE AMUR

Other finds also bear witness to the links between the ancient and modern cultures of the Amur. In the course of excavations carried out at Kondon in 1965, we unearthed a Neolithic dwelling in which were a dozen vessels, shattered and crushed by the weight of earth; they carried the already familiar pattern of broad spirals over a background of comb-impressed dotted lines.

And suddenly, while the pottery was being uncovered, the archaeologist's knife touched the surface not of a sherd, but of some relatively small artefact. A few minutes later the cry rang out: "A statuette!"

pl. 27

This was the first anthropomorphous statuette, and at that time the only one in the whole of the Neolithic Amur. It was made of clay and had been thoroughly burnished and fired. The figure reveals the skillful hand and observant eye of the sculptor who made it. It seems to hold the accumulated experience of many generations of sculptors, of age-old, persistent, and individual artistic traditions.

The depiction is entirely realistic. It is not simply a generalized image of a woman, but rather a portrait. The Neolithic sculptor has conveyed with remarkable warmth the features of an actual human face, with a soft oval outline, broad cheekbones, a slender chin, and small pouting lips. The woman's nose is long and thin, like those of the North American Indians. The eyes, exaggeratedly long and narrow, like arched slits, are deeply cut in the soft clay. The forehead is low; the upper part of the head is slanted back.

In contrast to the finely modeled head, the bust of the figurine is only a rough outline, and there are no arms. But this makes the face still more alive. Even now in Kondon one can meet Nanai girls with faces of this type. They radiate the same subtle feminine charm as the statuette which has lain for thousands of years in the ground of this Stone Age dwelling. Perhaps the most unexpected thing about the Kondon statuette is that the head and thin, slender neck are slightly inclined forwards, towards the viewer, recalling the Egyptian queen Nefertiti.

While the Kondon statuette is attractive for its feminine grace, another of the same period, found in a Neolithic dwelling on the island of Suchu, has quite a different appearance. This too is a figure without arms. However, its manner is not soft and sculptural, but harsh and austere, like a line drawing. The narrow slant eyes are sharply and deeply cut, as if by a single energetic stroke of the sculptor's hand. The small nostrils seem to breathe menace and wrath. The whole statue is dynamic and powerful. If the Kondon statuette resembles Nefertiti, this one brings to mind literary images —Pushkin's Queen of Spades or the Vénus d'Ille in Mérimée's story of the same name. But it has distinct mongoloid features; they are even slightly exaggerated and made more pronounced by the artist.

pl. 26

The absence of arms in both statuettes also testifies to the links between ancient and modern, to the continuity of cultures. In our ethnographical museums there are many sculptures without arms, made by Nivkh, Nanai, and Olcha artists. These include *sevons*, figures embodying the spirits of illness and shamans' helpers during their magic rituals, and *dzhulins*, incarnations of female spirits, the guardians of dwellings and Mother-goddesses of the families living there.

One of the most remarkable petroglyphs of Sikachi-Alian shows an even more striking closeness to ethnographical material. This is a rare example of a mask with a body, again without arms, although there would have been ample room for them on the boulder. The face is roughly sketched, with holes for eyes and mouth; it is carved on two adjoining faces of the rock, as if hewn out of a log with two or three blows of an axe. That is how the Nanai craftsmen, highly skilled wood-carvers, hewed their wooden idols or *sevons*. By using the grain of the tree-trunk, they were able to show on the cut surfaces not only the *sevon's* face and his pointed hat, but also his eyes. Just like the *sevon*, this figure on the stone is three-dimensional; it has a diamond-shaped trunk, entirely filled in with chevrons (angled lines one inside the other). In this it most of all resembles the Nanai *sevon*, the hunting spirit Girki-Ayami. Another feature of resemblance between the Nanai ritual sculptures and the petroglyphs is the characteristic raylike pattern around the head and headdress. All this once more confirms the remarkable continuity of artistic traditions in the Amur region.

pl. 25

THE ANIMAL—MASTER OF THE TAIGA

In the Neolithic pit-dwellings where the female statuettes were found, on the island of Suchu (which in the Olcha language means "abandoned camp"), excavations also uncovered clay figures of a bear. The bear is shown realistically, with a heavy body, massive head, and typical muzzle. One can sense his primordial strength. Even in the smallest sculptures he inspires respect: like it or not, you step aside when the master of the taiga makes his way heavily through the dense thicket, turning over the logs in search of ants, his favorite delicacy. Judging by the hole pierced through the back of the animal while the clay was still soft, the figures must have been hung on a cord during some kind of ceremony or ritual. We also encounter stone figures of bears (on pestles and sinkers). It would be surprising if such representations had not been found during the excavation of Neolithic settlements, since we know what an important place the bear has occupied in the rituals and beliefs of the Amur tribes from prehistoric times.

pl. 33

Among the rituals involving bears (both images and live animals), the most important was the bear-festival: after a ritual feast in his honor the bear was slaughtered, and this was followed by a sacred meal and then the burial, a respectful celebration of his departure to the other world. All of this

complex symbolism had a central place in the social life of the Amur tribes and their neighbors
not only in the Siberian taiga, but on Sakhalin, the Kuriles, and Hokkaido. The symbolism
of the bear-festival was a reflection in a fantastic form of the actual social structure of these ancient
hunters of the taiga, and of their two-clan organization, based on the blood relationship of two
tribes or phratries.

The people of the Stone Age constructed for themselves an imaginary mythological picture
of the world, based on the example of actual human communities. According to their beliefs the
world was divided into two classes: people and beasts; the latter possessed all the characteristics
of human beings. Men and beasts entered into kinship relations and co-operated with one another.
The beasts responded to people's needs by giving them their bodies for food. In return, the people
brought the beasts sacrifices, making them a "gift" of what they lacked.

The bear is also one of the most widespread images in the art of the present-day nations
of the Amur. The bear-figures of modern folk art are close to the Neolithic statuettes: they show
the same lifelike quality, the same terse and expressive design.

The image of the elk is also at the heart of the mythology of the primeval hunters. This animal
was a basic source of food and clothing. Its bones were made into spear- and arrow-heads, its
antlers into bows. And not only bows, but also works of art—once again, figures of elks and bears.
If the bear was the totem of one half of the endogamous tribe, the elk was at the head of the other.
In the legends of the Siberian tribes, the cosmic elk appears as the zoomorphic representation
of the earth and sky, the incarnation of the Universe. The image of the cosmic elk was linked with
the fate of the Universe: the hunter-bear or group of hunters-bears chase the elk; when the elk
is caught and killed, catastrophe will overtake the world, and the Universe will perish.

pls. 40, 41, 44 That is why the striking elk pictures appeared on the rocks of Sikachi-Alian. They show not only
a true-to-life silhouette of the animal, but also the ribs and conventionally presented inner organs:
the body of the animal is shown as if in longitudinal section, as the hunter saw it while he cut
up his prey with a stone knife.

Nor did the prehistoric artists forget the third ruler of the Far Eastern forests—the tiger, who also
played an important role in the beliefs of the Amur peoples.

pl. 46 In one of the best compositions on the boulders of Sikachi-Alian, the figure of a tiger is clearly
shown—with a striped body, a long tail, and a catlike round muzzle stretched forward. Just such
tigers are a popular subject in the ritual shaman sculpture of the Amur nations. It may be that some
of the masks, which at first seem to be anthropomorphous, in fact represent a tiger or something
which is half-man, half-tiger. There is something beastlike, awesome, and powerful about the
strikingly impressive mask on the bank of the Amur, through which we first made acquaintance
with the mysterious world of the Sikachi-Alian petroglyphs. Did not the tiger also produce such
an impression on the ancient inhabitants of the Far East, who, when they met him, fell to their
knees and humbly implored him to pass them by? And is not the tiger shown as the lord of the Amur
on the slab of basalt at Sikachi-Alian?

THE BIRD—CREATOR OF THE WORLD

There is another common theme in the ancient and folk art of the Amur peoples—the bird.
Among the petroglyphs of Sikachi-Alian we find a depiction of a sitting duck or swan. It has a large
circular head with a round eye, like those of the masks.

On the same rock another bird is shown with its back to the first. Its eye is very large, almost
completely filling the head, and there is no dot inside it. Its bill is long and slightly curved.
But unlike the first, this bird has a somewhat longer body.

Apart from ducks and swans—waterfowl—the Sikachi-Alian boulders include two representations
of a woodland bird which resembles a sitting wood grouse. One of the depictions belongs to the

earlier, presumably pre-Neolithic layer, to the pre-ceramic, or, as it is usually called, Mesolithic era. It is incised, together with the primitive figures of beasts, on a slab of rock beneath an outcrop of the bank, where the remains of a Mesolithic settlement were found with characteristic leaf-shaped blades made of black stone.

In Sheremetyevo on the Ussuri, the second most important concentration of petroglyphs in the Far East, depictions of birds are more frequent. Represented there are mostly waterfowl—swans *pl. 51* or geese and ducks. Clay figurines of birds were found in a Neolithic dwelling on the island of Suchu. This time the birds are shown in flight, with wings spread. *pl. 57*

The collections of our ethnographical museums contain many parallels to them—depictions of birds, including waterfowl (geese, ducks, and swans).

Birds figure in the legends and myths of the Amur nations; for example, in the myth about the creation of the Universe recorded by Laufer in the nineteenth century: "In the beginning of the world there were only three men, called Shankoa, Shanwai, and Shanka. There were three divers and three swans. Once upon a time the three men sent the three swans and the three divers to dive for soil, stones, and sand. The birds dived. For seven days they stayed under water. Then they emerged. They brought earth, stones, and sand and they began to fly about, carrying the earth that they had brought. They flew all around the world. The earth originated when the divers flew, holding earth and stones in their bills. Mountains and plains arose. The divers flew about; and where they flew, rivers arose. Thus they determined the courses of the rivers. They flew toward the sea, and the Amoor river arose."

In Sikachi-Alian, as also at Sheremetyevo, aquatic birds are shown in pairs, which corresponds to the mythological beliefs about the creation of the Earth by two divers, two demiurges, two brothers or sisters. Another important feature is the slantwise cross carved on the breast of a swan drawn on the Sheremetyevo rocks. This is a hint at the bird's cosmogonal significance, its active role in the creation of the world.

Birds play no less of an active part in the myths about the "tree of the world"; the souls of people or shamans, in the mysterious other world, "grow up" in nests on the branches of this tree. These souls have the appearance of waterfowl—ducklings. According to the Nanai legends there are three such trees: one in the sky, in which all souls live before their incarnation in the form of unfledged ducklings; another identical one in the nether world, in the kingdom of the dead; and the third on the earth—a birch tree carrying the objects of the shaman rituals. The shaman tree with birds —the souls of yet unborn people—sitting in its branches, mentioned in the legends, is depicted on the wedding robes of the Nanai women, with their splendid ornamental patterning. On these the birds sit in pairs, facing one another, just as on the petroglyphs: these birds too are participants *pl. 61* in the cosmogony and reflect the image of the Universe.

THE GREAT SERPENT

Another subject which is common to the ancient and modern art of the Amur region is the snake. One of the Sikachi-Alian stones is incised with a snake coiled into a tight spiral: it seems as if in a moment it will straighten itself and strike out at the enemy. On other stones the snakes are twisted into supple plaits; they interweave, twine, and untwine as if they were alive. In one of the petroglyphs there are seven snakes (seven being a sacred, magical number).

Sometimes the snake-spiral is an essential component of the anthropomorphous rock carvings. For example, snakes' heads with dots inside are seen near the fish-shaped eyes of one Sikachi-Alian mask. Another mask is girdled by supple spirals with distinct arrow-shaped snakes' heads. Similar figures of snakes are to be found on the pottery. One of the vessels found during excavations at the Nivkh village of Takhta on the Lower Amur is decorated with the relief figure *pl. 64* of a snake, whose scaly skin is shown by tiny notches.

19

The image of the snake is linked with the most widely used motifs in the decorative arts of the Amur peoples—the spiral and the vertical zigzag. The significance of this image in the art of the Amur region can be appreciated if we consider the local legends in which the divine serpent appears as a beneficent being, endowed with supernatural power and wisdom. In the mythology of all the Tungus tribes, including the Nanai, a gigantic cosmic serpent is the demiurge, the creator of the Universe. According to the Nanai legends the earth was originally smooth and covered by the waters of the ocean. But then two gigantic creatures appeared—a mammoth and a serpent. With his lithe body the serpent ploughed deep valleys. The water flowed away down them, leaving space for all the living creatures on the earth. The main sign of the cosmic serpent, who descended to earth in the form of lightning, is his fiery trait, the zigzag. The combination of spirals and vertical zigzags in the ornamentation of the Neolithic period on the Amur reflects the ancients' beliefs about the unity of the celestial fire—the lightning (zigzag)—and the solar serpent (spiral). The unity of these symbols, linked with the worship of the sun, the source of life, embodied the eternal idea of good, the concept of fertility, the dream of human happiness. Thus one of the most popular motifs in the art of the peoples of the Amur (and many other nations of the Pacific Basin) has its roots in prehistory: it can be traced in the Amur petroglyphs and other Neolithic monuments.

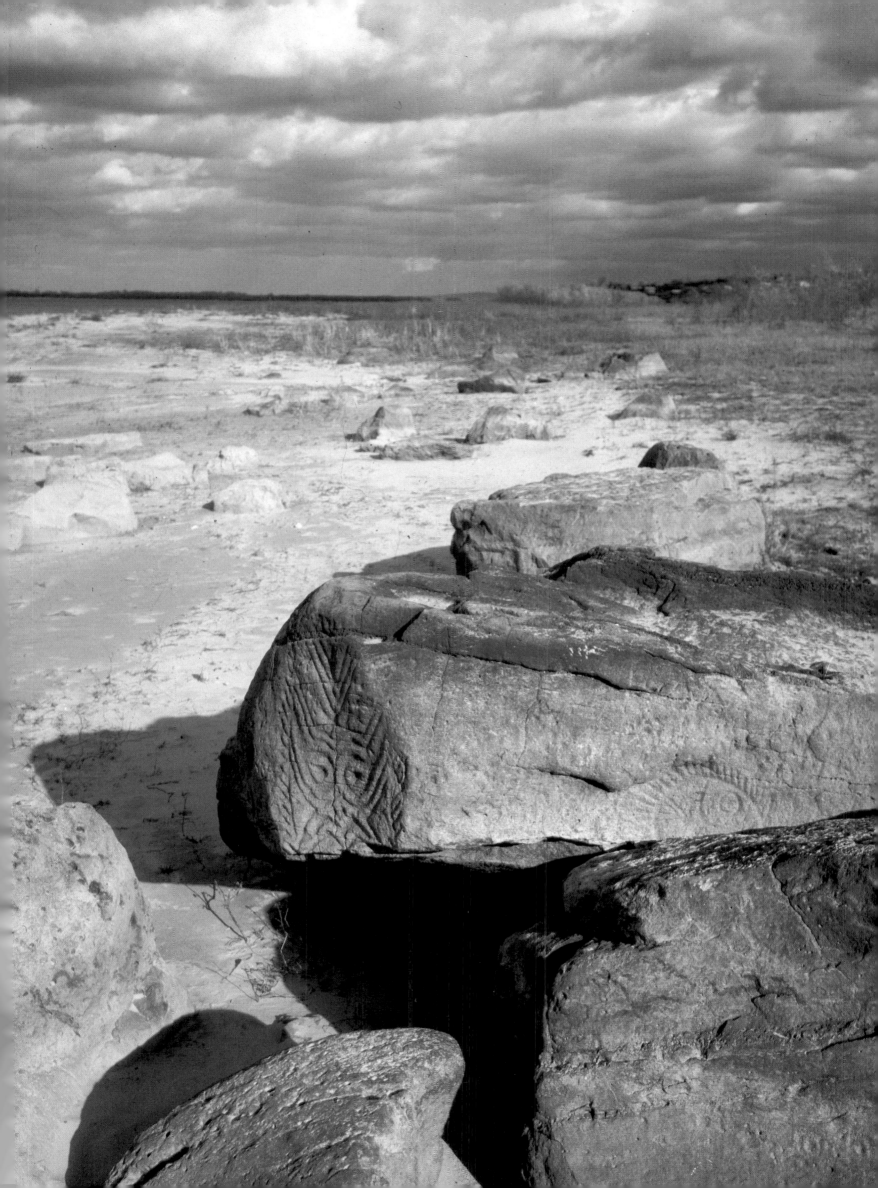

1

The bank of the Amur River at Sikachi-Alian (Khabarovsk district, Khabarovsk territory).

2

Sherd of a cup with an apelike mask in relief on rim. Yellow-brown clay. 15 × 8*. On the outside of the cup, a typical Neolithic pattern of vertical zigzag impressed with a comblike stamp. Fourth–third millennium B.C. Kondon, Solnechny district, Khabarovsk territory. NACAE, 1971. MIHPP, Inv. No. Кп-71/12696.

3

Apelike mask with projection above (feather of head-dress?). Incised on a basalt boulder. Height 31. Fourth–third millennium B.C. Sikachi-Alian, Khabarovsk district, Khabarovsk territory.

4–8

Petroglyphs of the Amur area depicting masks. Incised on basalt boulders. Fourth–third millennium B.C. Sikachi-Alian, Khabarovsk district, Khabarovsk territory. 4 — mask with halo, or "radiance" (tiger?), height 63; 5 — elongated oval mask tapering at the bottom, height 21; 6 — oval mask, with "radiance", height 48; 7 — apelike mask, height 42; 8 — oval masks (upper one with "radiance"), height 47 (right).

9, 10

Petroglyphs of the Ussuri area depicting masks and a bird. Incised on a basalt cliff. Fourth–third millennium B.C. Sheremetyevo, Viazemsky district, Khabarovsk territory: 9 — truncated oval masks, height 12; 10 — oval mask and a water bird, height 54, 30.

11

Basalt cliff with petroglyphs on the bank of the Ussuri near Sheremetyevo (Viazemsky district, Khabarovsk territory).

12–15

Petroglyphs of the Ussuri area depicting masks and a boat. Incised on a basalt cliff. Fourth–third millennium B.C. Sheremetyevo, Viazemsky district, Khabarovsk territory: 12 — truncated oval mask with "radiance" and "fish-shaped" eyes, height 76; 13 — craniform masks, height 28, 18; below, oval mask, height 60; 14 — apelike mask with "radiance", height 32; 15 — mask with "radiance" and boat, height of mask 24, length of boat 57.

* Dimensions are given in centimeters.

16

Three statuette heads. Clay, yellow-brown, red-ochre and dark gray. Height 4.6, 3.6, 3.4. The mongoloid face type, with narrow slanting eyes and prominent cheekbones, is expressively shown. Fourth–third millennium B.C. Suchu island on Amur River. Ulchsky district, Khabarovsk territory. NACAE, 1972. MIHPP, Inv. Nos. Cy-74/8931, Cy-72/7424, Cy-74/14819.

17

Apelike mask. Incised on a basalt boulder. Height 28. Fourth–third millennium B.C. Sikachi-Alian, Khabarovsk district, Khabarovsk territory.

18

Potsherd with masks. Yellow clay. Height 33.5. The masks outlined by grooves and filled in with impressions of a comblike stamp. The background burnished red. Third millennium B.C. Voznesenskoye, Amursk district, Khabarovsk territory. FEAE, 1965. MIHPP, Inv. No. B-65/46, 79, 79a.

19

Potsherd with anthropomorphous images. Yellow-brown clay. Height 20.5. The anthropomorphous images outlined by grooves and filled in with impressions of a comblike stamp. The background burnished red. Third millennium B.C. Voznesenskoye, Amursk district, Khabarovsk territory. FEAE, 1965. MIHPP, Inv. No. B-65/1.

20

Ritual shaman mask. Wood. Height 23. Decoration in black and red pigment. Nanai, 19th century. Collected by V. Arsenyev. Khabarovsk Museum of Local Studies, Inv. No. 1608.

21

Ritual shaman mask. Wood. Height 25. Decoration in black and red pigment, with a glued-on beard and tufts of hair. Udeghe, 19th century. Collected by V. Arsenyev. Khabarovsk Museum of Local Studies, Inv. No. 1609.

22

Pestle with an apelike mask in relief. Light brown basalt. Height 9.5. Third–second millennium B.C. Chiorny Yar, Ulchsky district, Khabarovsk territory. NACAE, 1976. MIHPP, Inv. No. 1976/350.

23

Hunter's waist-bag. Fish-skin. 17.5 × 11. Embroidery: a stylized mask. The borders edged with squirrel fur; fish-skin tassels at the bottom. Nanai, early 20th century. Naikhin, Nanaisky district, Khabarovsk territory. Collected by V. Arsenyev in 1911. SME, Inv. No. 1871-34.

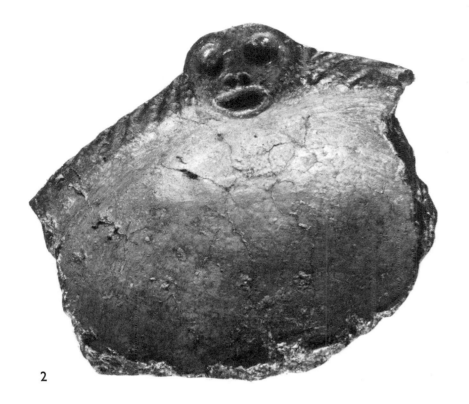

2

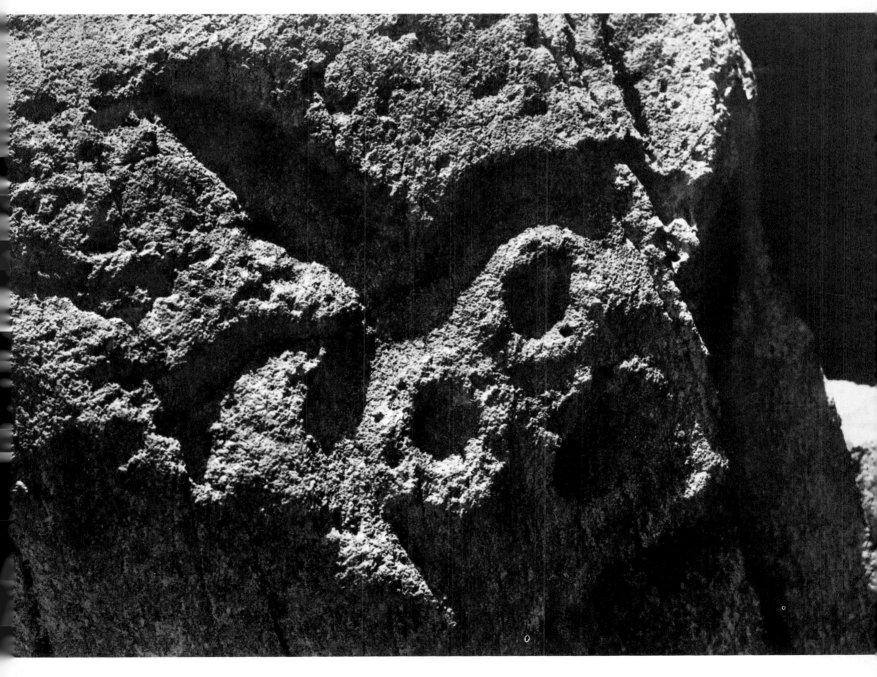

3, 4 →

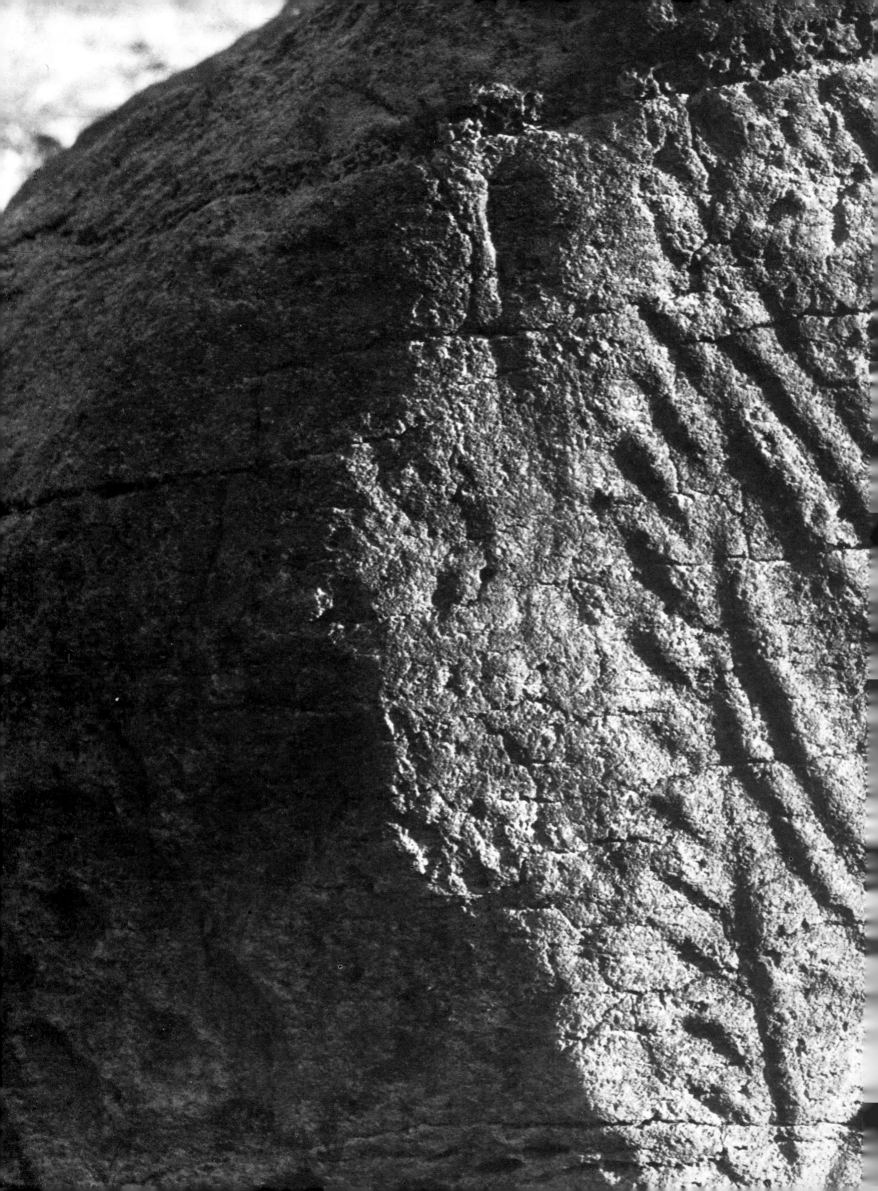

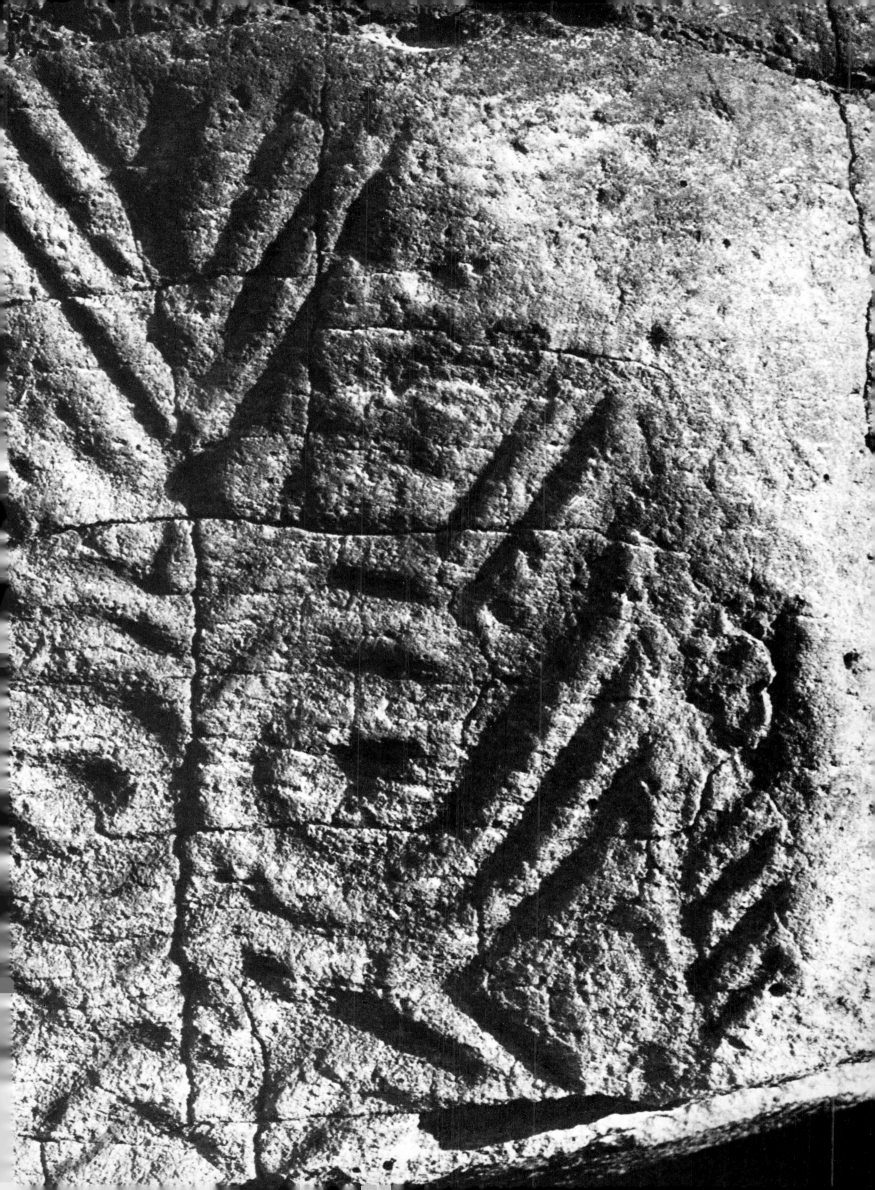

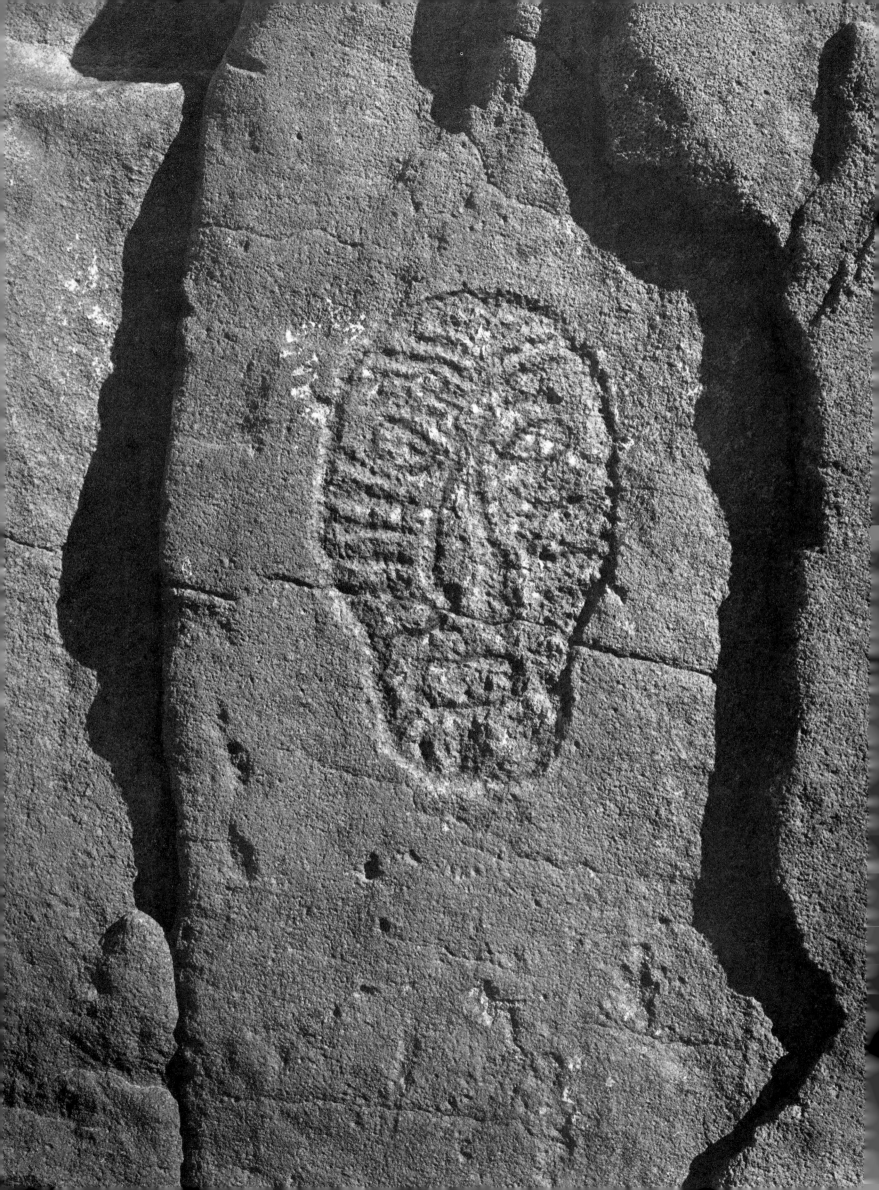

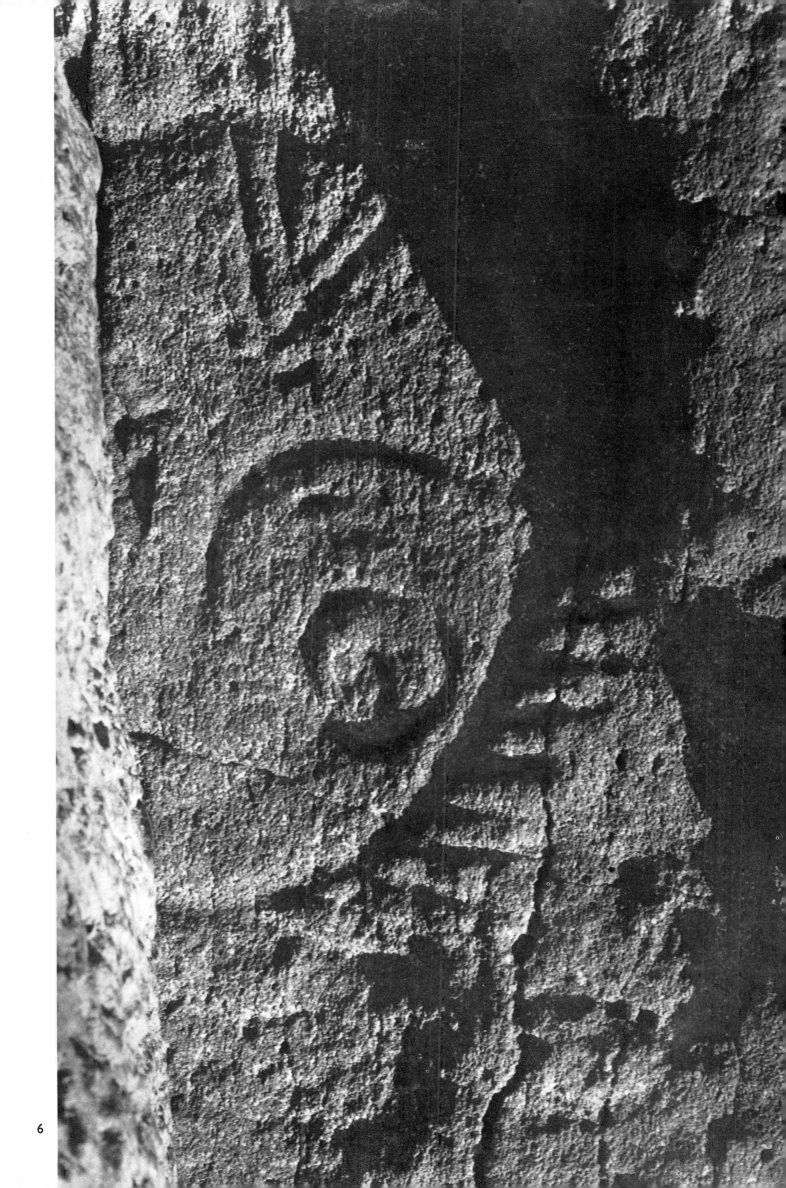

5 6

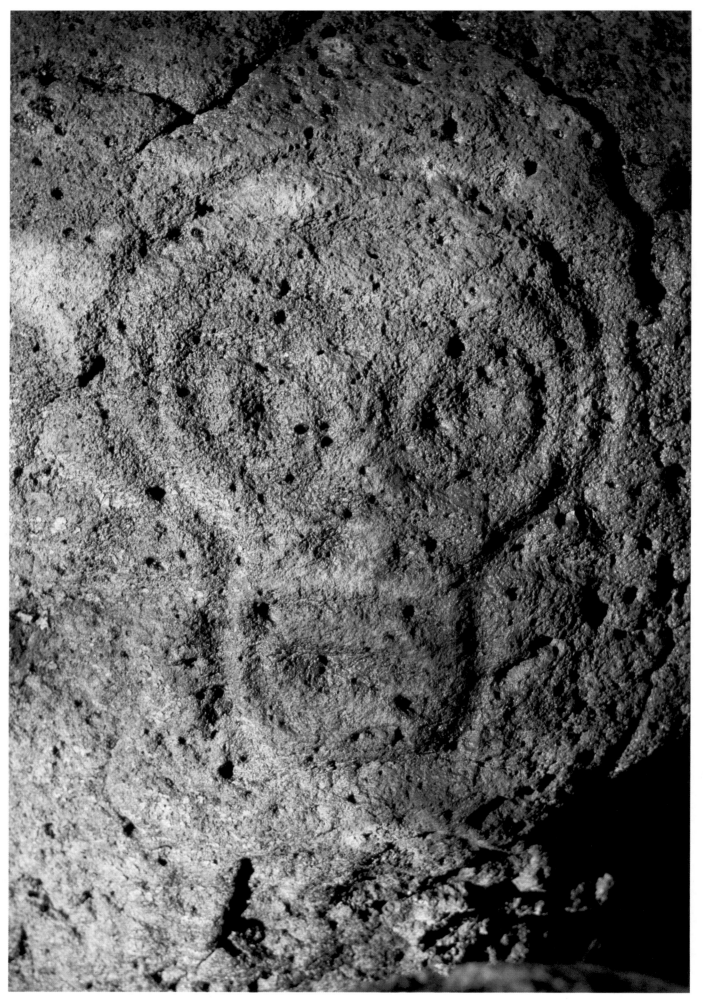

7

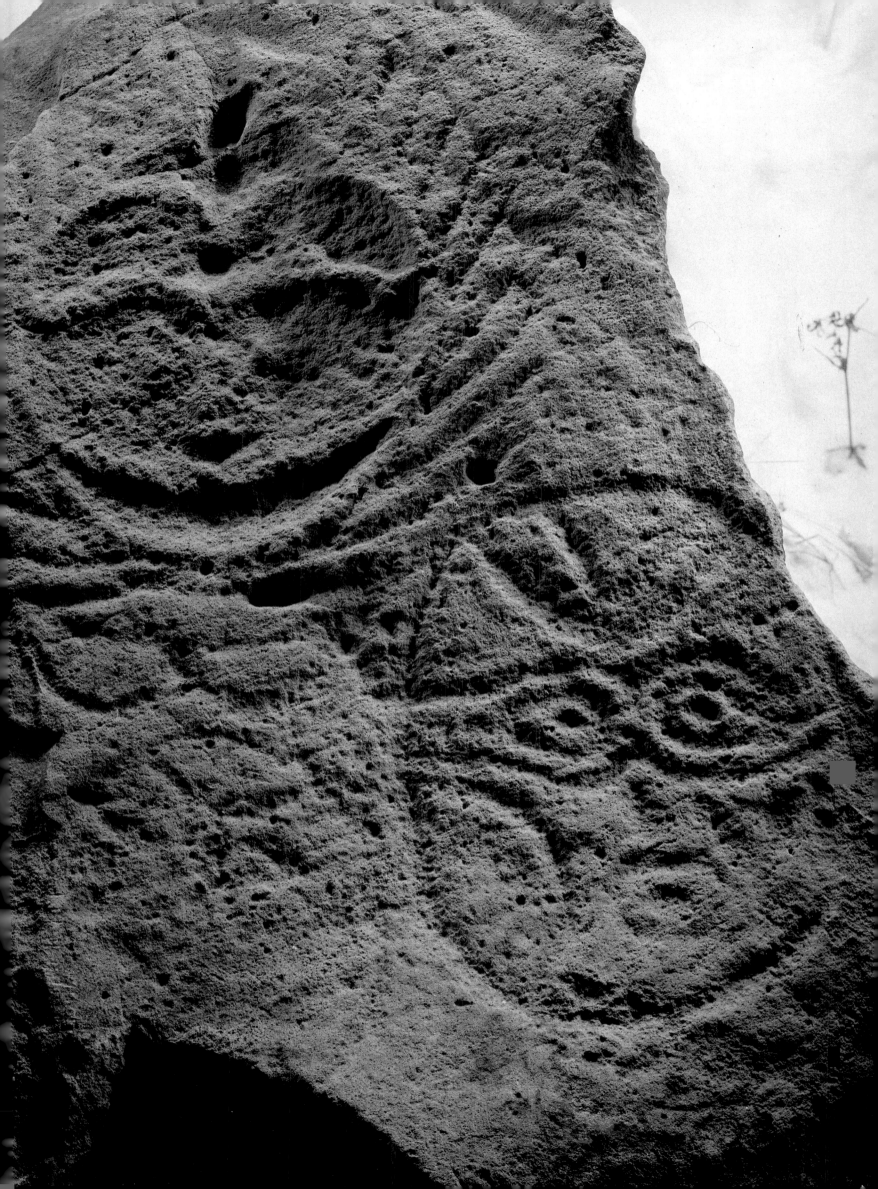

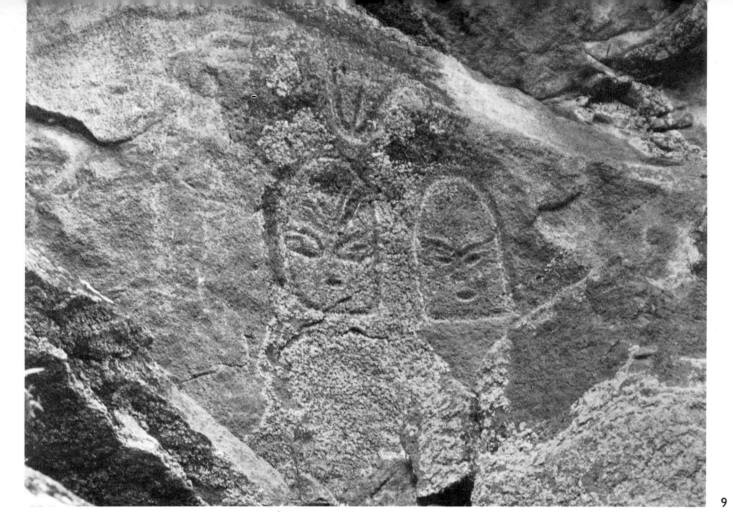

9

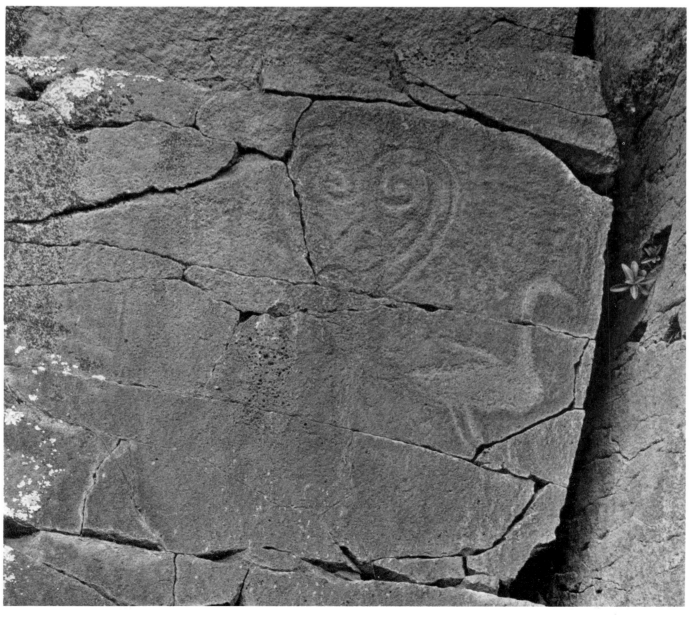

10 11

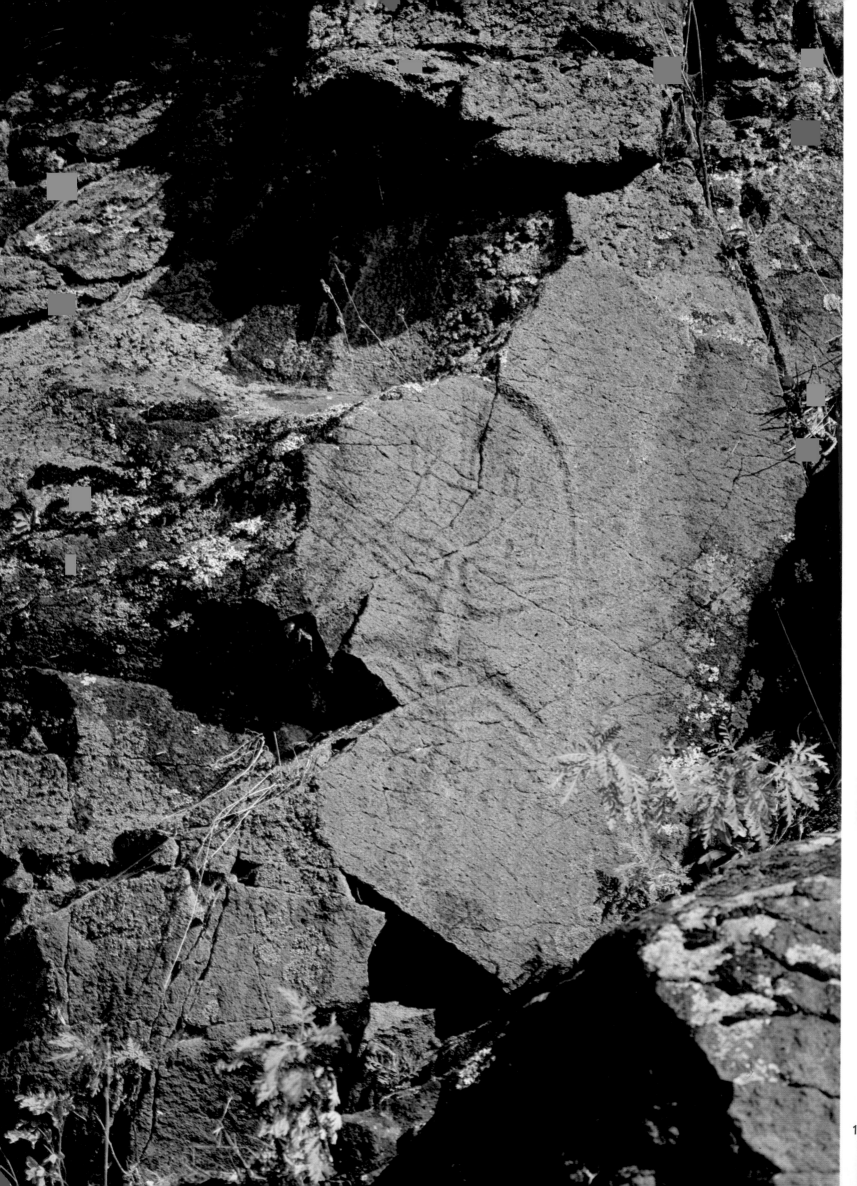

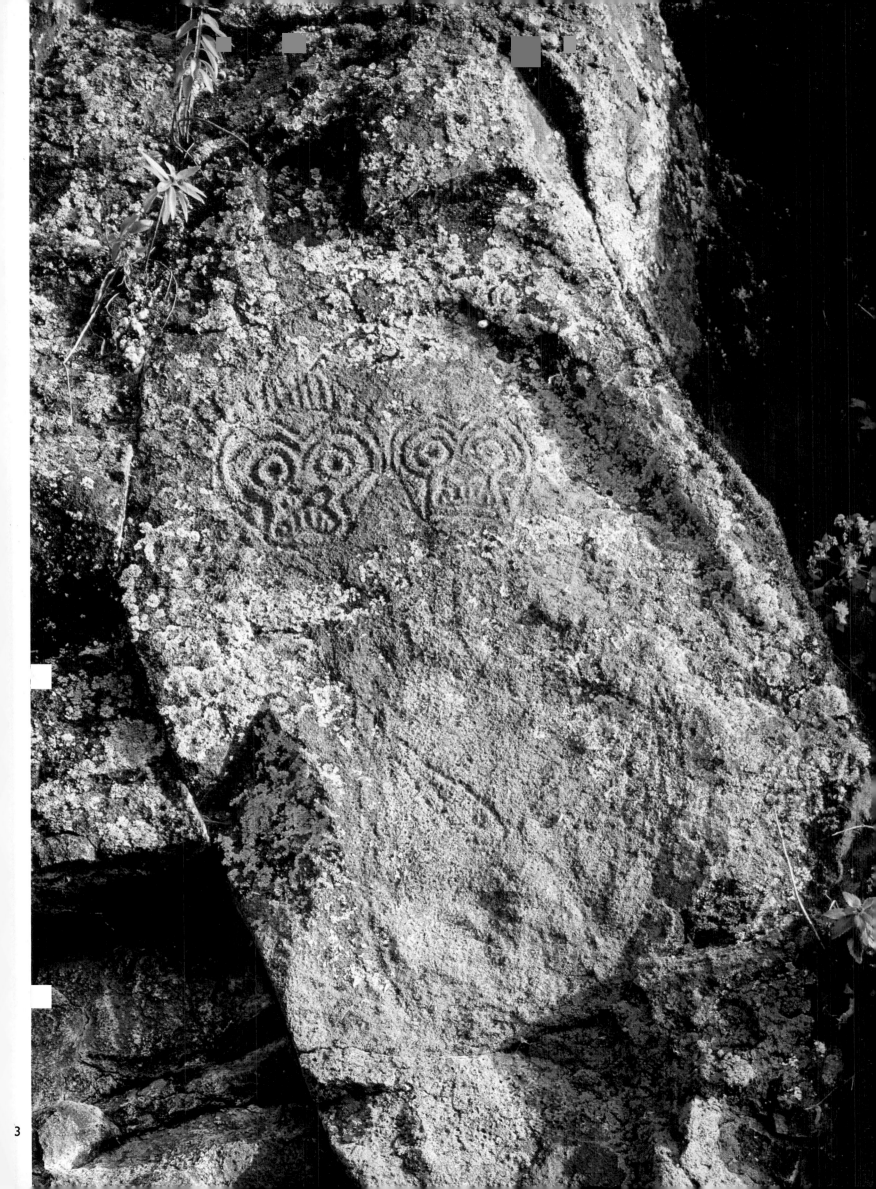

3

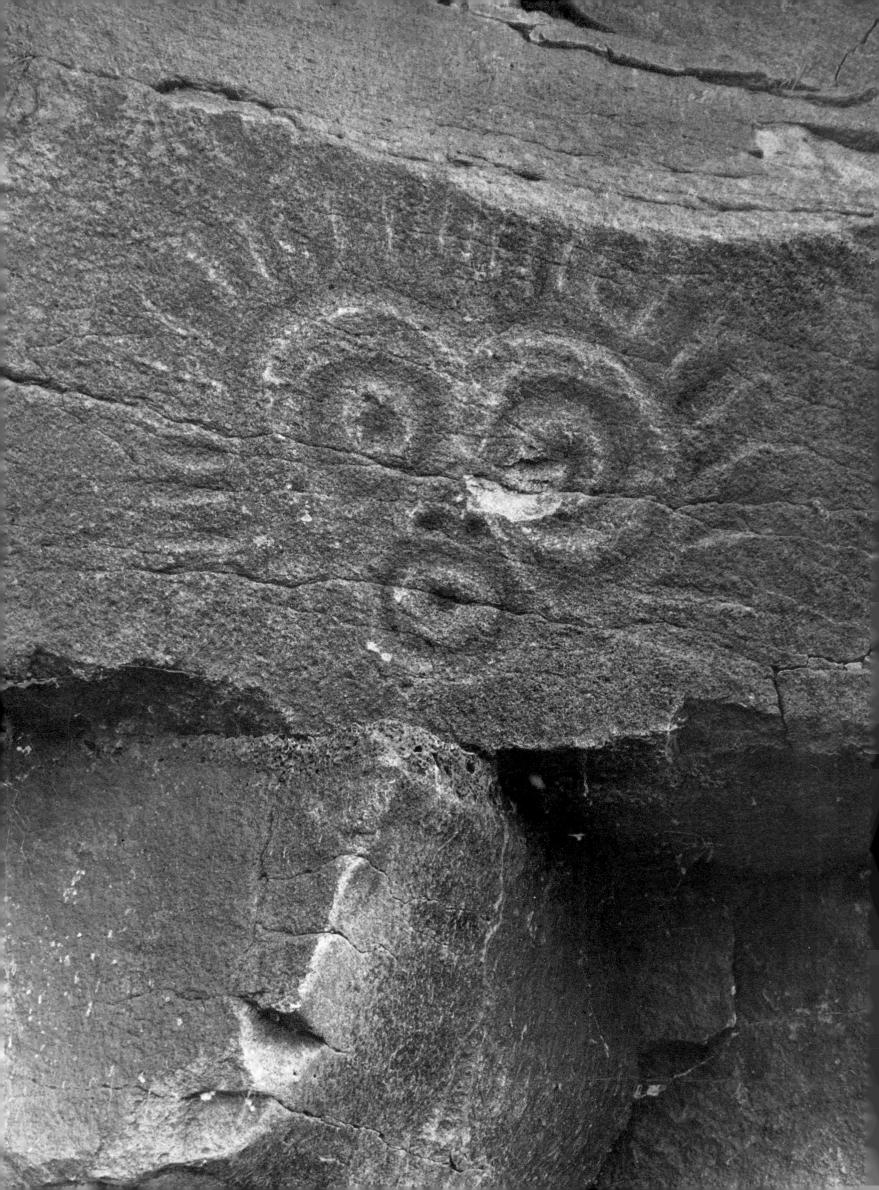

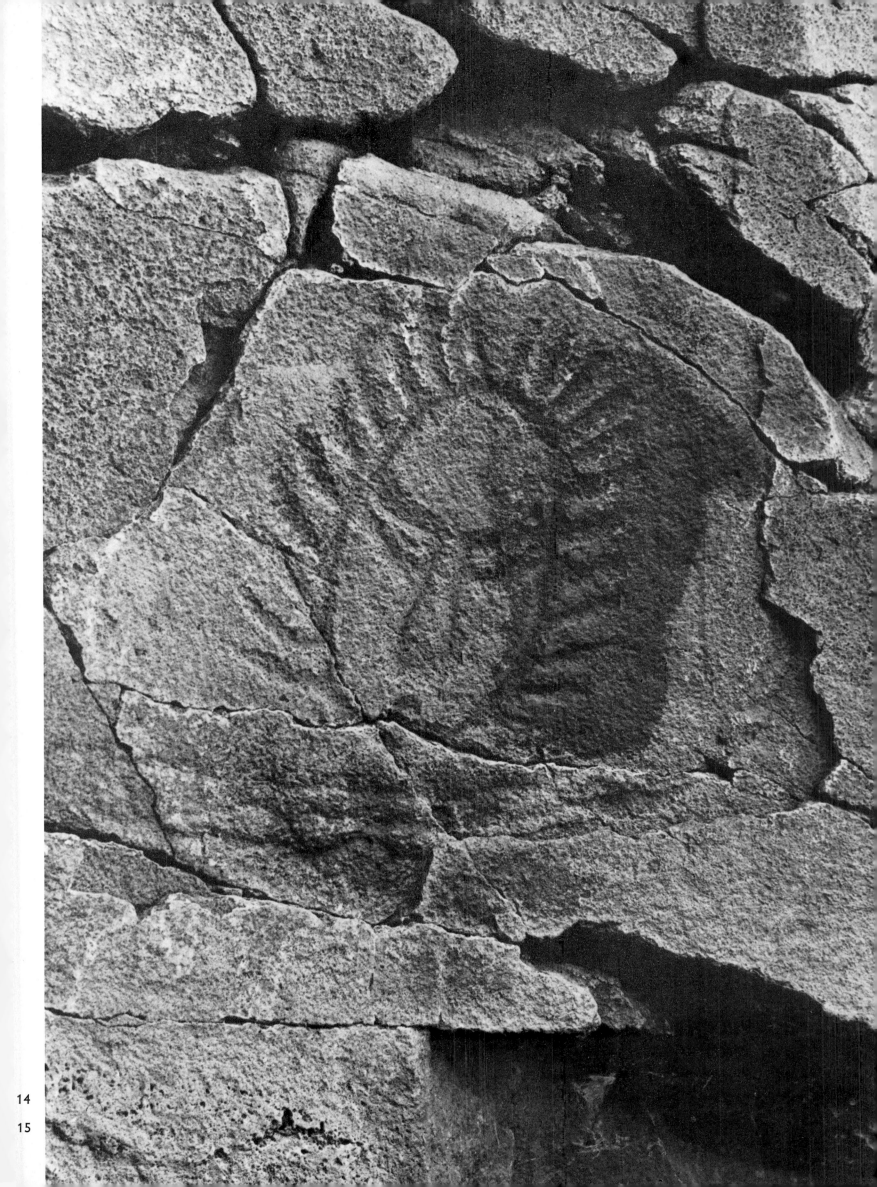

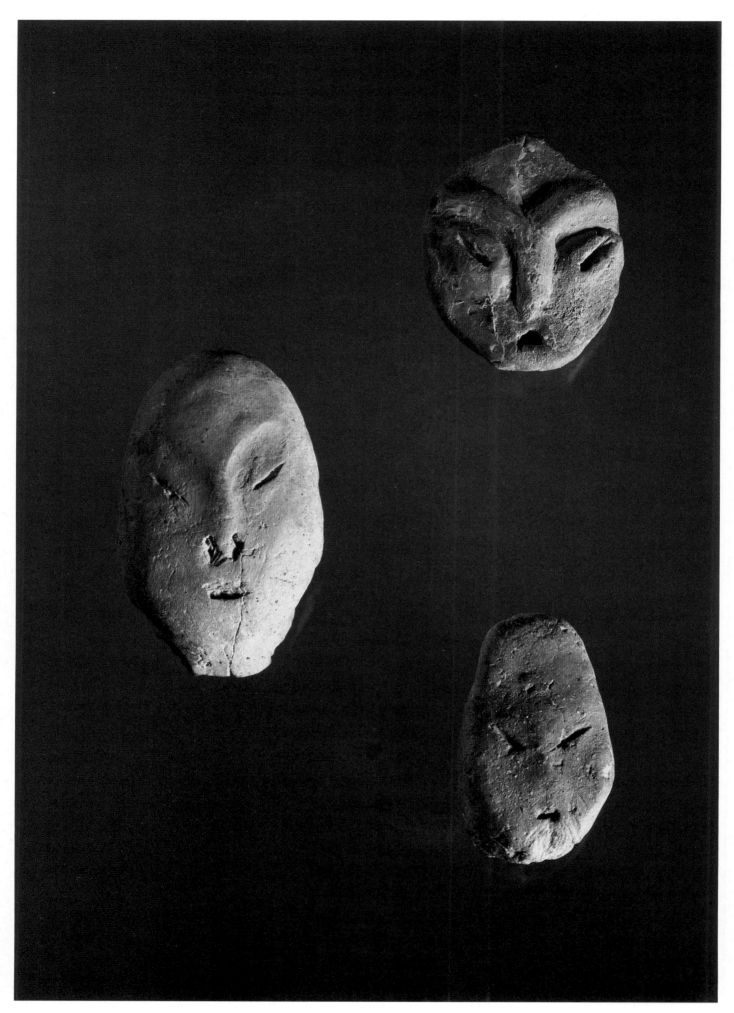

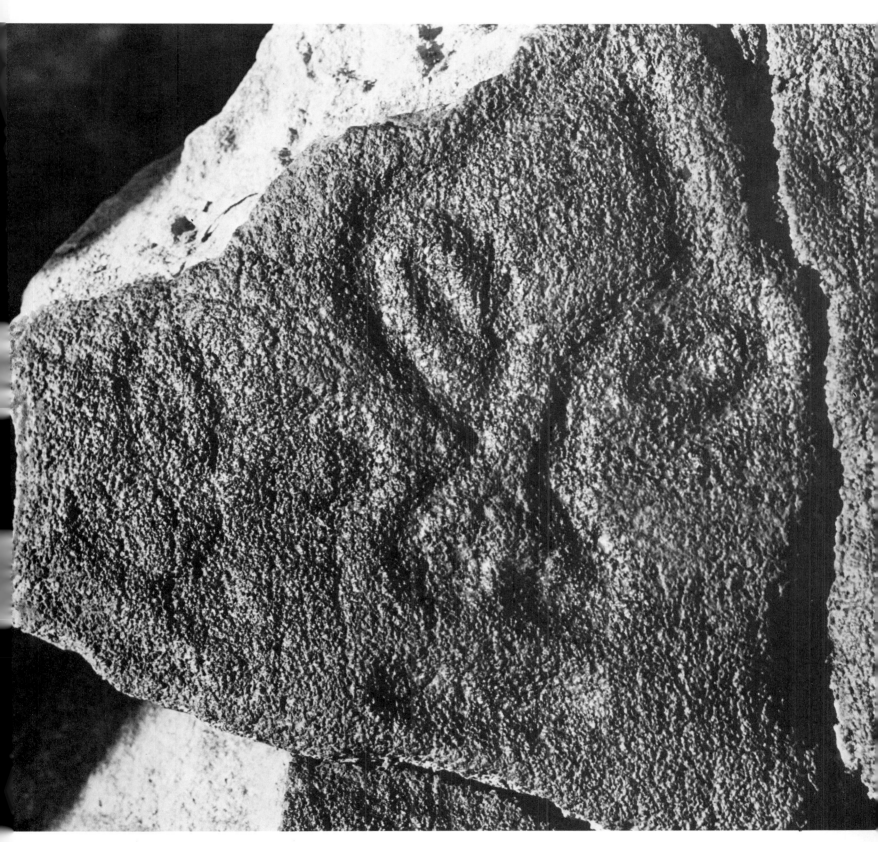

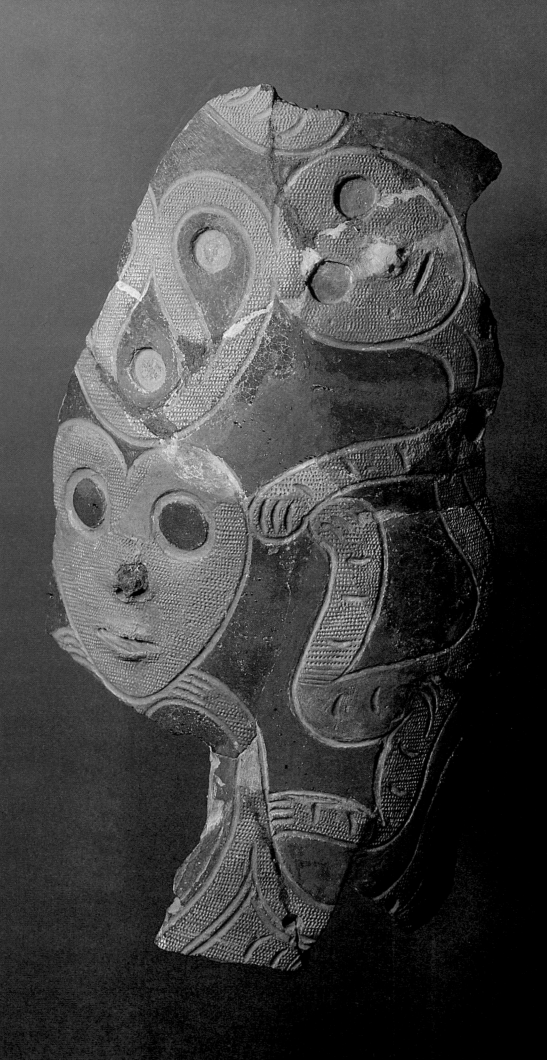

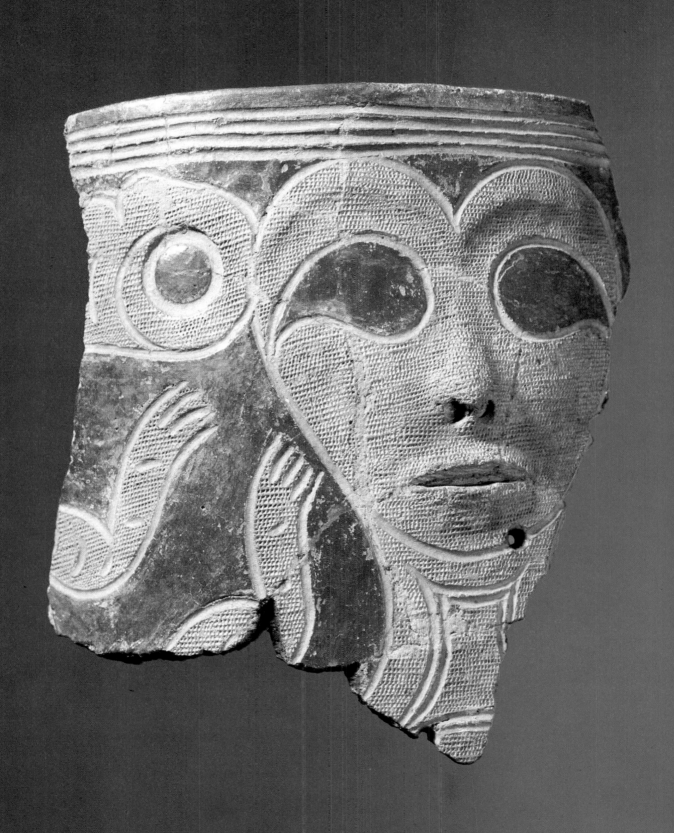

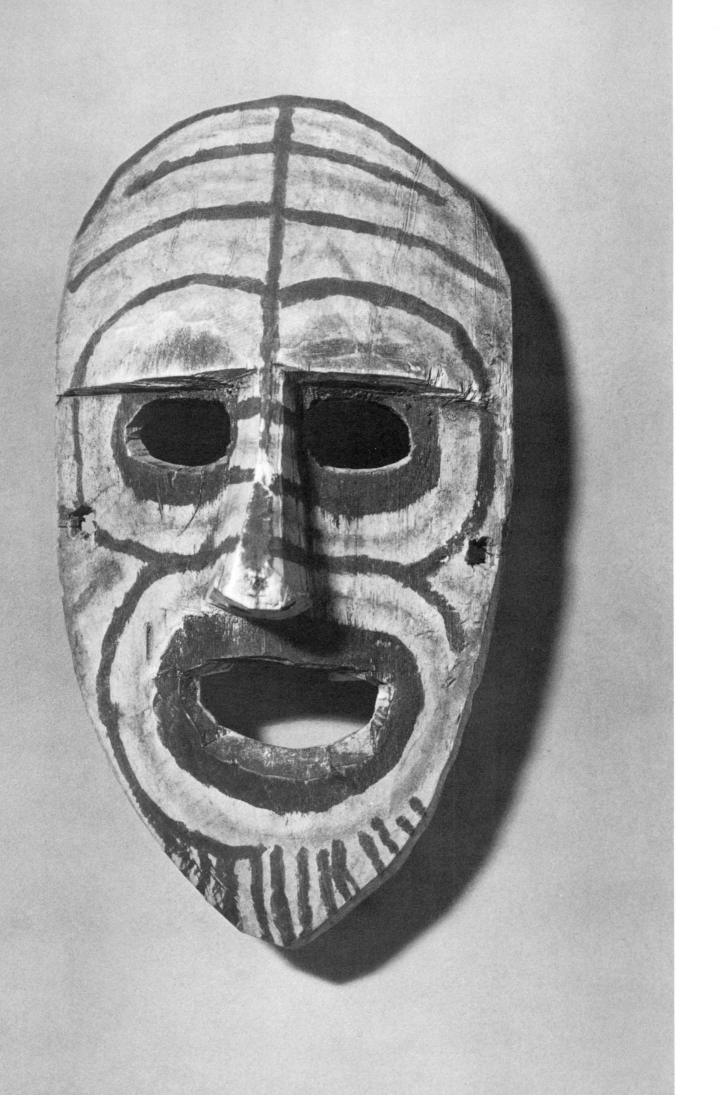

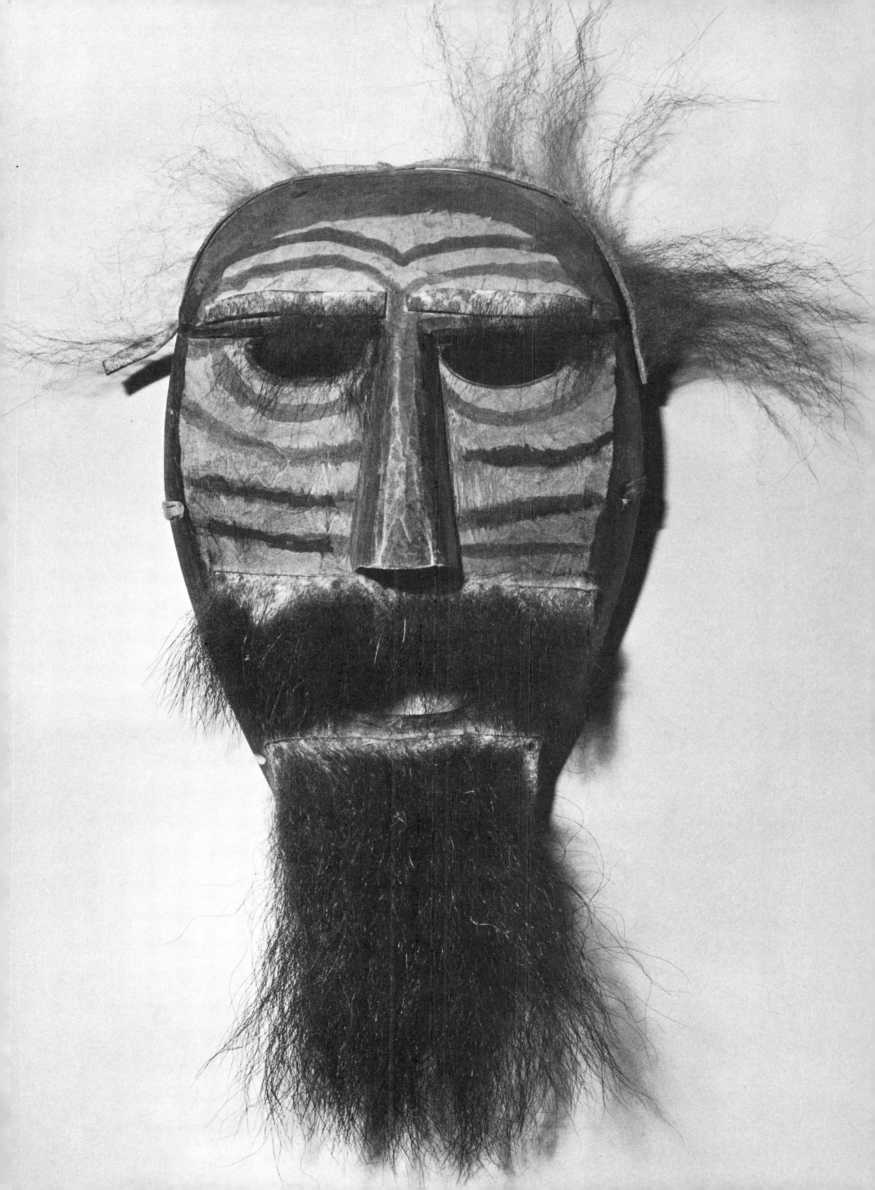

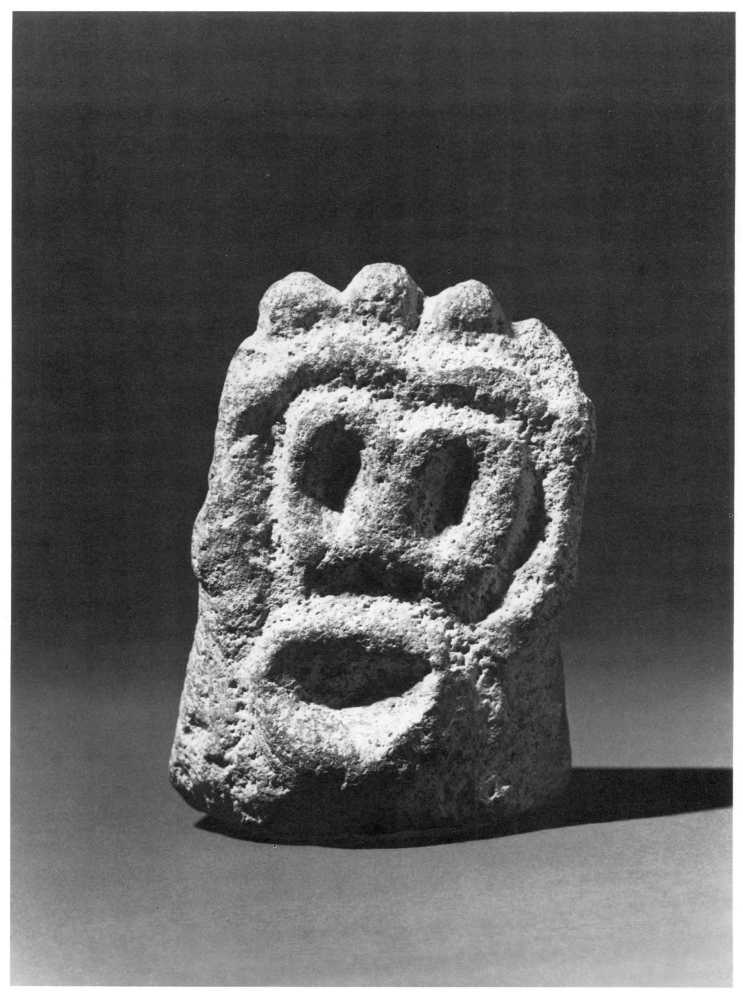

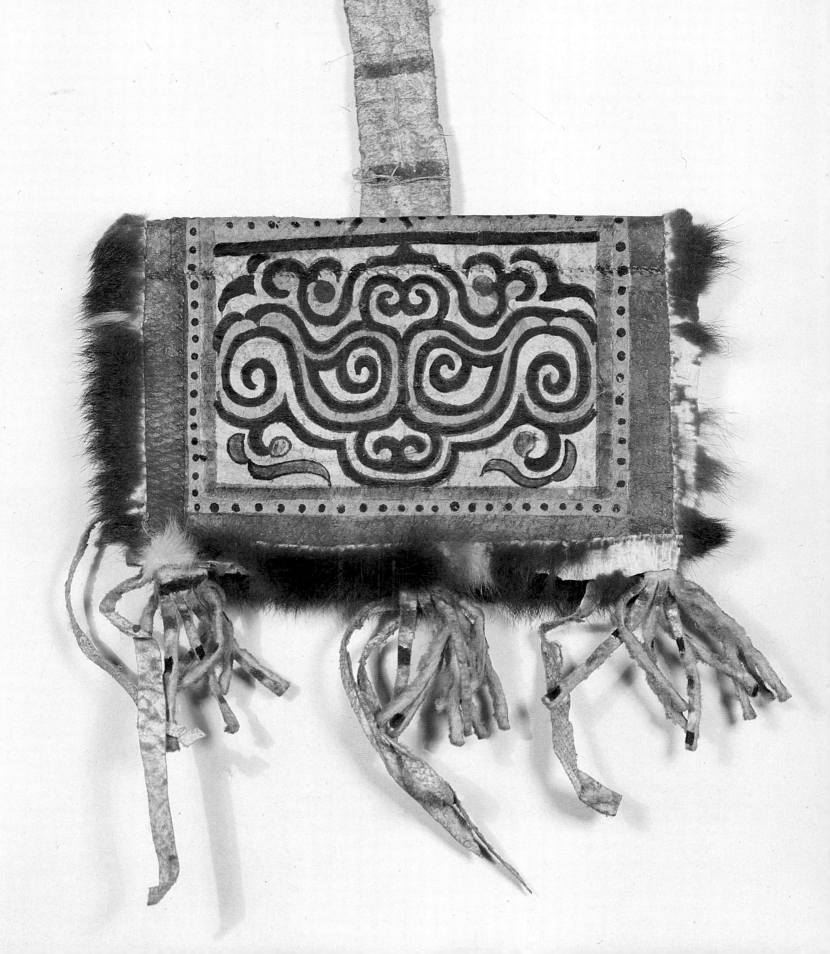

26

Statuette of a woman ("Queen of Spades").
Yellow-brown clay. Height 6.6.
The mongoloid face type with slanting
eyes and broad cheekbones is emphasized.
Torso schematic, arms absent. Fourth–
third millennium B.C. Suchu island
on Amur River, Ulchsky district,
Khabarovsk territory. NACAE, 1973.
MIHPP, Inv. No. C-73/РП-8764.

27

Half-length figure of a woman (Kondon
"Nefertiti"). Light yellow clay. Height 12.
Note realistic details of the face
and plasticity of modelling. Torso schematic,
arms absent. Fourth–third millennium
B.C. Kondon, Solnechny district,
Khabarovsk territory. FEAE, 1963. MIHPP,
Inv. No. Кп-63/48090.

28

Sevons. Wood. Height 97, 34, 59.
On the breast of the right-hand figure,
two small anthropomorphous idols. Olcha,
early 20th century. Bulava, Ulchsky
district, Khabarovsk territory. FEAE,
1968–69 (collected by V. Timokhin).
MIHPP, Inv. Nos. МИИФ-385, 386, 389.

29

Idol-talisman. Wood, fox-fur, leather.
Height 49. On the chest and belly,
a painted design of animals and birds.
At the back two straps. Orochi, Udeghe,
late 19th–20th century. Dynmi River
(tributary of the Aniuy), Nanaisky district,
Khabarovsk territory. Collected by
V. Arsenyev in 1911. SME,
Inv. No. 1870-49.

30

Anthropomorphous idol. Gray basalt.
Height 48. Probably a representation
of the guardian spirit of a house, similar
to the Nanai *dzhulin* described by
ethnographers. 6th–12th century A.D.
(Moh-hoh period). Found near the camp-
site of Mukha, Nanaisky district,
Khabarovsk territory. FEAE, 1971 (chance
find). MIHPP, Inv. No. МИИФ-398.

31

Figure of a *sevon* (detail). Wood. Total
height 110; height of the detail 44.
The structure of wood is skillfully used
to show the eyes. Olcha, early 20th century.
Bulava, Ulchsky district, Khabarovsk
territory. FEAE, 1968. MIHPP,
Inv. No. МИИФ-386.

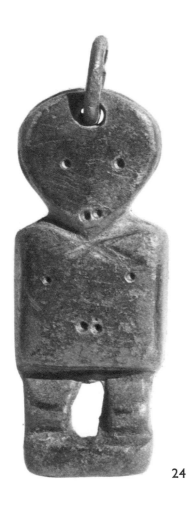

24

24

Anthropomorphous amulet (*sevon*,
incarnation of a spirit). Bronze. Height 6.
Nanai, 19th century. Malyshevo (school
museum), Khabarovsk district, Khabarovsk
territory.

25

Anthropomorphous figure. Incised
on the edge of a basalt rock. Height 54.
Analogous in style and shape to images
of the hunting *sevon*, Girki-Ayami,
described by ethnographers. Fourth–third
millennium B.C. Sikachi-Alian, Khabarovsk
district, Khabarovsk territory.

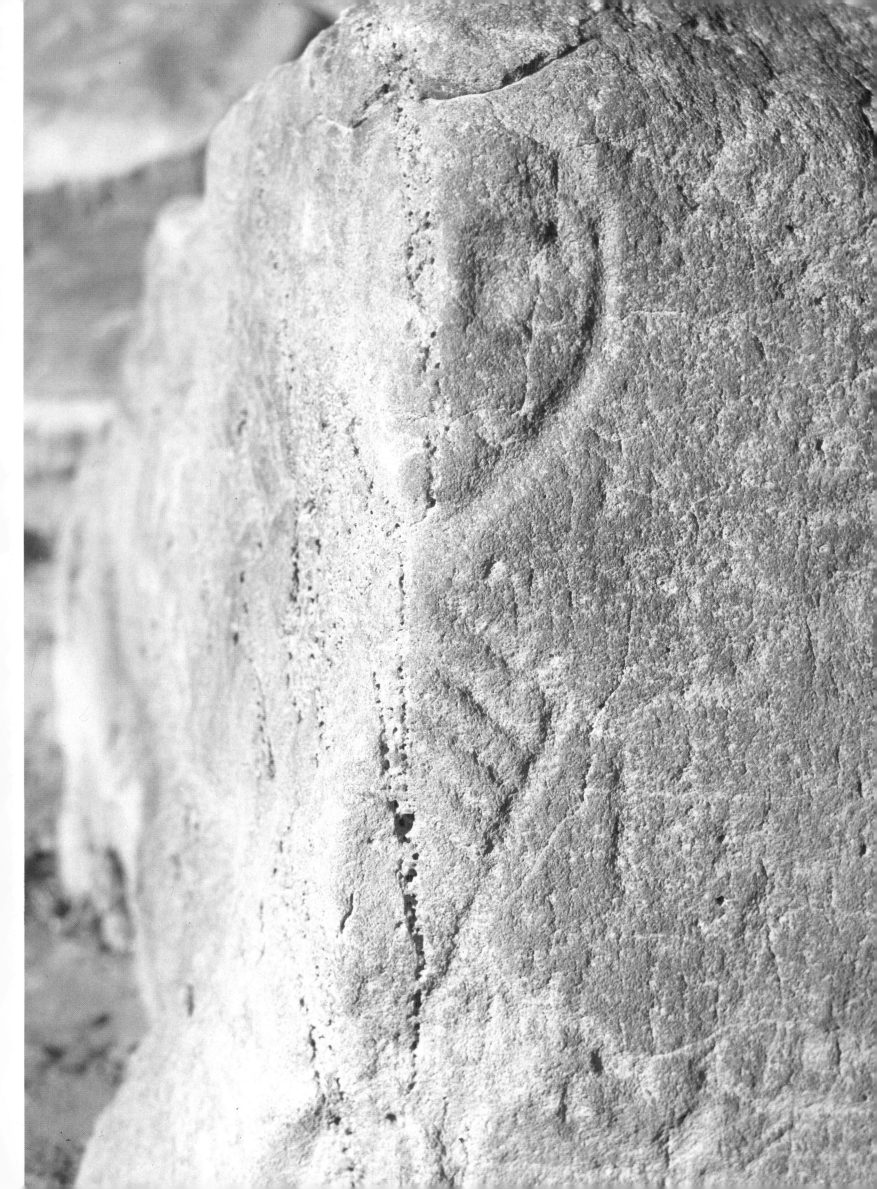

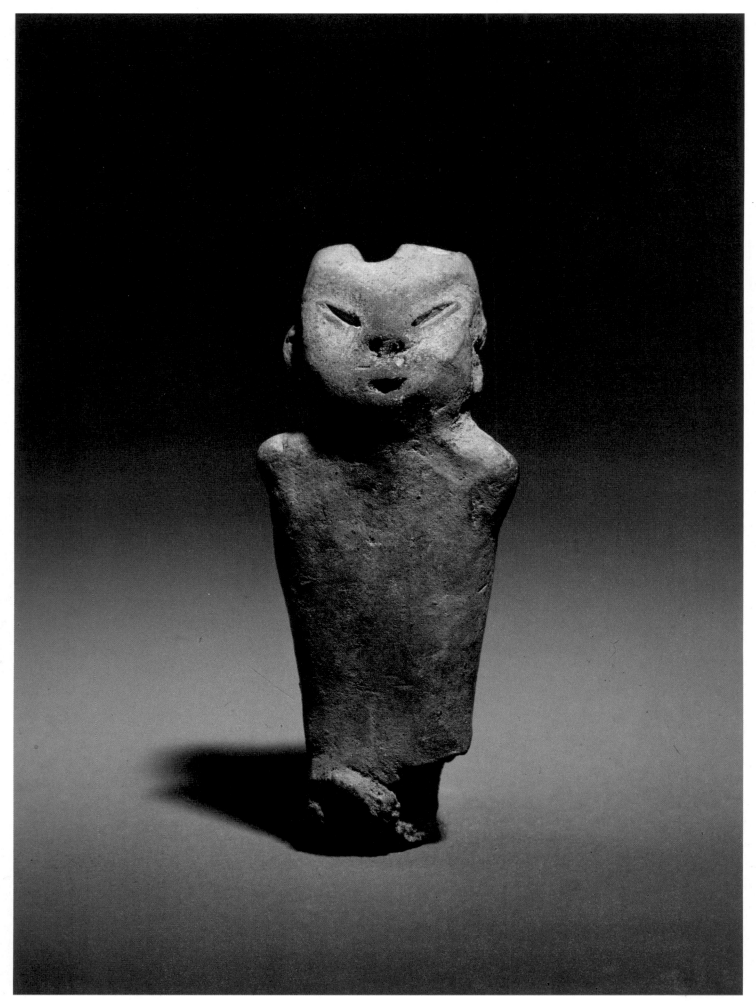

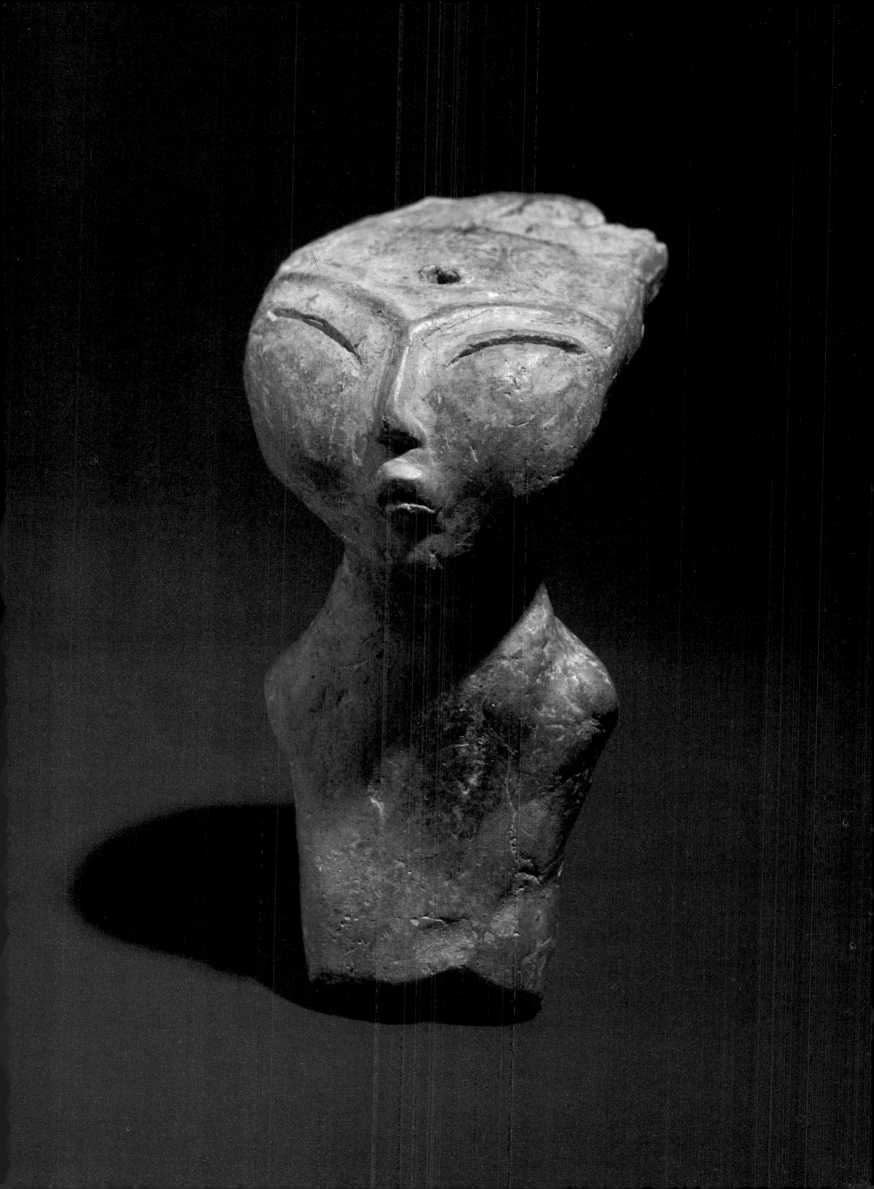

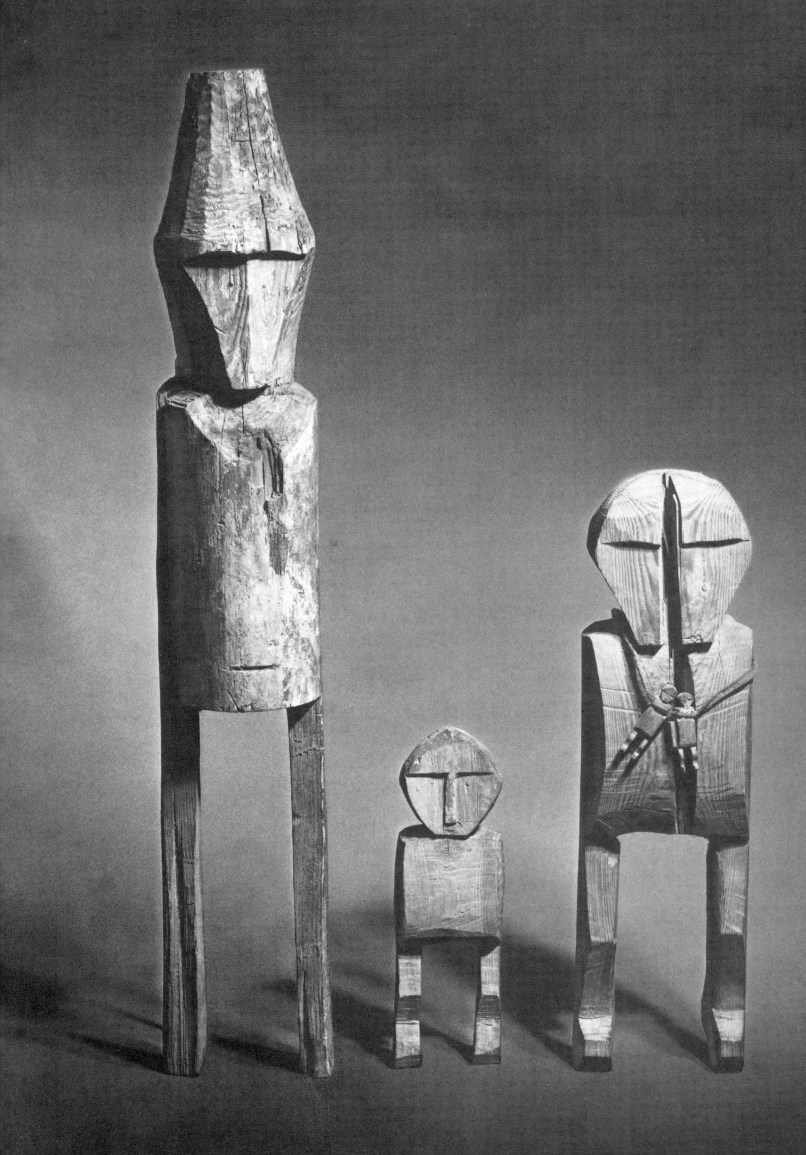

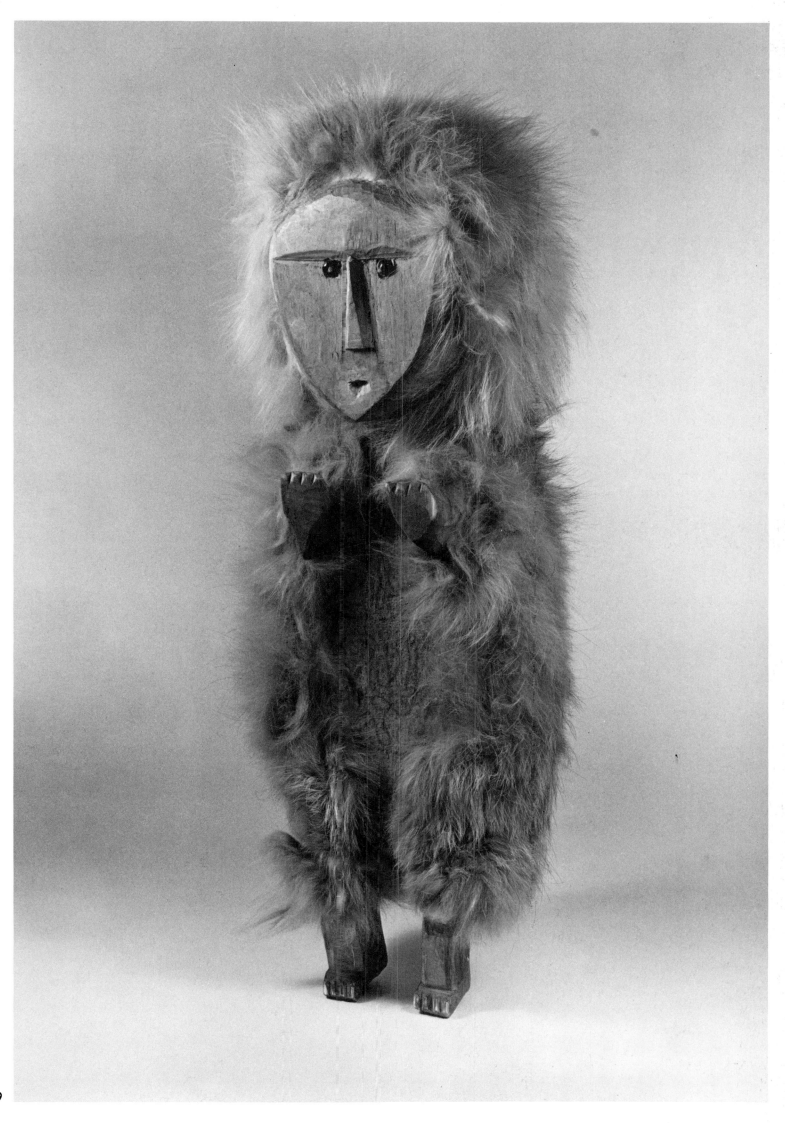

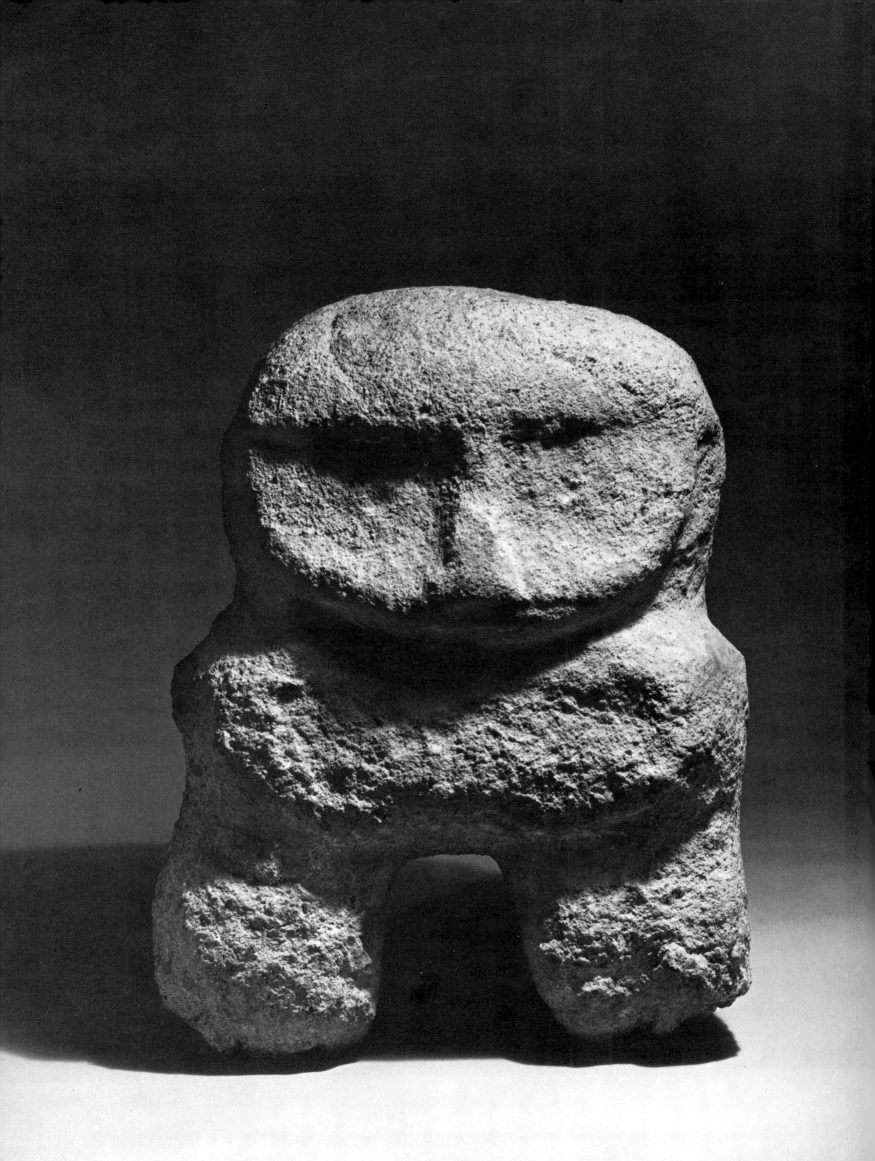

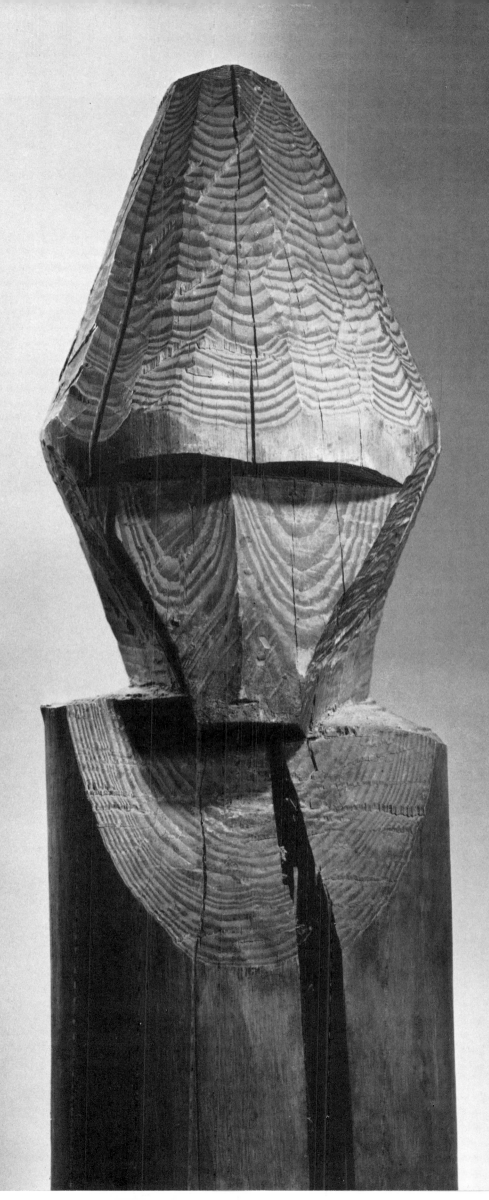

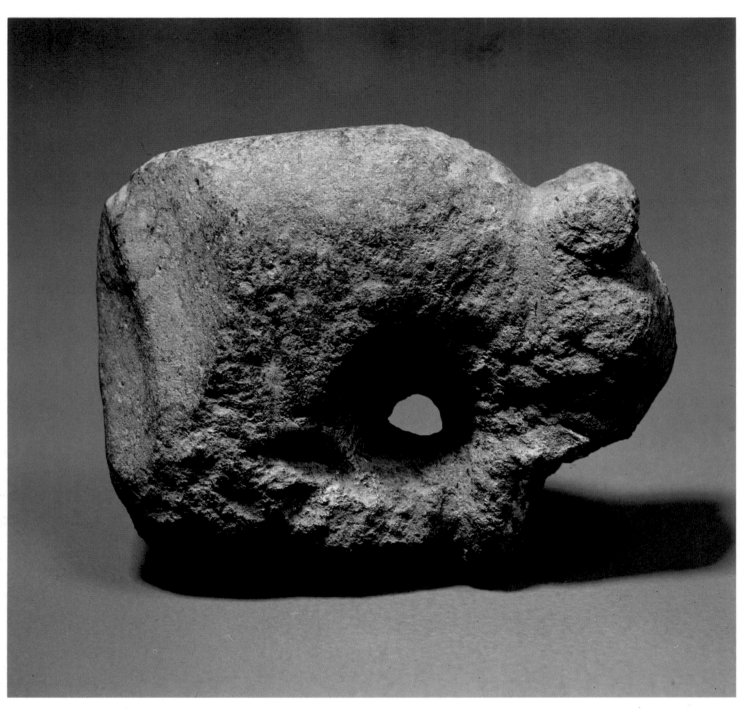

34

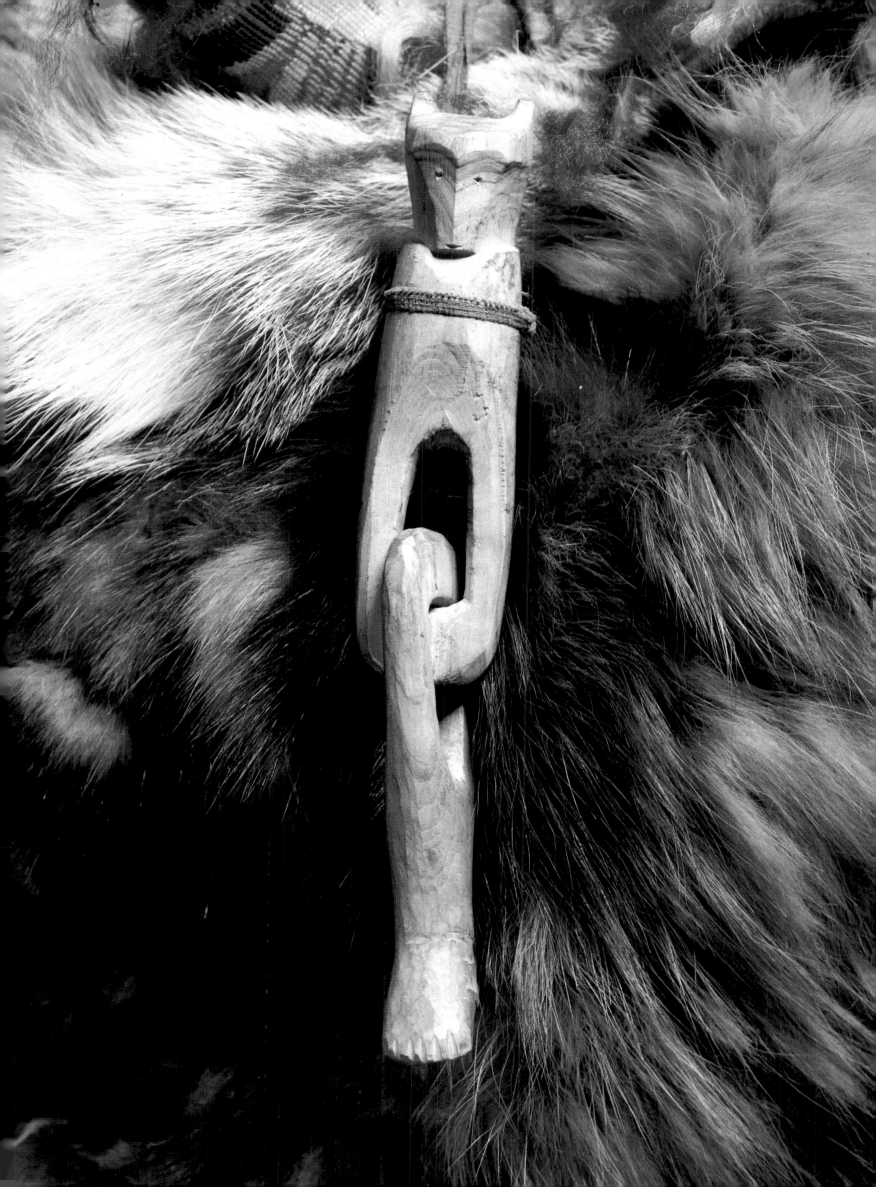

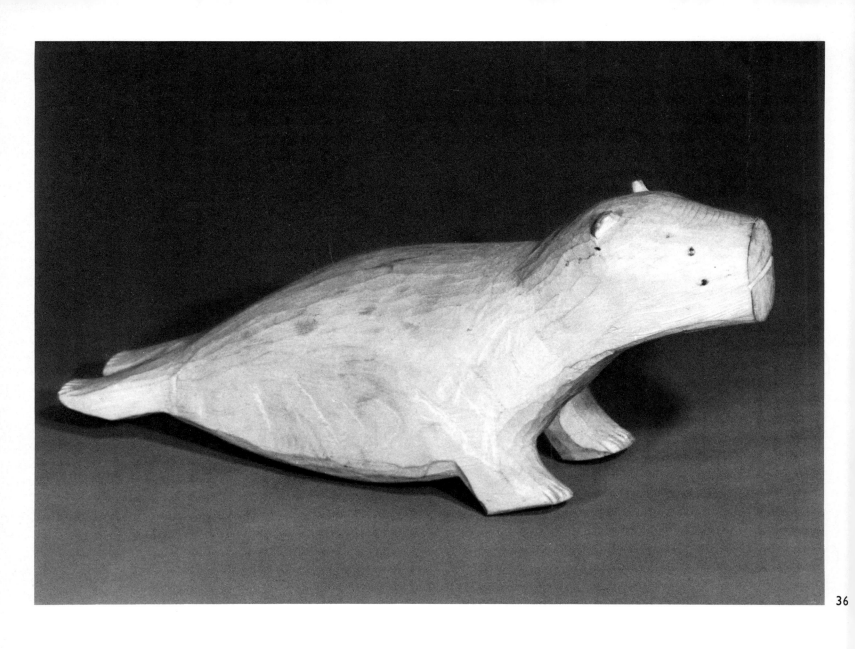

36

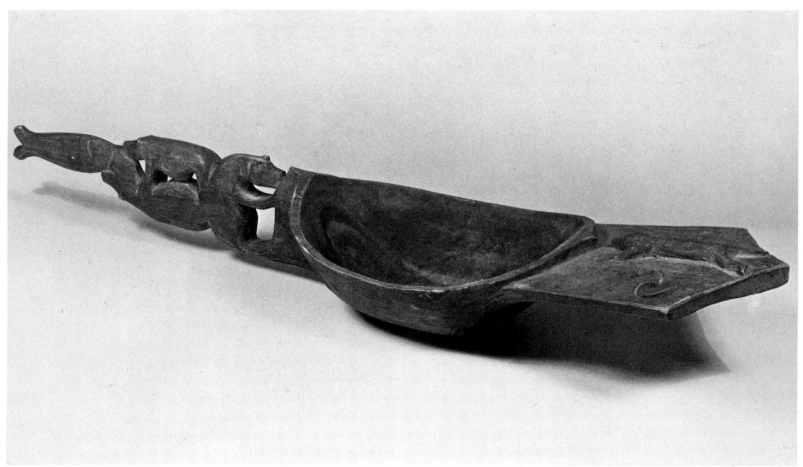

37

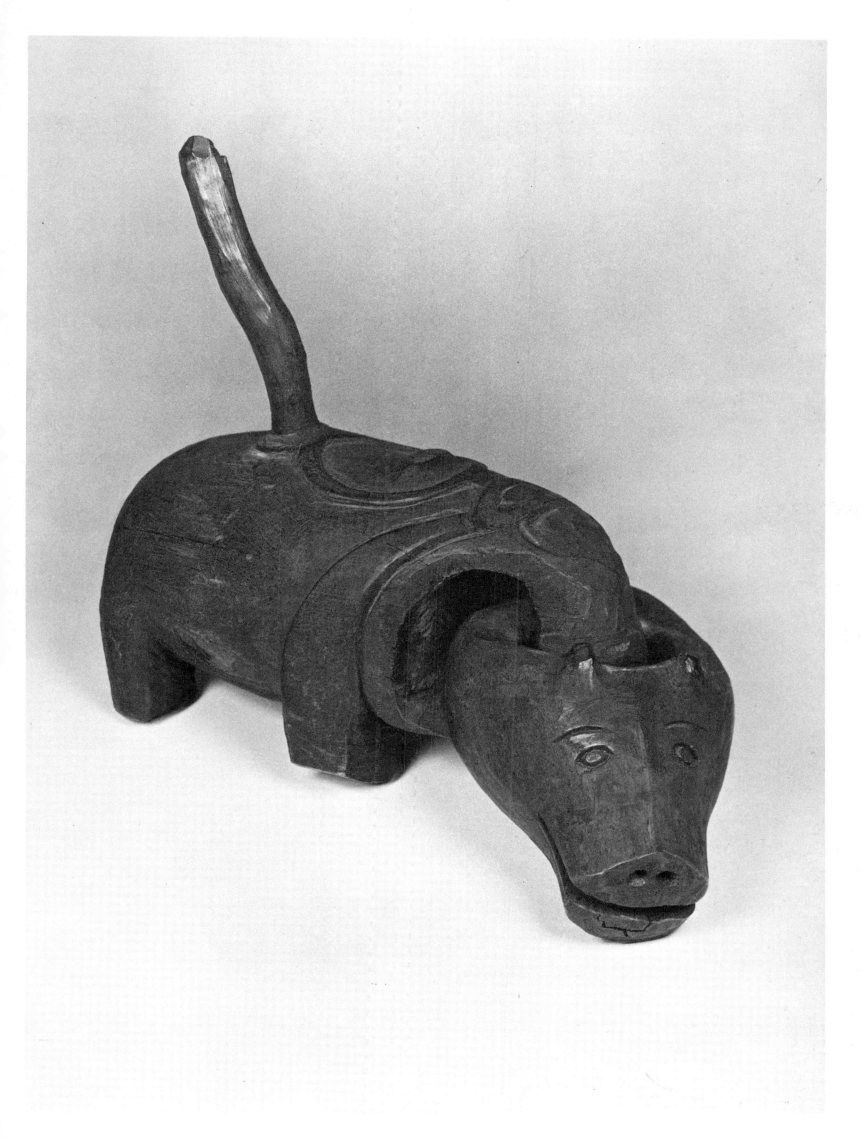

39, 40 →

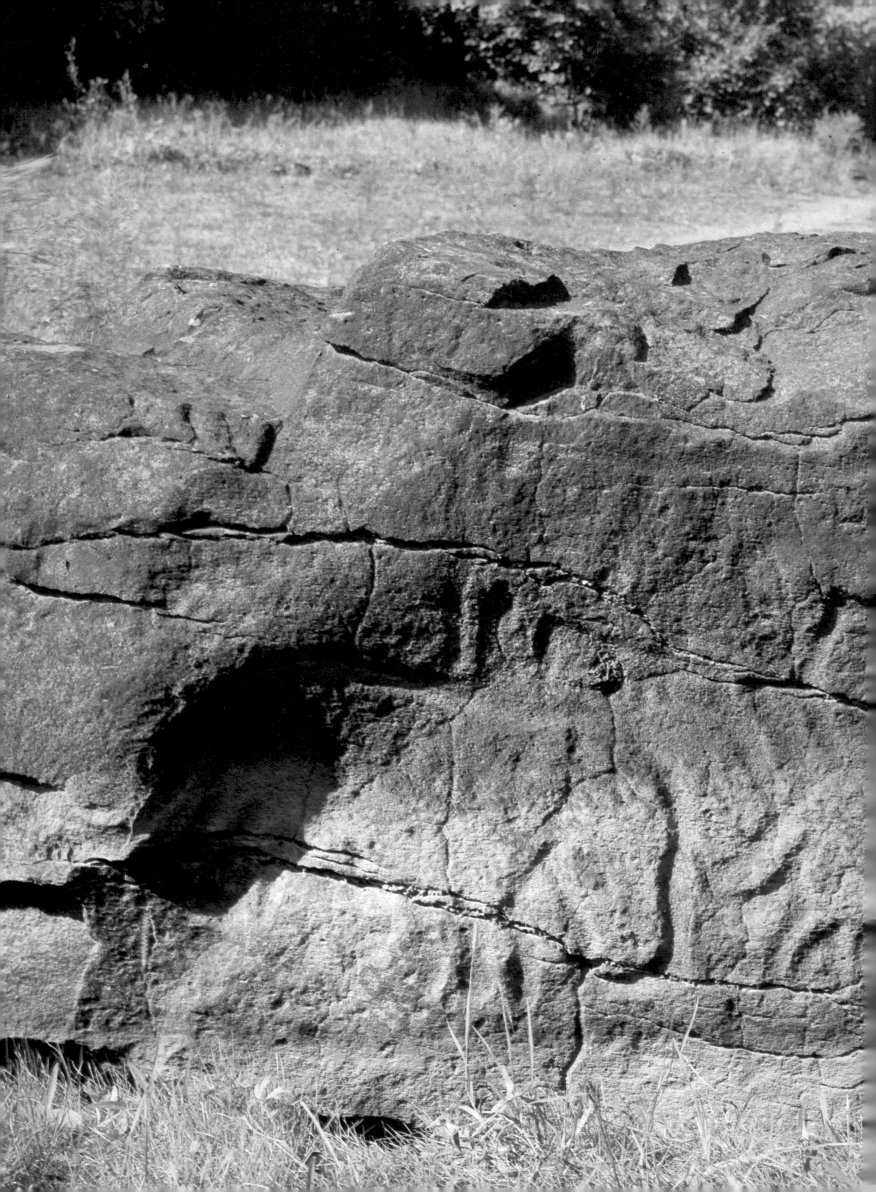

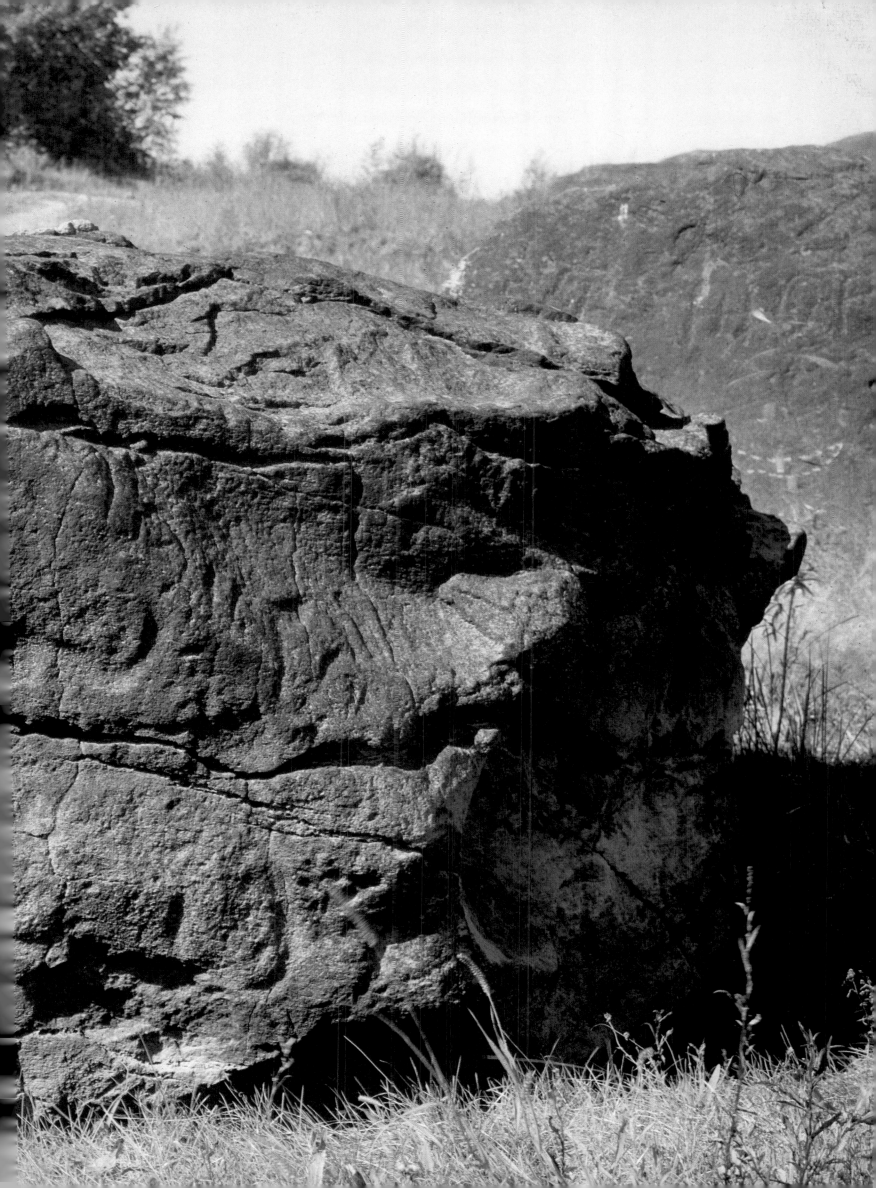

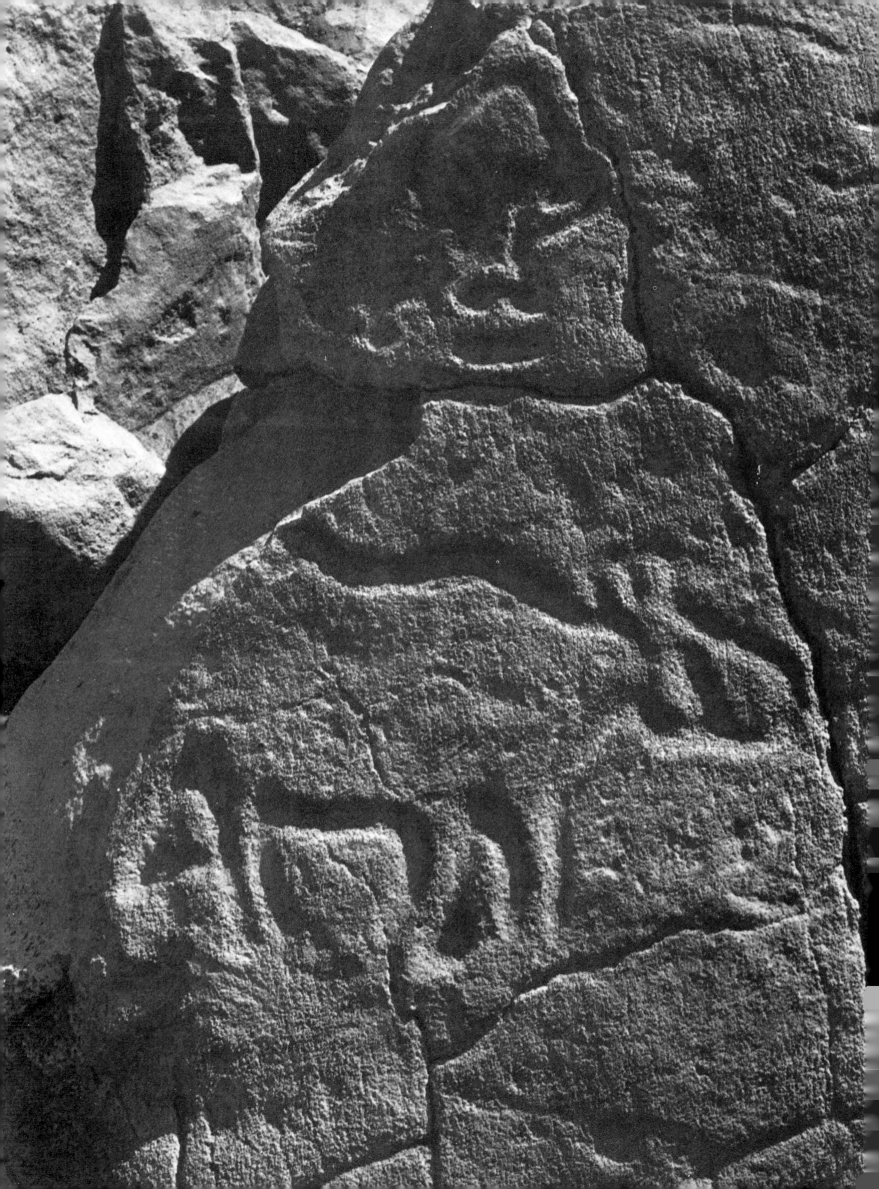

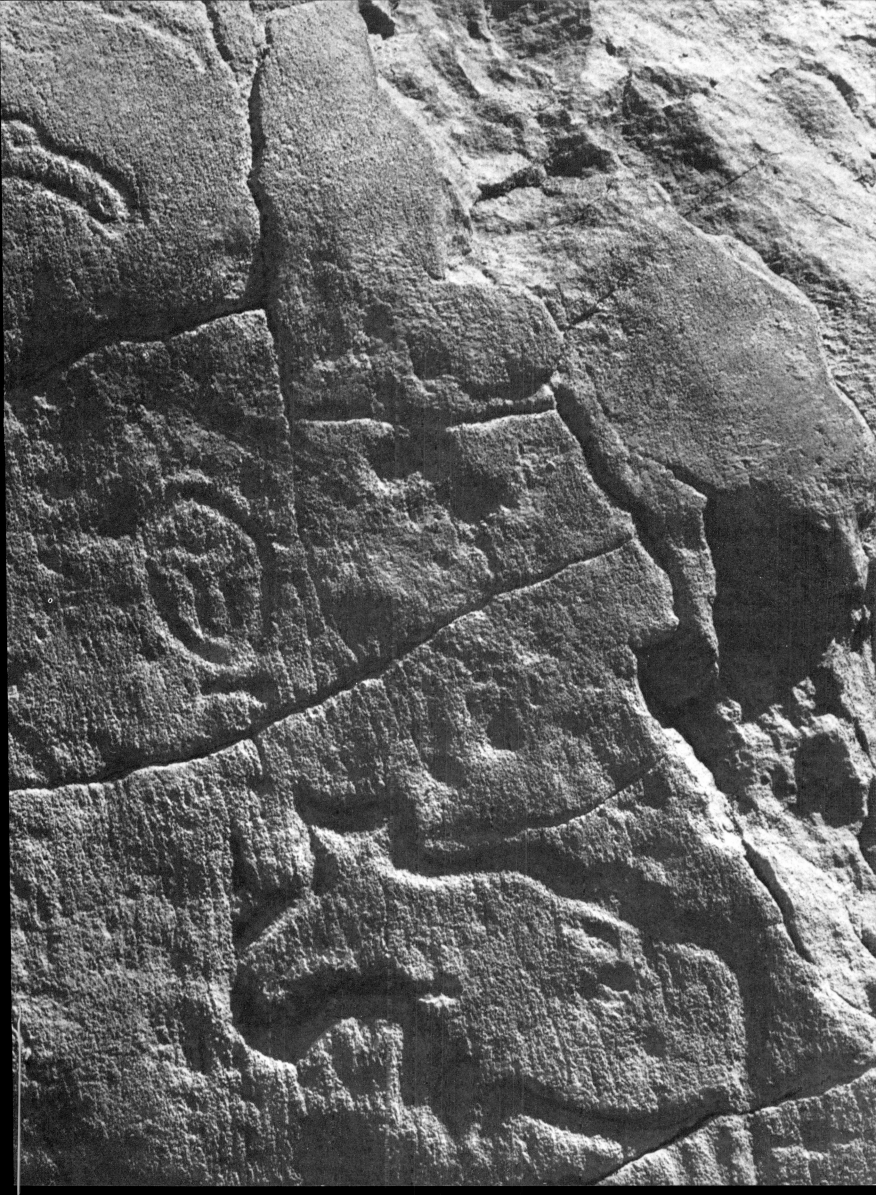

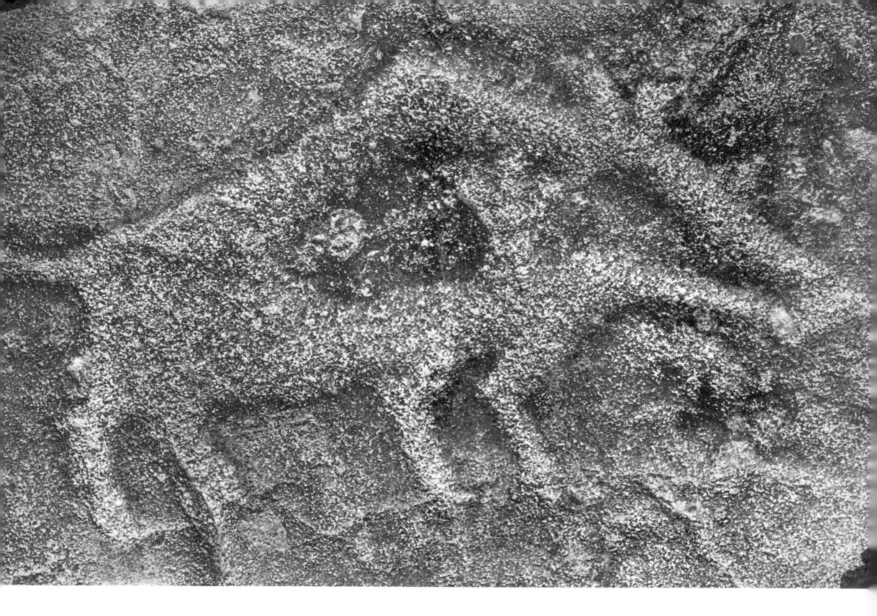
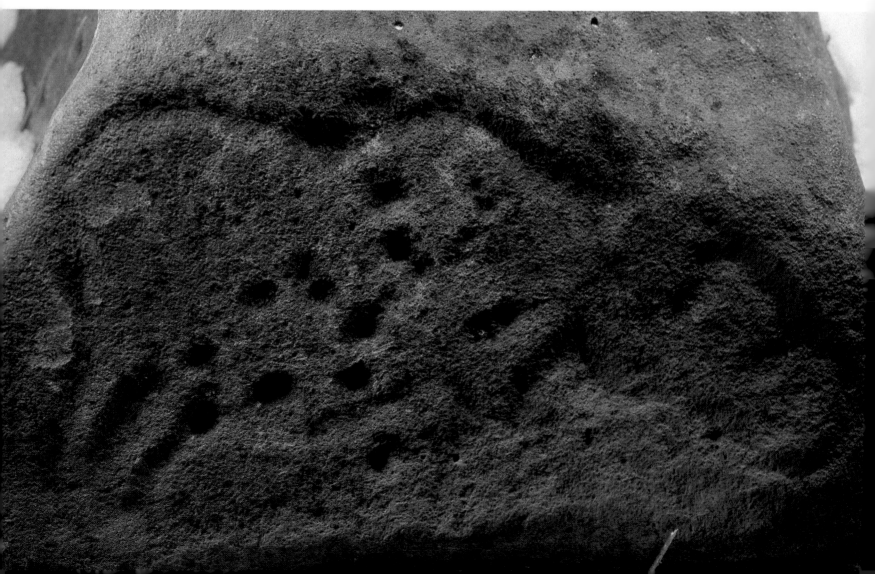

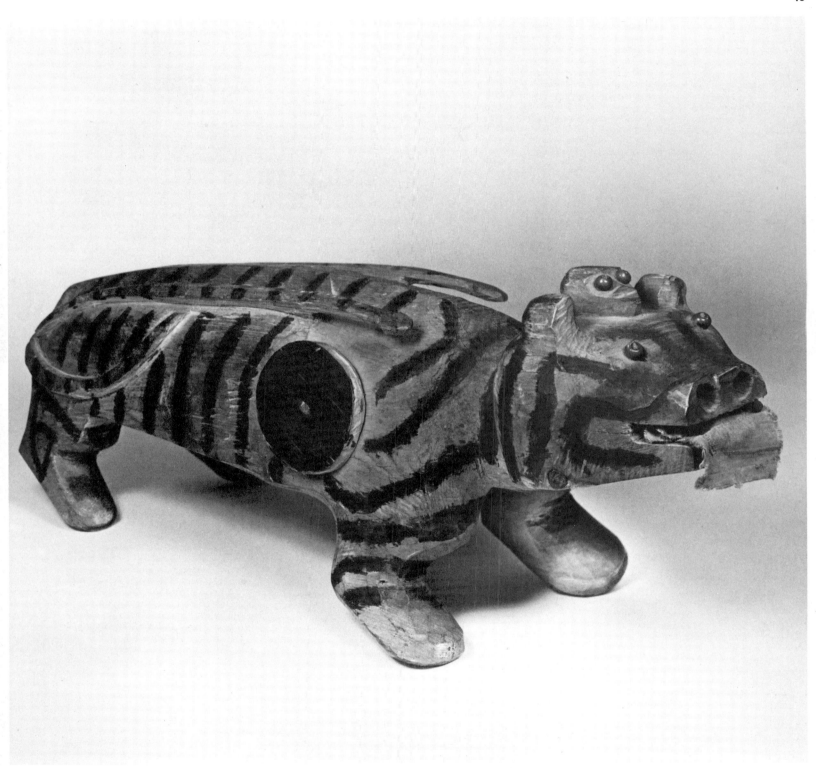

41, 42

44 →

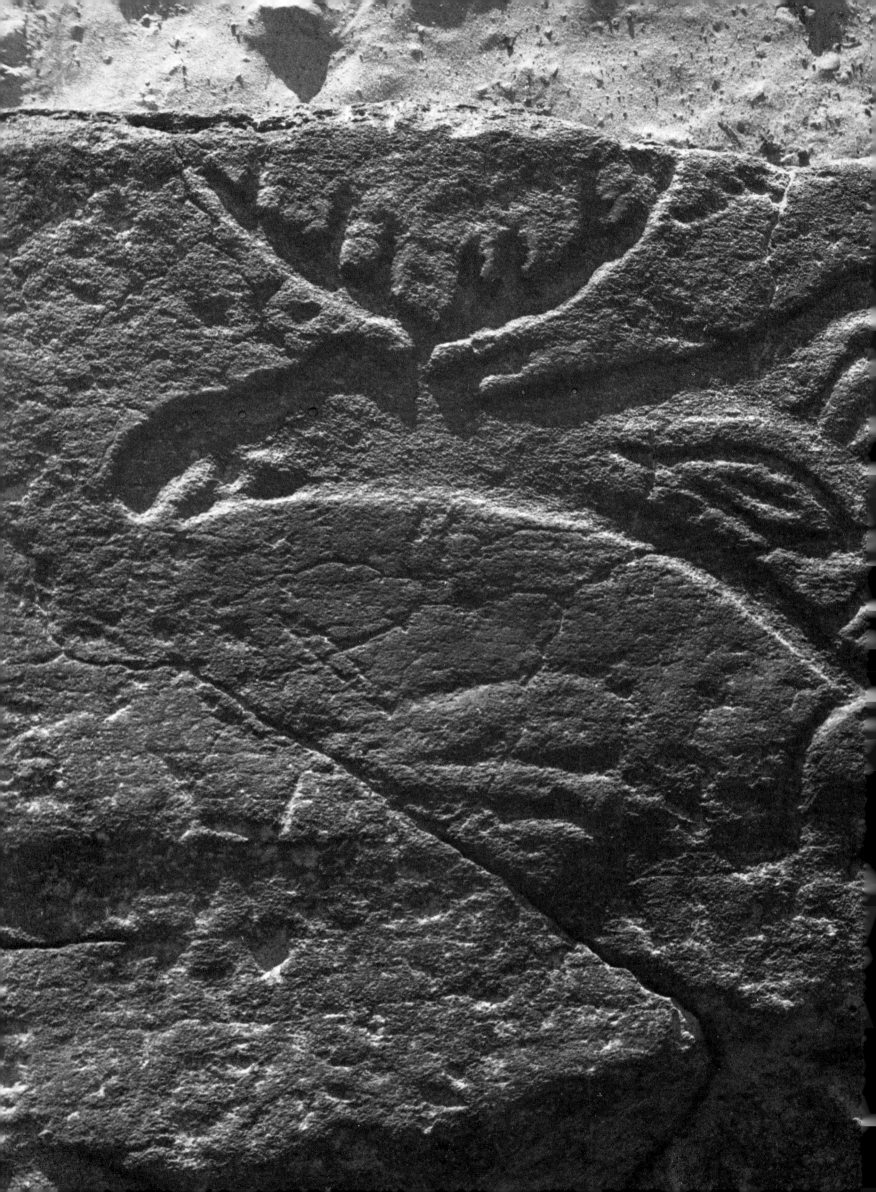

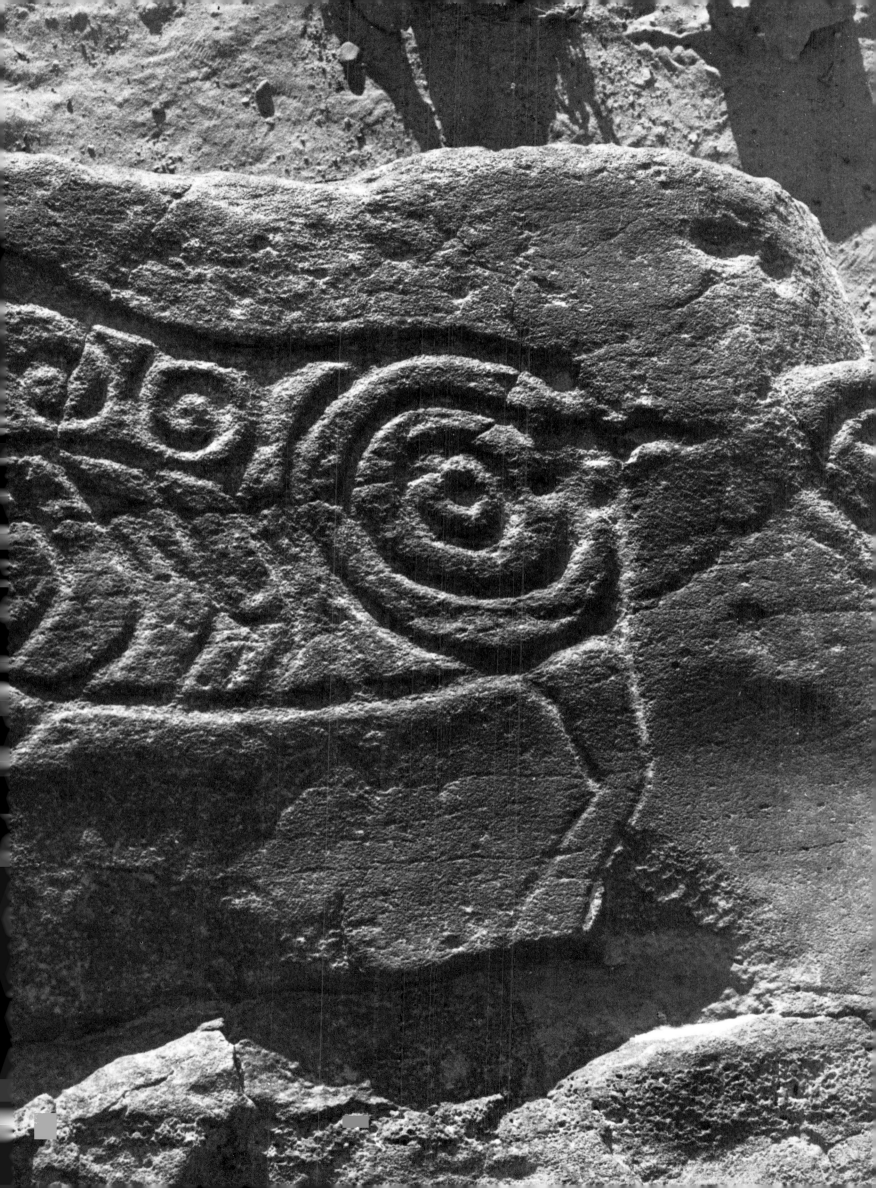

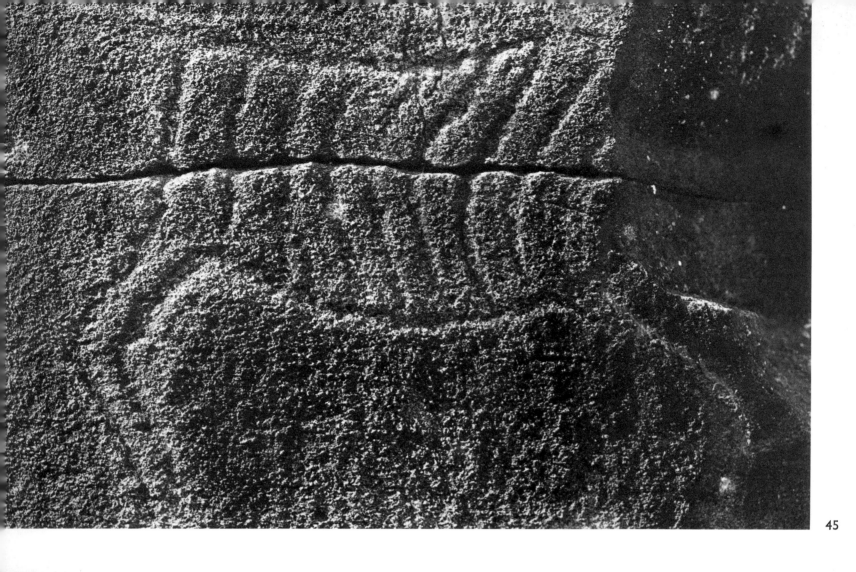

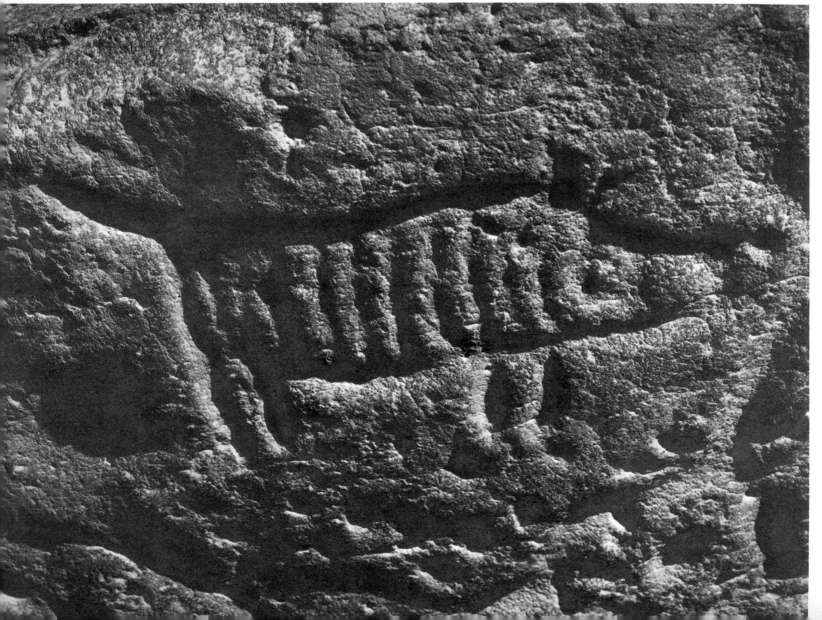

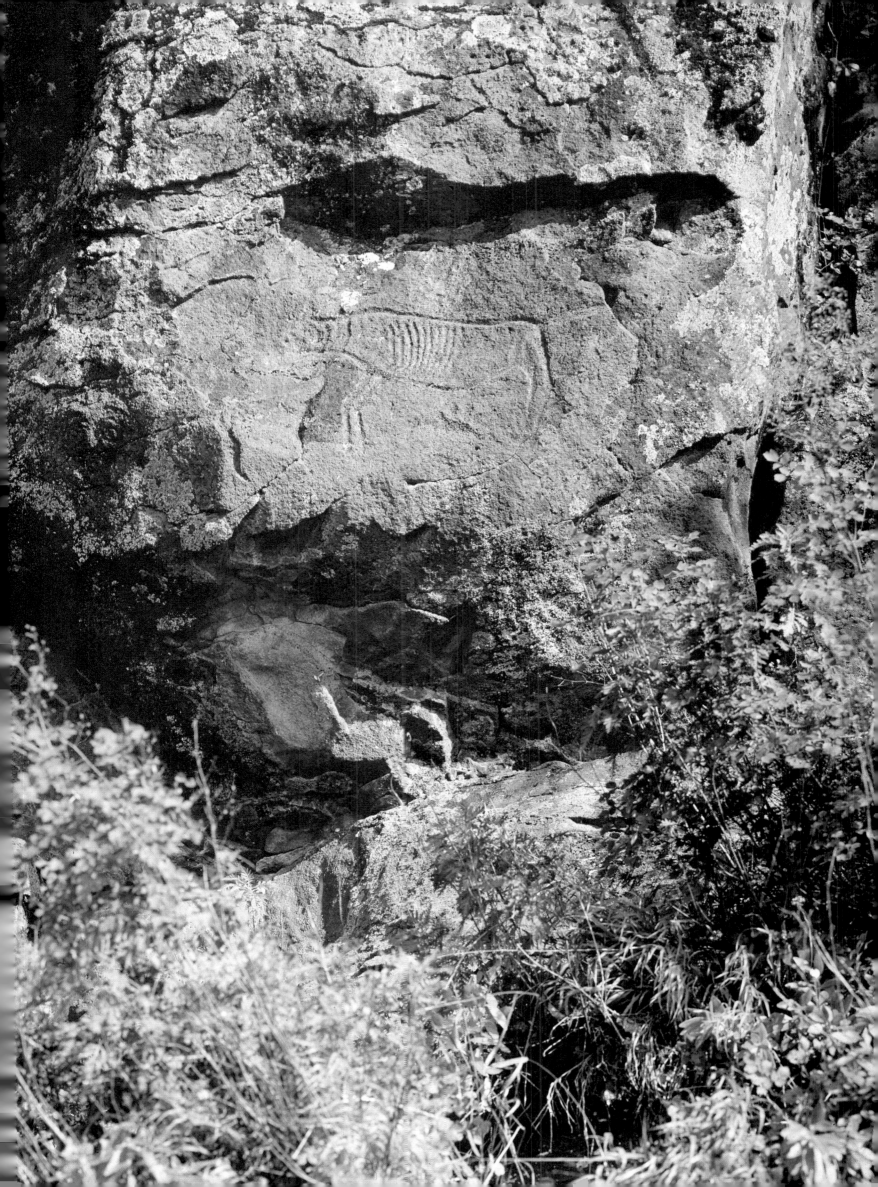

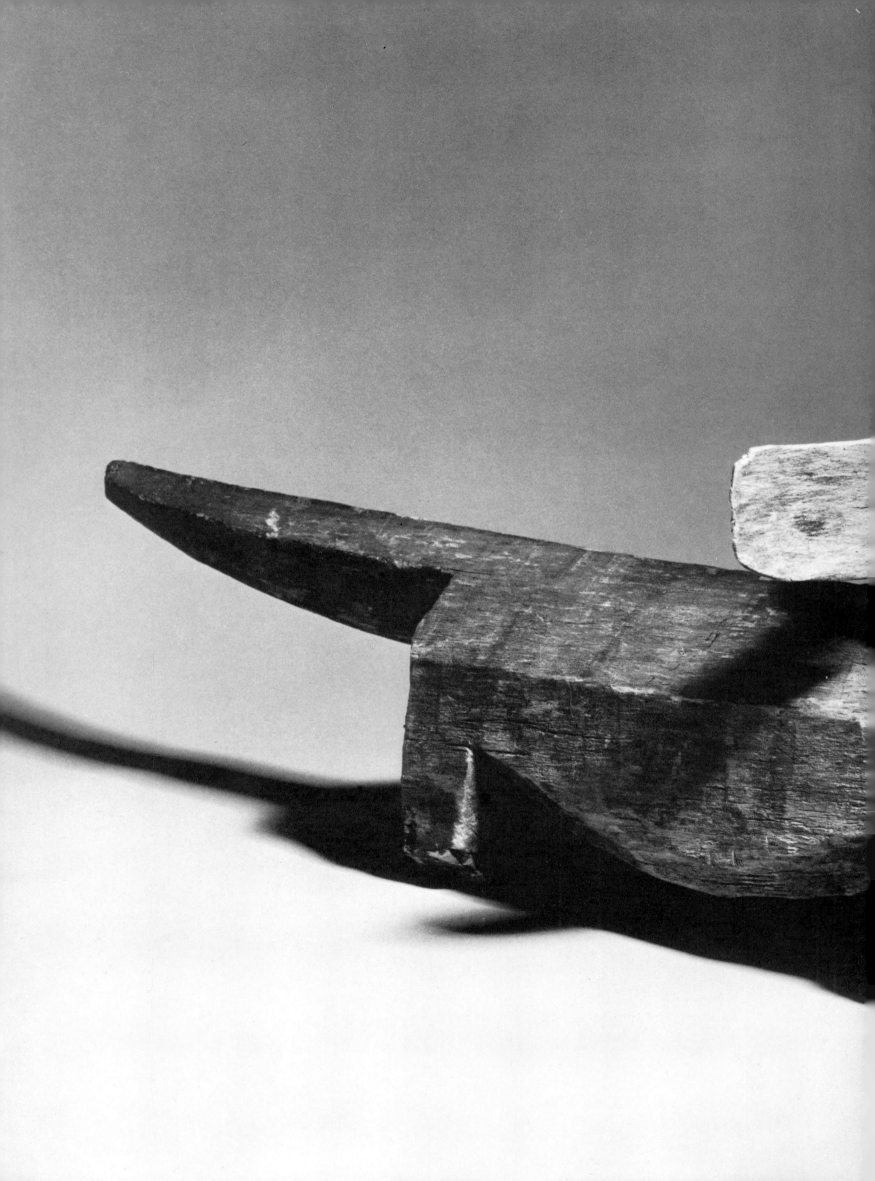

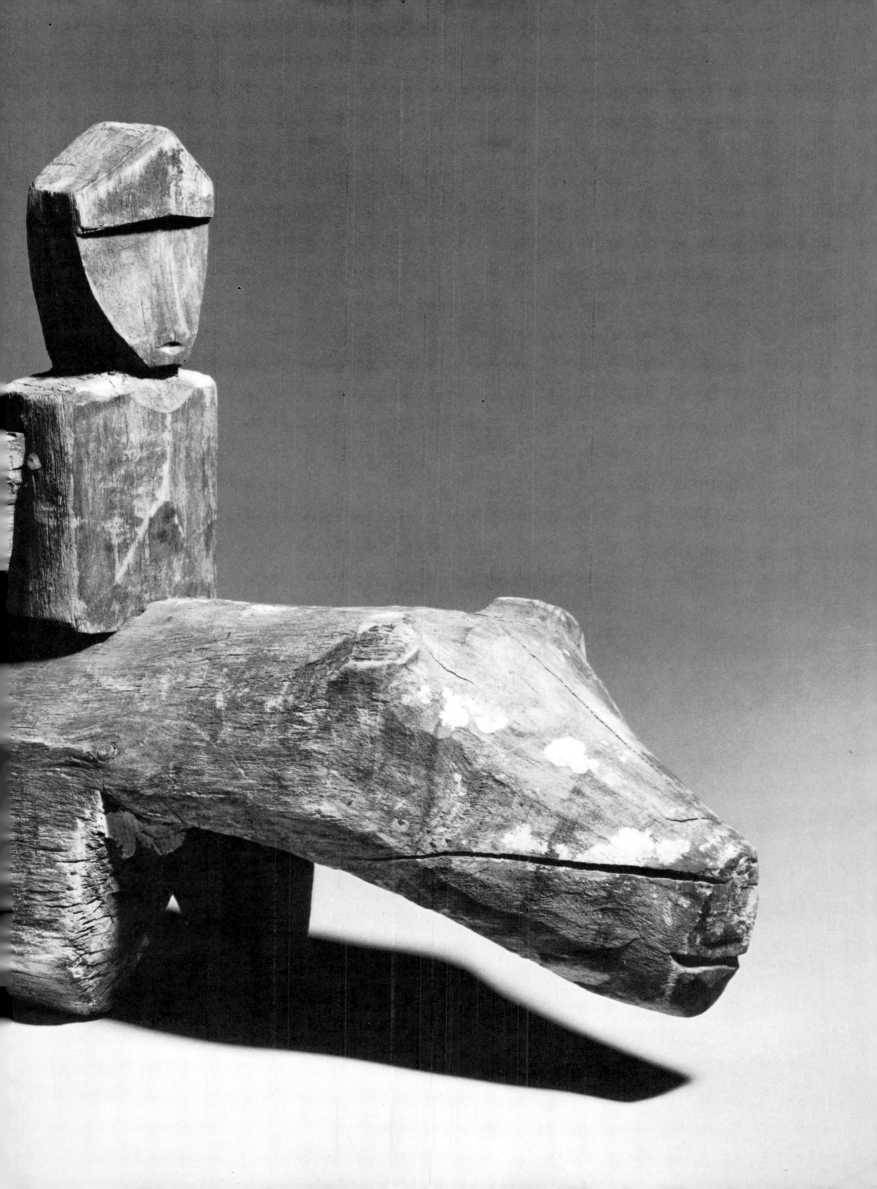

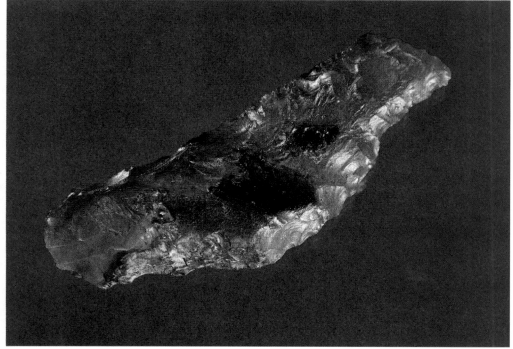

49

49

Bird. Flint. Length 4. Eighth–sixth
millennium B.C. (Mesolithic period).
Sikachi-Alian, Khabarovsk district,
Khabarovsk territory. FEAE, 1969. MIHPP,
Inv. No. CK-69/23.

50

Festive robe (detail of back). Fish-skin.
58 × 43. Appliqué of blue-colored fish-skin:
serpents/dragons (mudurs), spirals,
transformed masks. Olcha, 19th century.
Bulava, Ulchsky district, Khabarovsk
territory. FEAE, 1967 (collected
by V. Timokhin). MIHPP,
Inv. No. МИИФ-314.

51

Swan with diagonal cross on breast.
Incised on a basalt cliff. Height 48. Fourth–
third millennium B.C. Sheremetyevo,
Vyazemsky district, Khabarovsk territory.

52

Basalt rock with petroglyphs (below,
a seated bird, height 24). Seventh–sixth
millennium B.C. (Mesolithic period).
Sikachi-Alian, Khabarovsk district,
Khabarovsk territory.

53

Woman's festive robe (detail). Fish-skin.
32 × 24. Decorated in red and blue pigment
with spiral patterns (transformed masks).
Nanai, 19th century. Kondon, Solnechny

district, Khabarovsk territory. FEAE, 1971
(collected by V. Timokhin). MIHPP,
Inv. No. МИИФ-573.

54

Robe (detail of back). Fish-skin. 35 × 25.5.
Decoration in blue and red pigment:
transformed masks. On the hem, bronze
plaque-pendants in the form of masks
(height 1). Nanai, 19th century. Kondon,
Solnechny district, Khabarovsk territory.
FEAE, 1971 (collected by V. Timokhin).
MIHPP, Inv. No. МИИФ-590.

55

Robe (detail of back). Fish-skin. 45 × 20.5.
Decoration in blue and red pigment:
birds, transformed masks. Nanai, 19th
century. Kondon, Solnechny district,
Khabarovsk territory. FEAE, 1971
(collected by V. Timokhin). MIHPP,
Inv. No. МИИФ-583.

56

Repository of spirits — shaman ritual
accessory. Wood. Height 40, diameter 28.
Shaped like a turret on four feet. The eight
upper crenellations crowned with human
figures. Below, relief depictions of seals,
birds, a fish, a snake, an insect, and sea
creatures. Testifies to the traditional links
between the ancient and modern culture
of the peoples of the Amur: some subjects
(the snake, human figures, fishes) are
analogous to those of ancient times, and the
treatment of the figures has com-

mon features with ancient Amur drawings
and sculptures. Nivkh, 19th–20th century.
Tamich, Nikolayevsk district, Khabarovsk
territory. Collected by V. Vasilyev
in 1913. SME, Inv. No. 5169-83.

57

Flying birds (amulets?). Dark brown clay.
Maximum length 3.9, width 3.8. Holes
for threading. Execution stylized and con-
ventional, but the streamlined form
is realistically rendered; the wide
wingspan of the birds in soaring flight
is emphasized. Late fourth – early third
millennium B.C. Suchu island on Amur
River, Ulchsky district, Khabarovsk
territory. NACAE, 1973. MIHPP,
Inv. Nos. C-73, P-П/8762-8766.

58

Sitting bird. Light brown clay. Length 4.5.
Fourth–third millennium B.C. Suchu island
on Amur River, Ulchsky district,
Khabarovsk territory. NACAE, 1975.
MIHPP, Inv. No. Cy-75/5167.

59

Sherd of burnished red vessel representing
the bill and part of eye of a bird of prey,
in relief. Yellow-brown clay. 5.4 × 5.9.
Decorated with incised spirals; between
them impressions of a comblike stamp.
The rim of the eye covered with red pig-
ment. Third millennium B.C. Takhta,
Ulchsky district, Khabarovsk territory.
FEAE, 1969. MIHPP, Inv. No. TAXT/2069.

60

Woman's festive robe (detail). White
cotton cloth. 33 × 25. Embroidery
in varicolored threads: elks and birds
on the branches of the "tree of the world."
Nanai, 19th century. Kondon, Solnechny
district, Khabarovsk territory. FEAE, 1968.
MIHPP, Inv. No. МИИФ-395.

61

Woman's wedding robe (detail). Chinese
silk. 41 × 32. Embroidery in varicolored
silk threads: scrolls with representations
of the "tree of life"; the sun and animals,
in the traditional Nanai folk style. Nanai,
19th–20th century. Nanaisky district,
Khabarovsk territory. From the collection
of the artist E. Evenbakh, 1934. SME,
Inv. No. 7247-2.

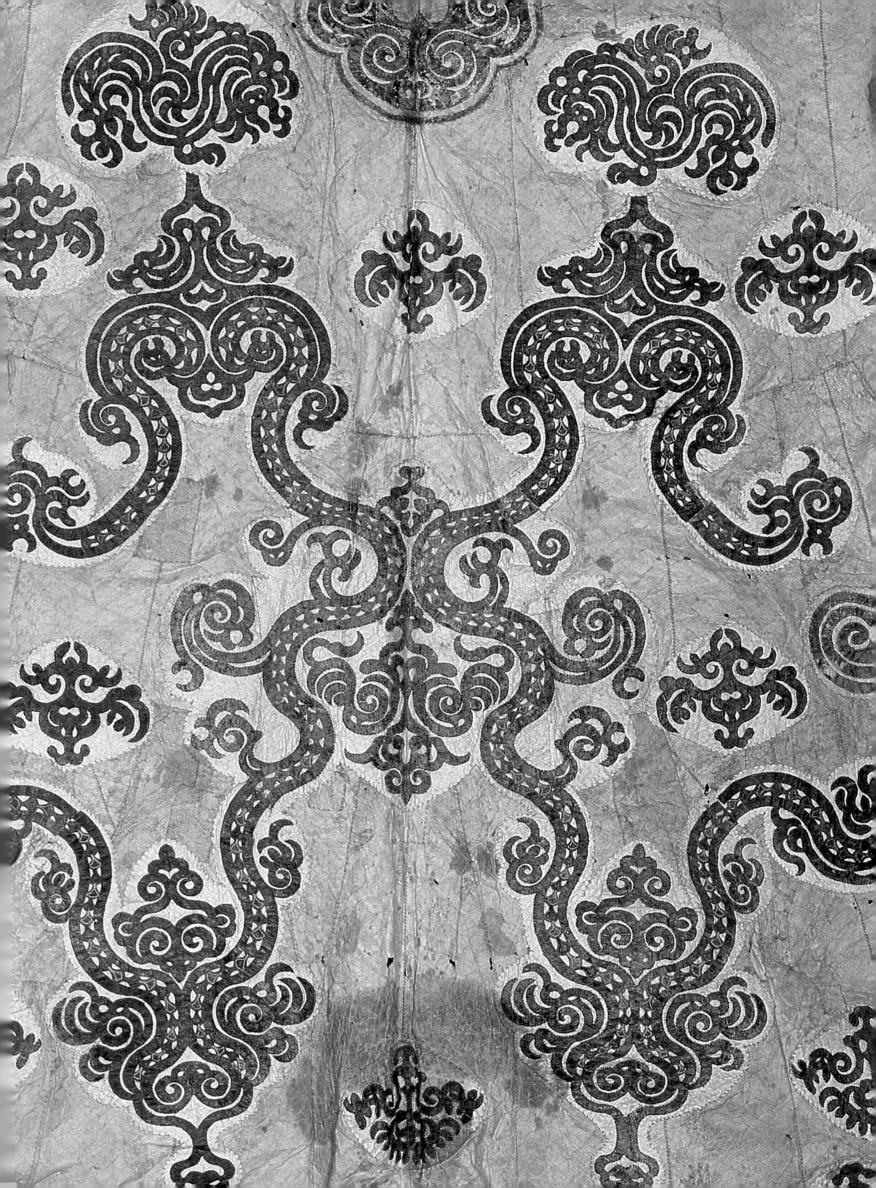

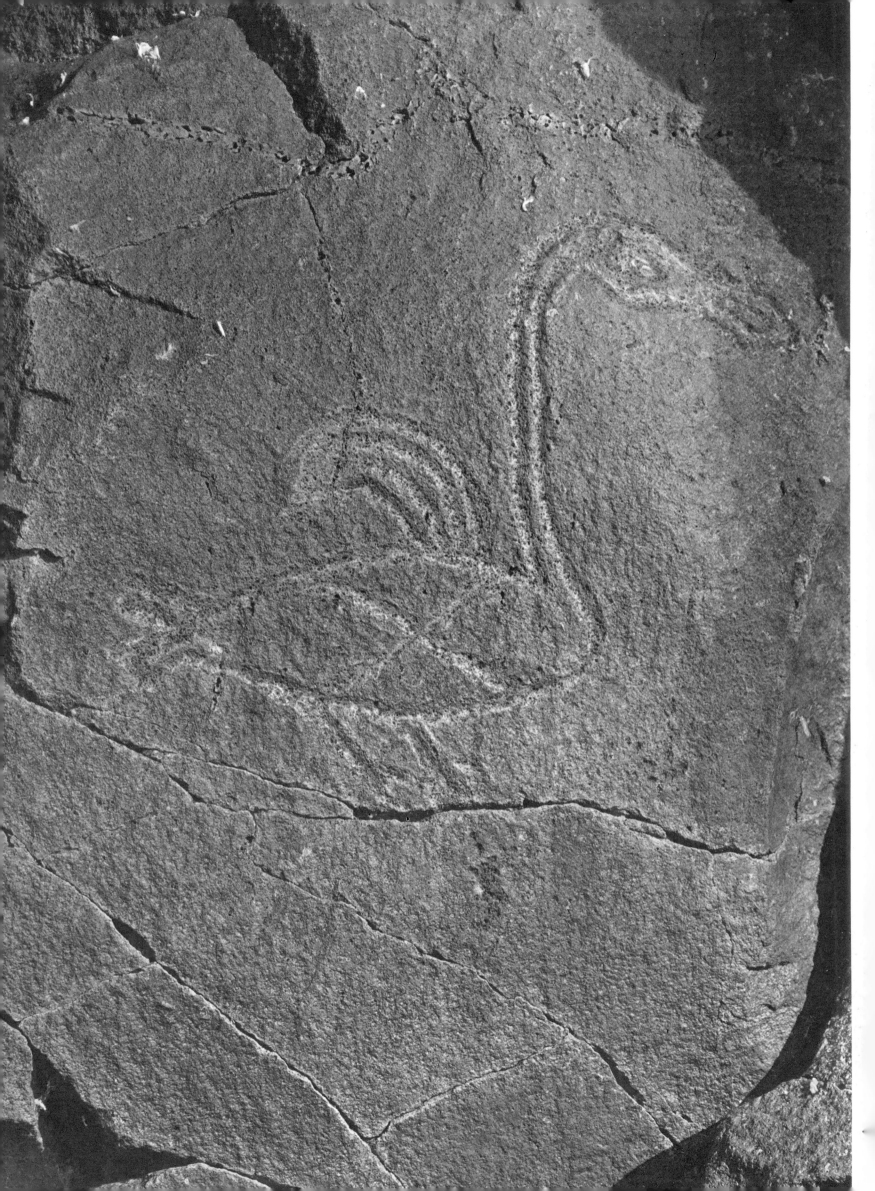

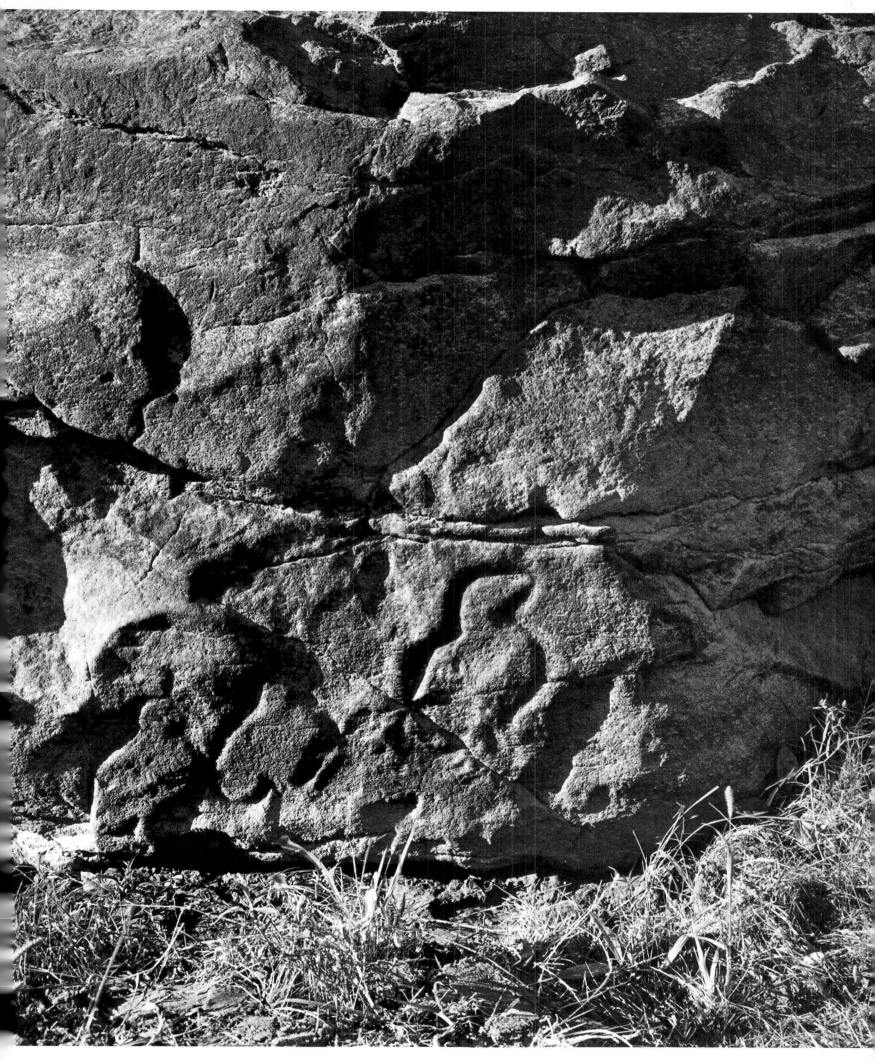

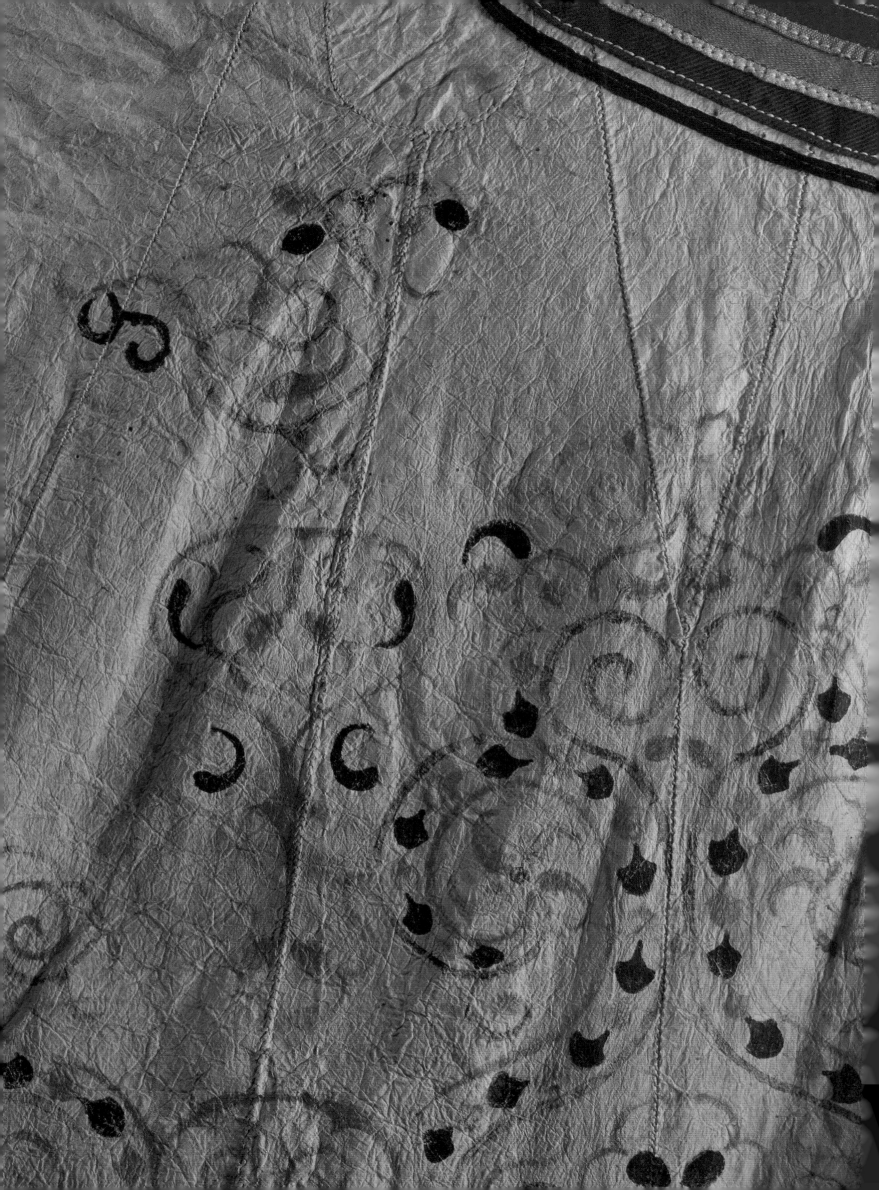

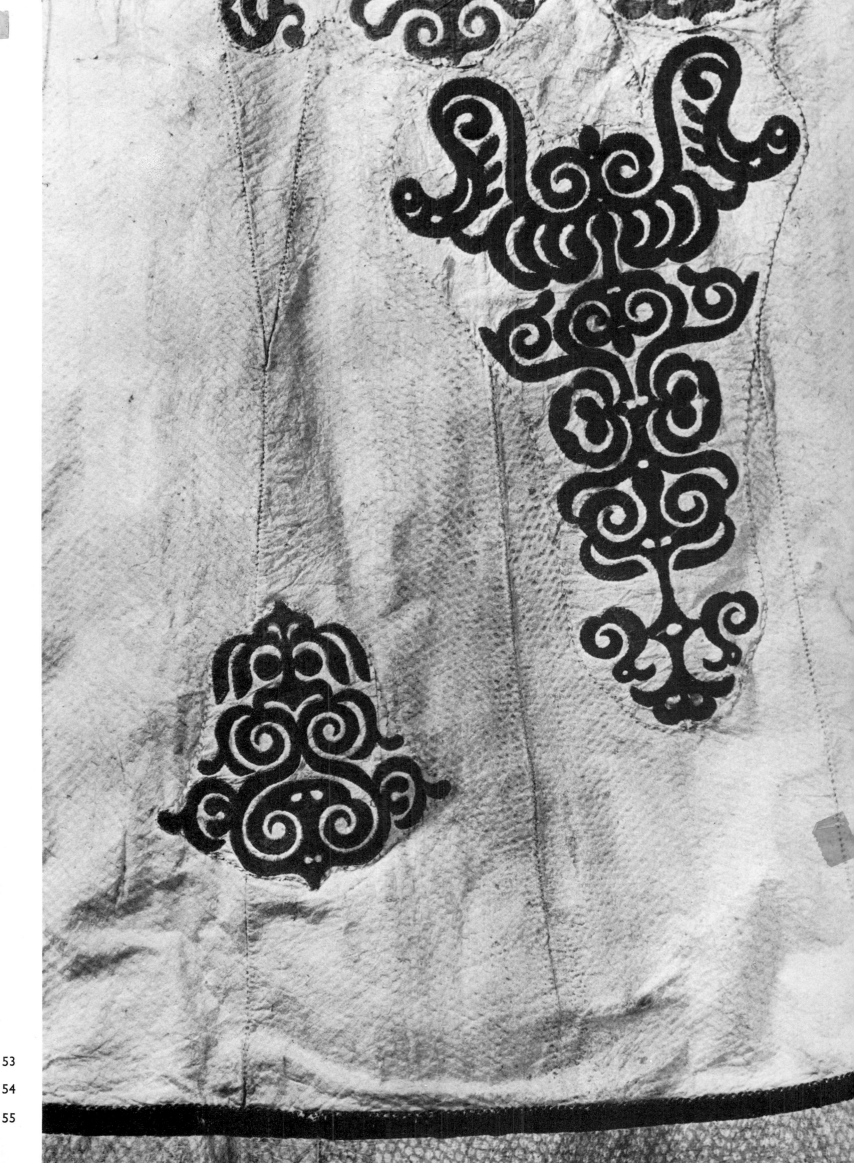

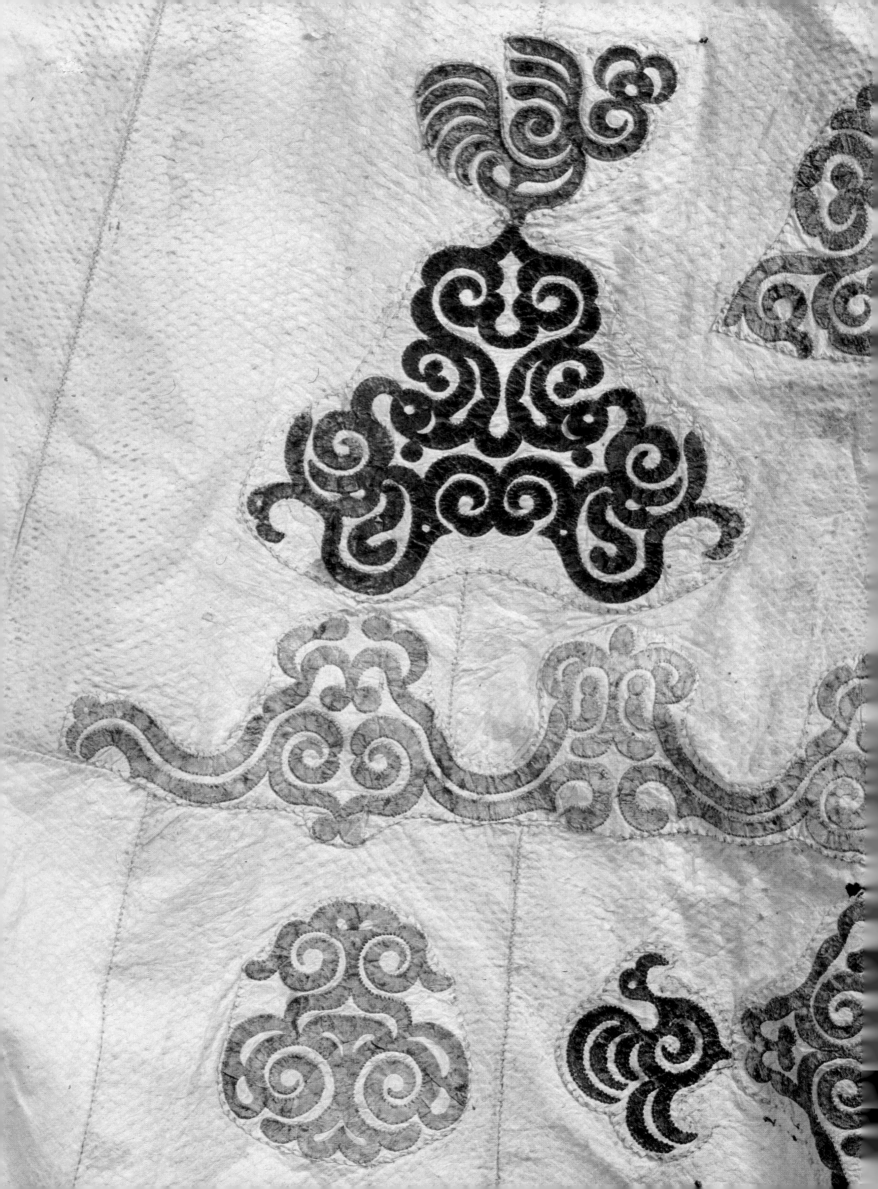

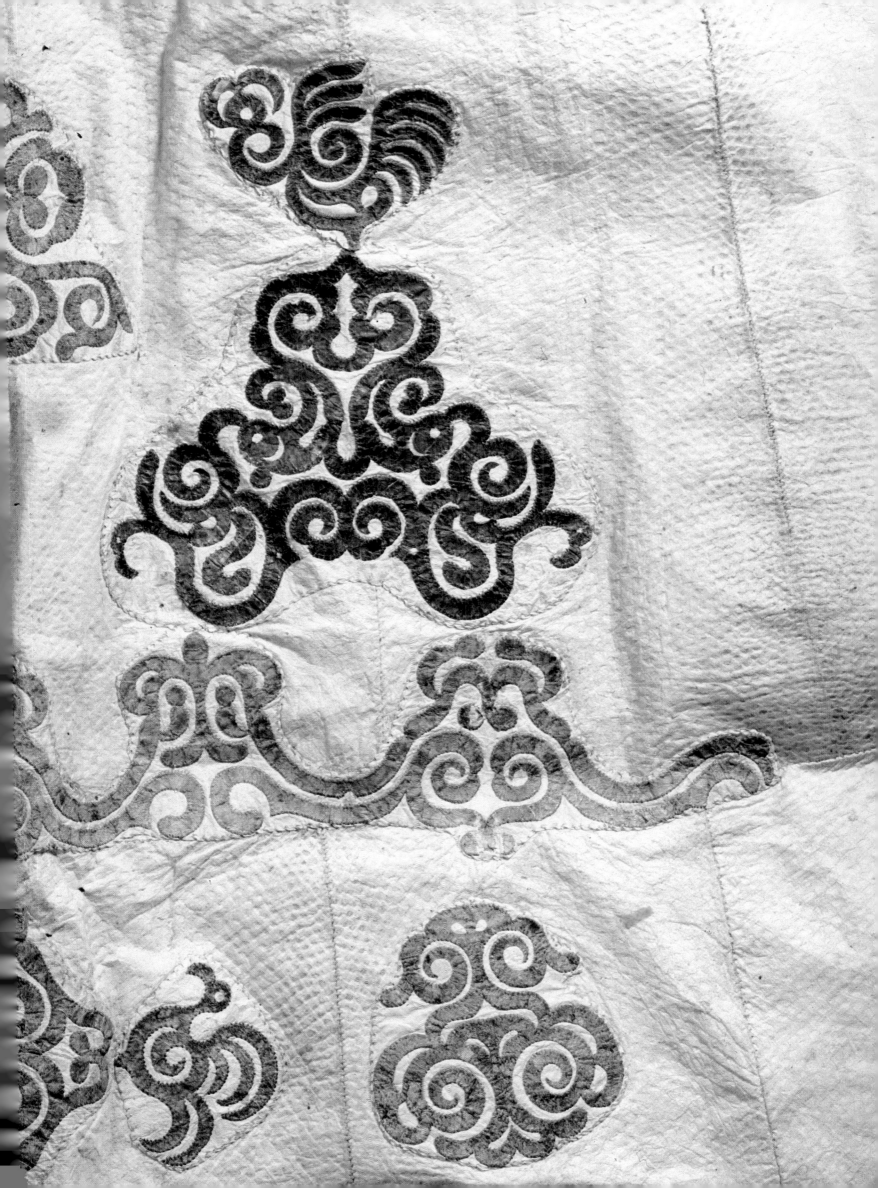

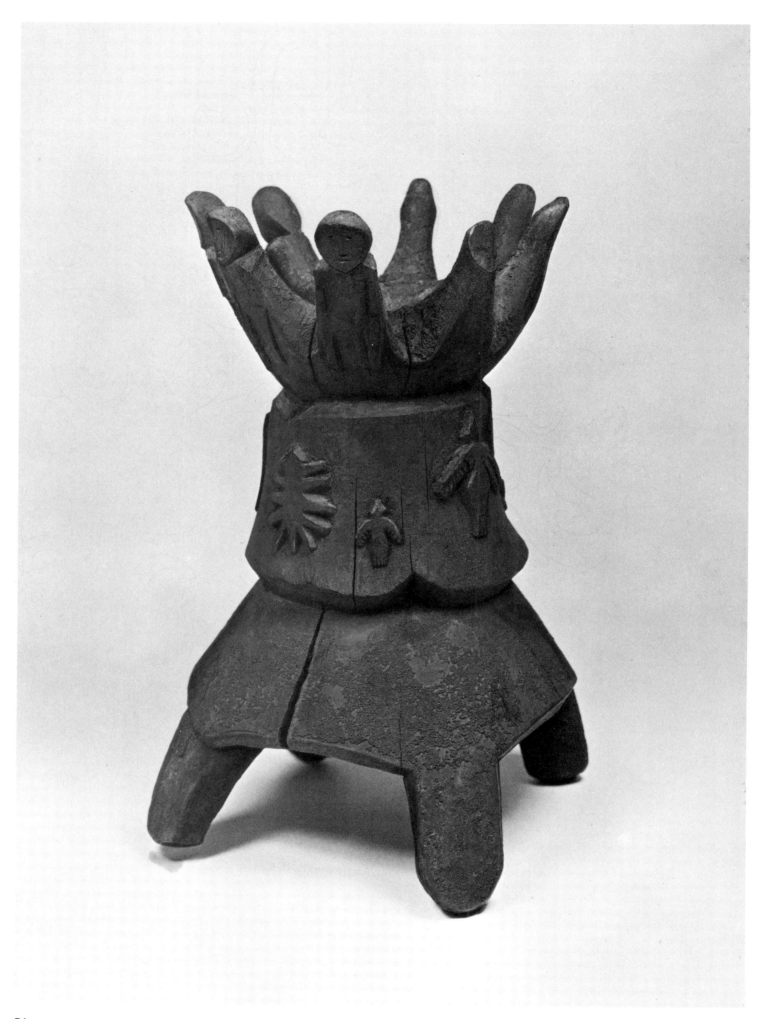

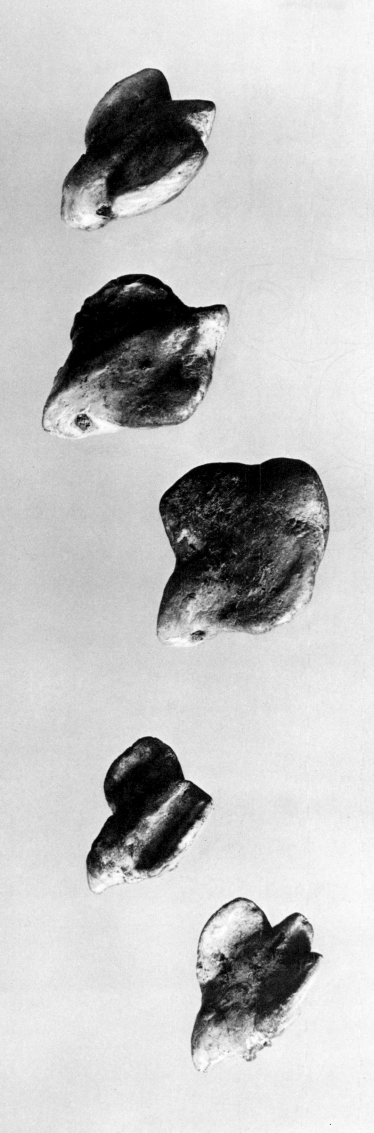

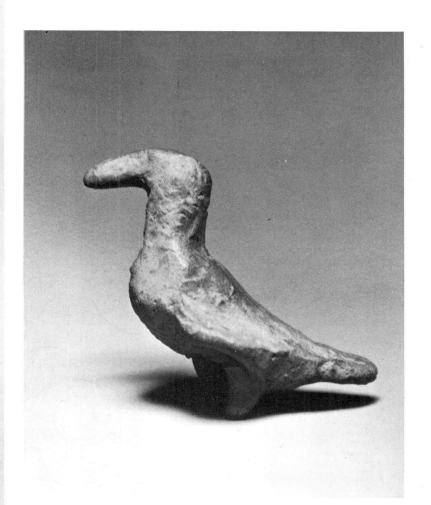

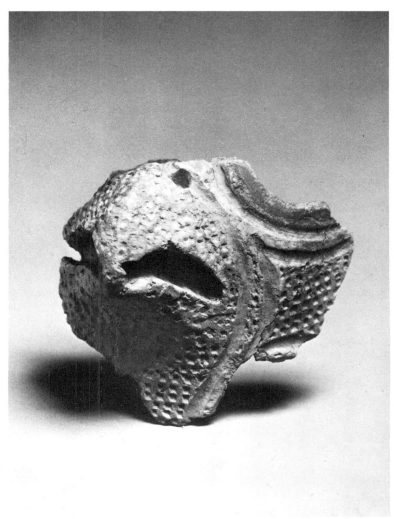

58, 59

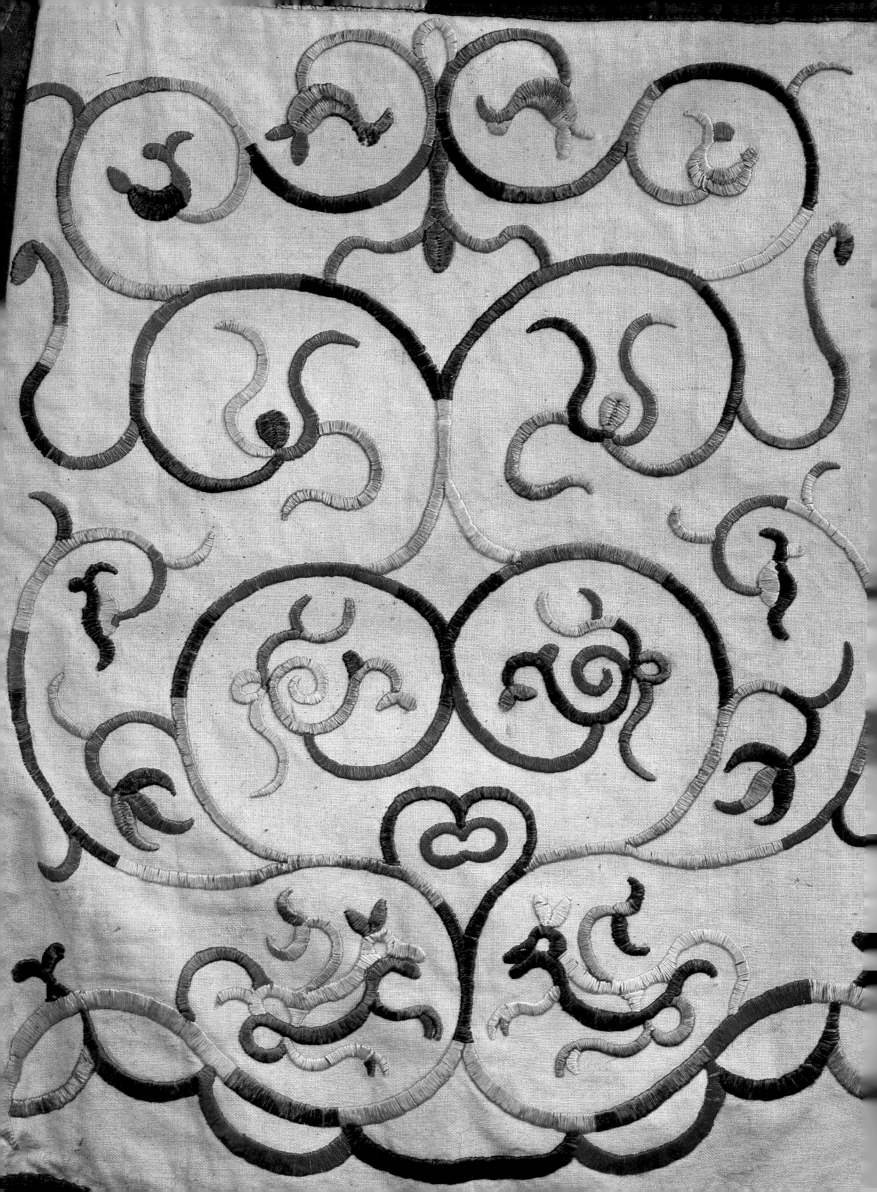

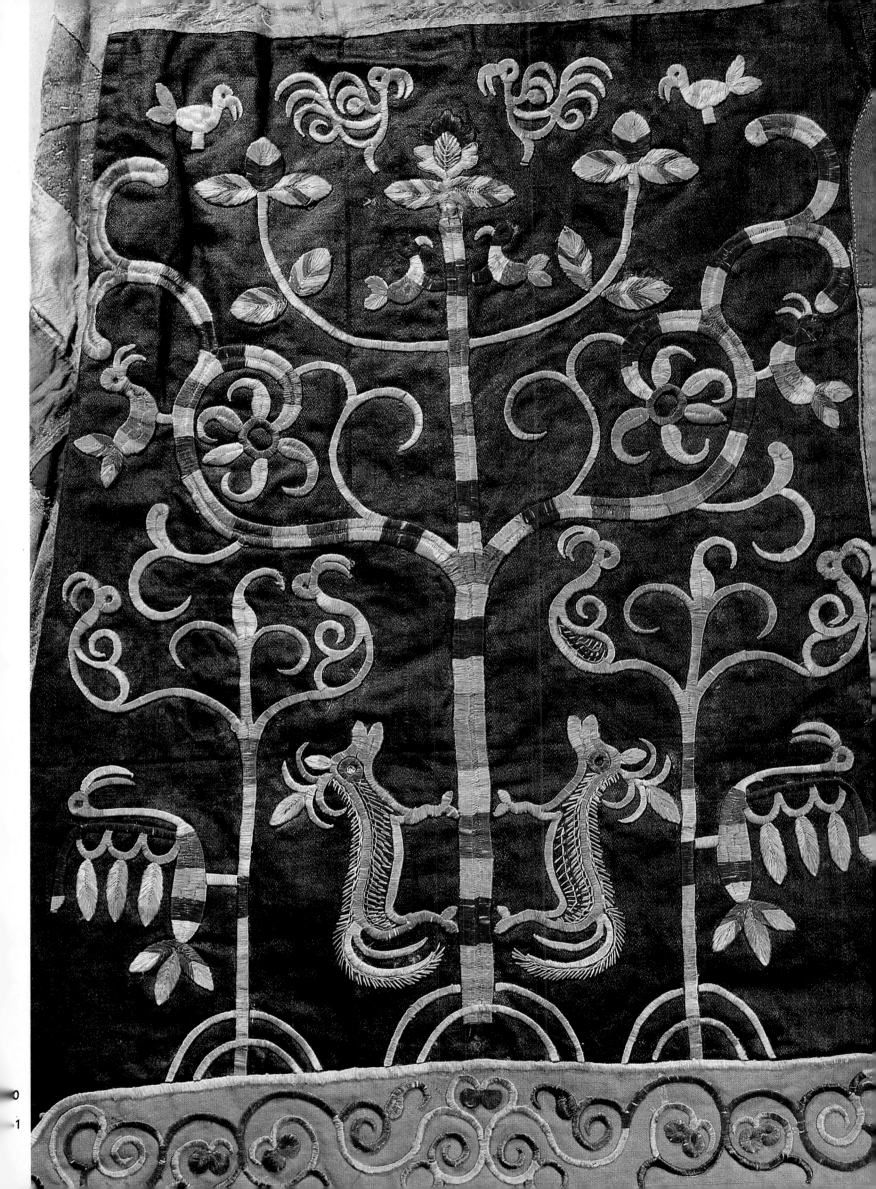

62

Potsherd with a spiral ornament. Light brown clay. 20 × 18. Two spirals inscribed one inside the other, filled in with impressions of a comblike stamp. On the background, traces of red paint. Third–second millennium B.C. Suchu island on Amur River, Ulchsky district, Khabarovsk territory. NACAE, 1973. MIHPP, Inv. No. C-73-П-3-4-790.

63

Potsherd with a spiral ornament. Yellow-brown clay. Height 18, diameter of body 30. The bands of the design filled in with impressions of a comblike stamp. Third–second millennium B.C. Lebiazhya Lagoon near Nakhodka, Partizan district, Primorye territory. FEAE, 1970. MIHPP, Inv. No. BC-70/15.

64

Potsherd with a snake in relief. Light brown clay. 7 × 8. The snake's body ornamented with impressions of a comblike stamp. The background burnished red. Third millennium B.C. Takhta, Ulchsky district, Khabarovsk territory. FEAE, 1968. MIHPP, Inv. No. TAXT/1931.

65

Two concentric circles. Incised on a basalt boulder. Diameter 24, 17. Fourth–third millennium B.C. Sikachi-Alian, Khabarovsk district, Khabarovsk territory.

66

Woman's festive robe (detail). Black, white, brown, and red cotton cloth. 32 × 47. Embroidery in varicolored silk threads: two dragons (*mudurs*), the "tree of the world," birds; the dragons' bodies ornamented with braces. Nanai, 19th century. Kondon, Solnechny district, Khabarovsk territory. FEAE, 1968. MIHPP, Inv. No. МИИФ-395.

67

Shaman drumstick. Wood, covered with kolinsky fur. 43 × 4.8. On the front, two relief figures of snakes twined around one another, covered with red pigment. The larger has large scales, an open jaw, and long protruding "barbot's" whiskers. On the handle, coiled lizards. Nanai, 19th–20th century. Khabarovsk territory. SME, Moscow holdings, Inv. No. 18176.

68

Box. Birch-bark. 18 × 48 × 34. Square at the bottom; edged with purple willow twigs. On the sides painted black, red, and blue, a spiral ornament in birch-bark appliqué. Nanai, 19th–20th century. Bolon, Nanaisky district, Khabarovsk territory. Collected by M. Kaplan in 1962. SME, Inv. No. 7438-13.

69

Shaman rug. Birch-bark. 51 × 86. Decorated with a stamped pattern of lizards and snakes. At the corners, tassels of varicolored cotton cloth. Used as a matting during the healing of the sick. Udeghe, 19th–20th century. Nikolayevsk district, Khabarovsk territory. Collected by E. Schneider in 1931. SME, Inv. No. 5656-156.

70

Shaman robe. Fish-skin. Total length 90, length of sleeve 43, width of hem 2.3. Kimono cut, fastens from right to left. Shallow incuts at the sides. The collar, lapels, and hem edged with colored bands, red alternating with dark blue and black. In the center, a wingless dragon with a round head and open jaws. Above it, a human figure holding a knife, wearing a bird-shaped headdress. At the sides, elks and insects. At the bottom, anthropomorphous, ichthyomorphic, and zoomorphic spirits. On the hem, a fish-skin fringe. Udeghe, late 19th–20th century. Nikolayevsk district, Khabarovsk territory. Collected by E. Schneider in 1931. SME, Inv. No. 5656-151.

71

Back of a shaman robe (see No. 70). 85 × 55. Decoration in dark blue, red, and yellow pigment: two wingless dragons; between them, anthropomorphous spirits, frogs, cloven-hoofed animals; at right and left, lizards. On the hem, a fish-skin fringe. Udeghe, 19th–20th century. Nikolayevsk district, Khabarovsk territory. Collected by E. Schneider in 1931. SME, Inv. No. 5656-151б.

72

Shaman skirt. Chamois. Length 82. Trapezoid, slit at the sides. The hem edged with bands of black and red cotton. Decoration in black and red pigment: tigers (?), snakes, lizards, frogs. Udeghe, 19th–20th century. Primorye territory. Collected by V. Arsenyev in 1911. SME, Inv. No. 18138 "T".

73

Shaman apron. Light-colored cotton cloth. 80 × 43.5. Decoration in black and red pigment: snakes, toads, and lizards. Embellished with leather tassels bearing varicolored glass beads, and trimmed with fur and cloth bands. Nanai, 19th – early 20th century. Primorye territory. Collected by V. Arsenyev in 1911. SME, Inv. No. 1998-11.

74

Shaman shirt. Chamois. Length 75. On the hem and short kimono sleeves, chamois fringes. Decoration in black and red pigment: symmetrical rows of lizards, snakes, tigers, and toads. Nanai, 19th century. Torgon campsite on Amur River, Nanaisky district, Khabarovsk territory. Collected by D. Solovyov in 1910. SME, Inv. No. 18141.

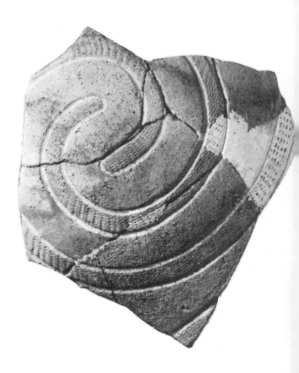

62, 63, 64

65

66

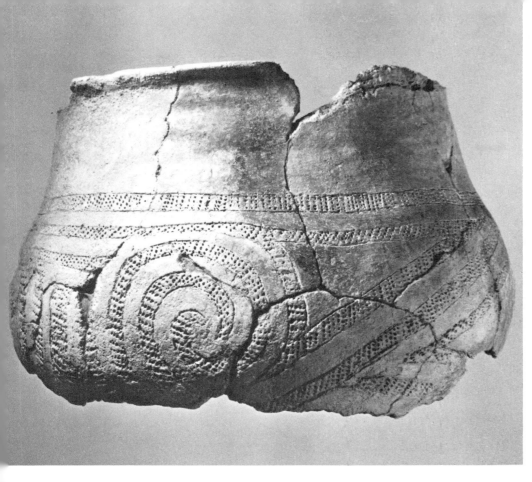
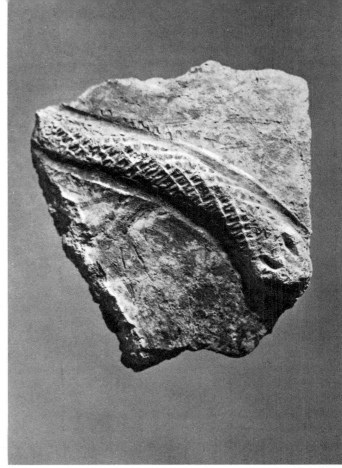
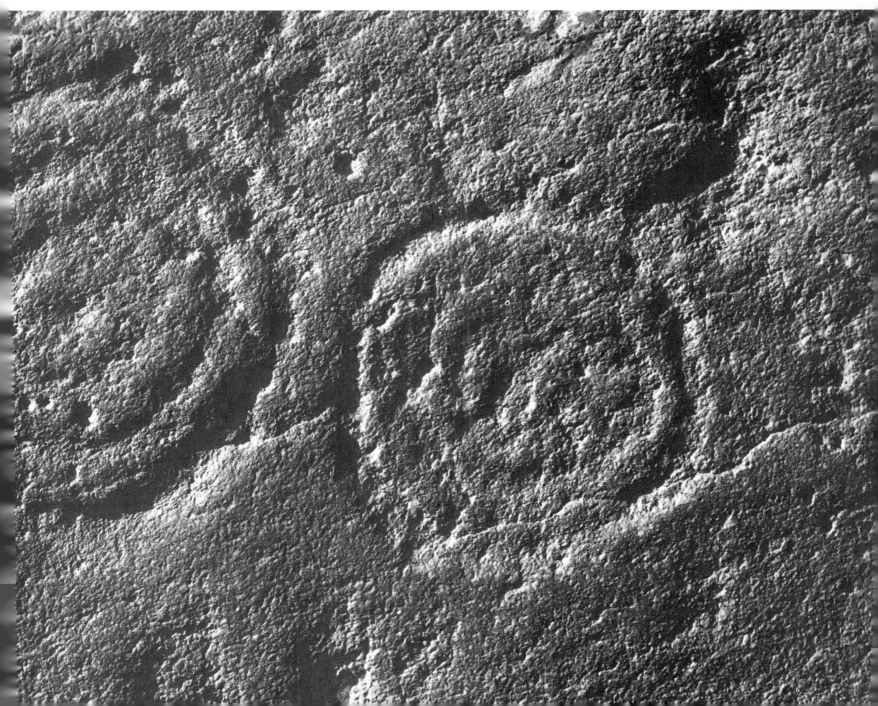

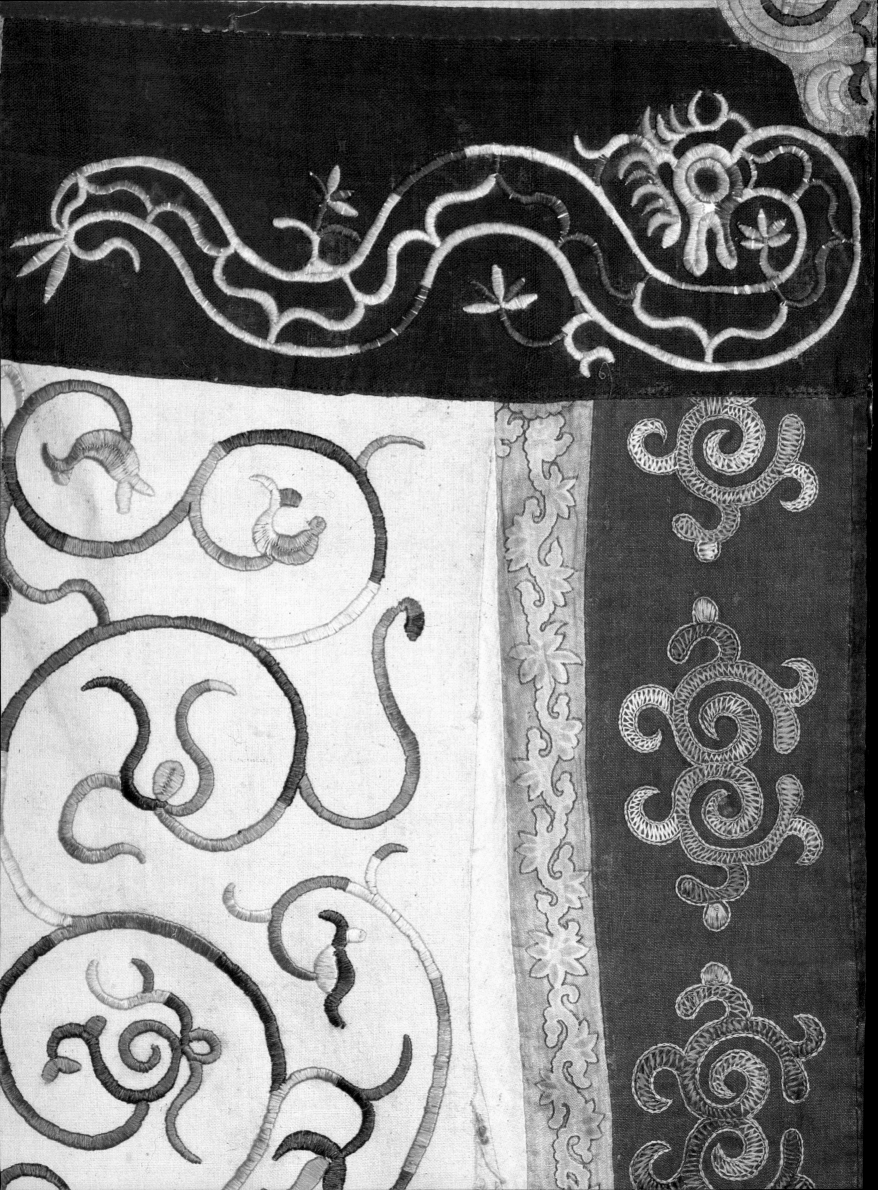

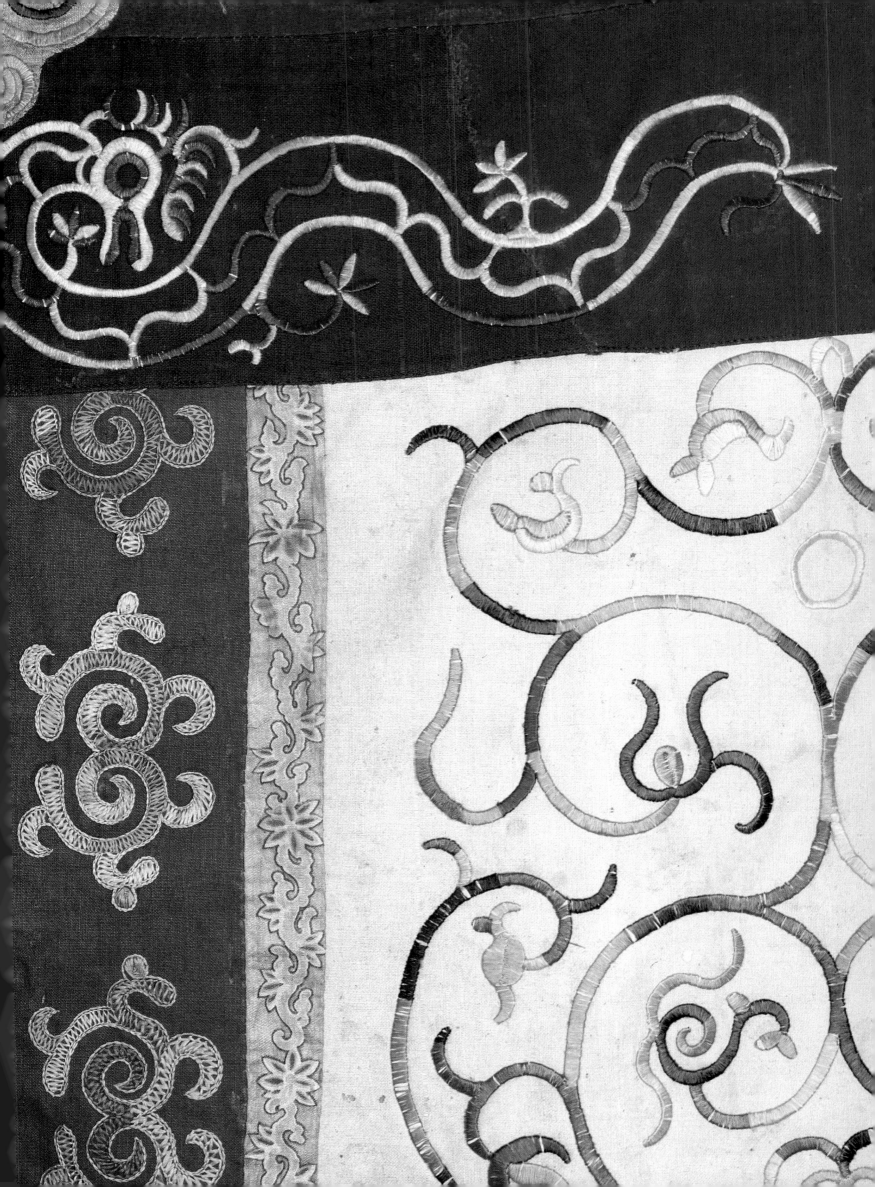

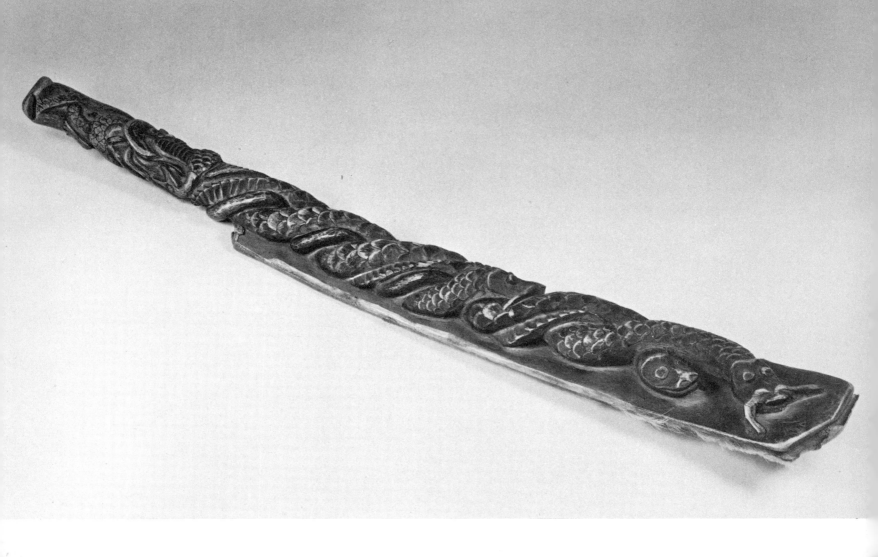

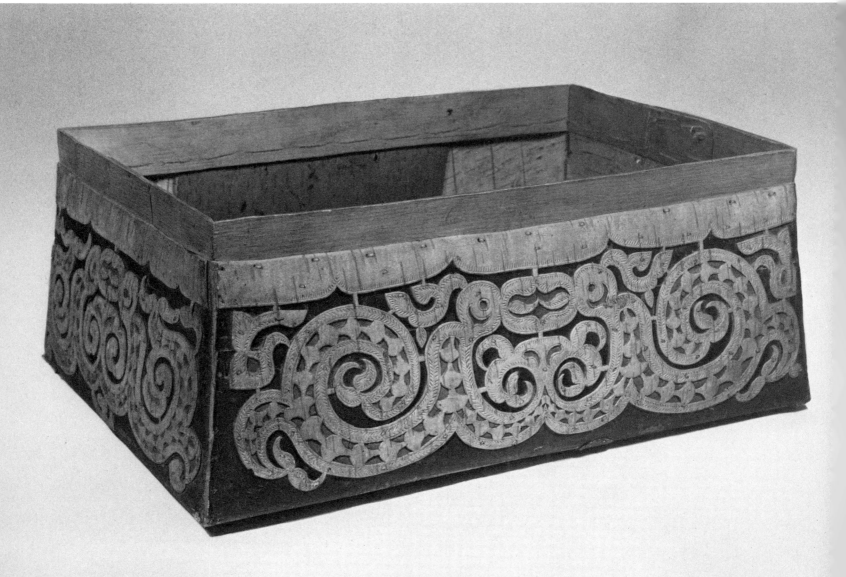

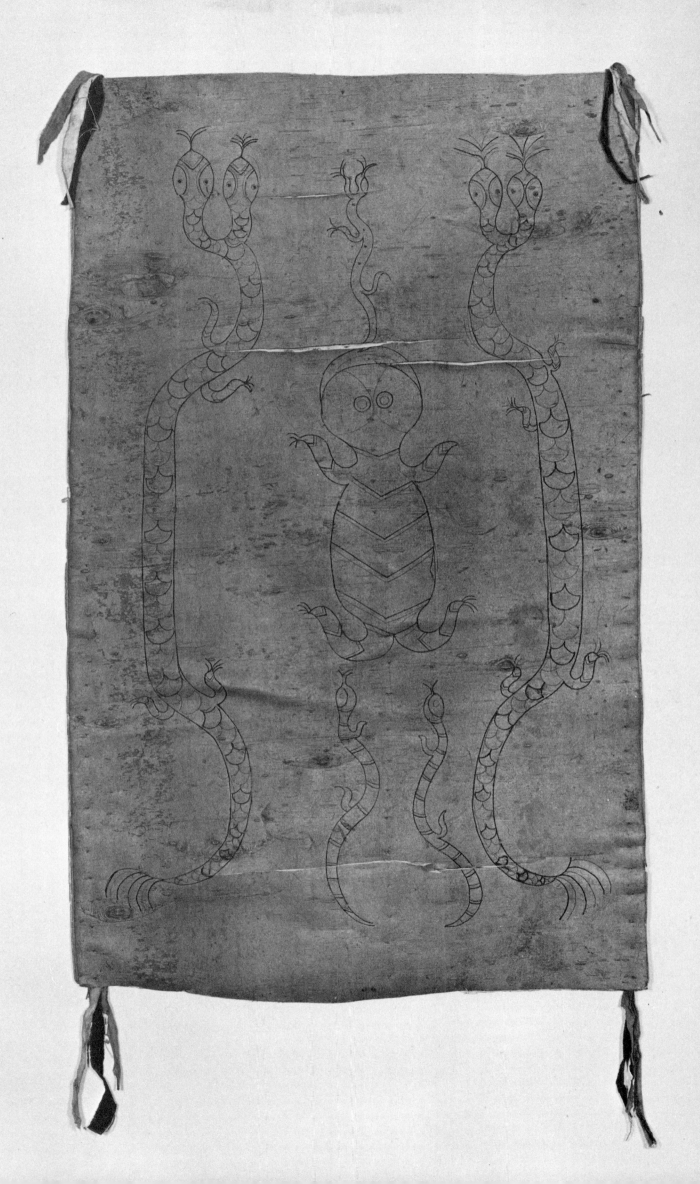

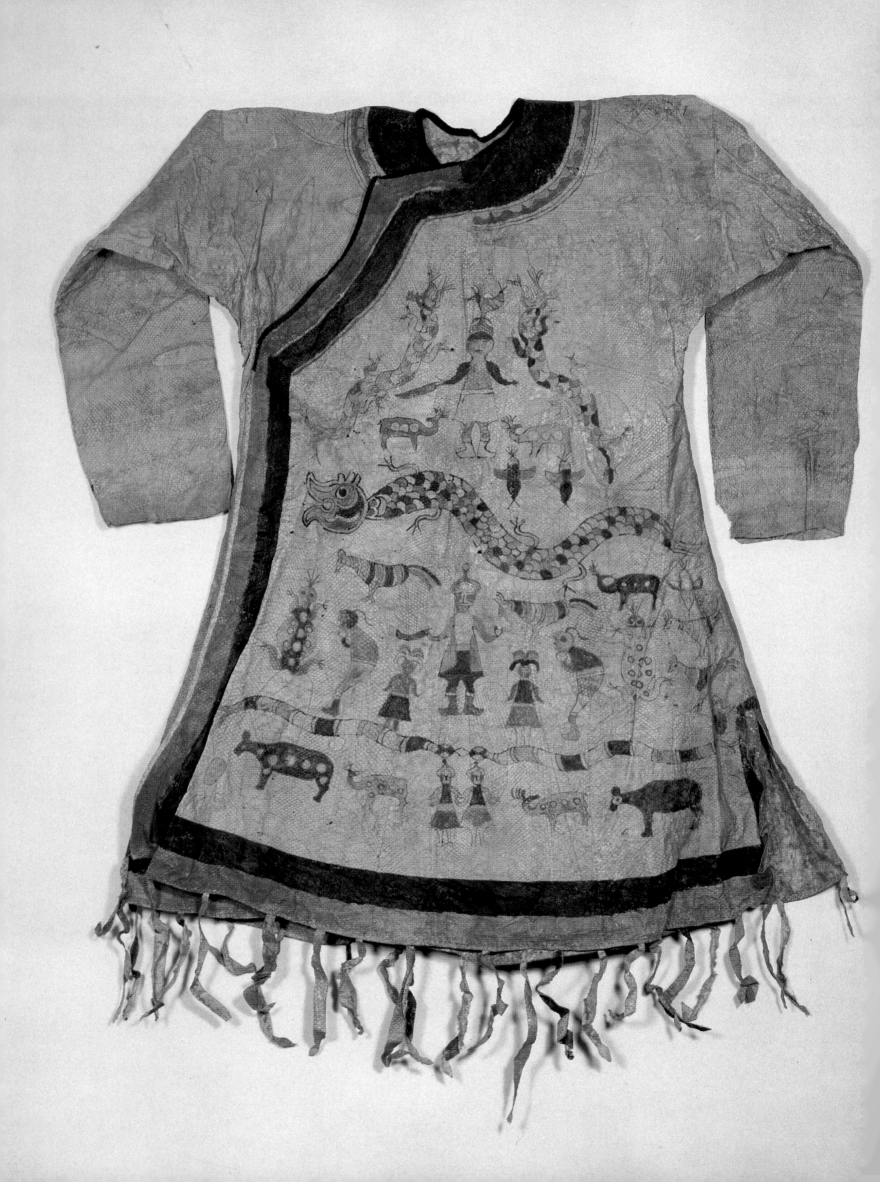

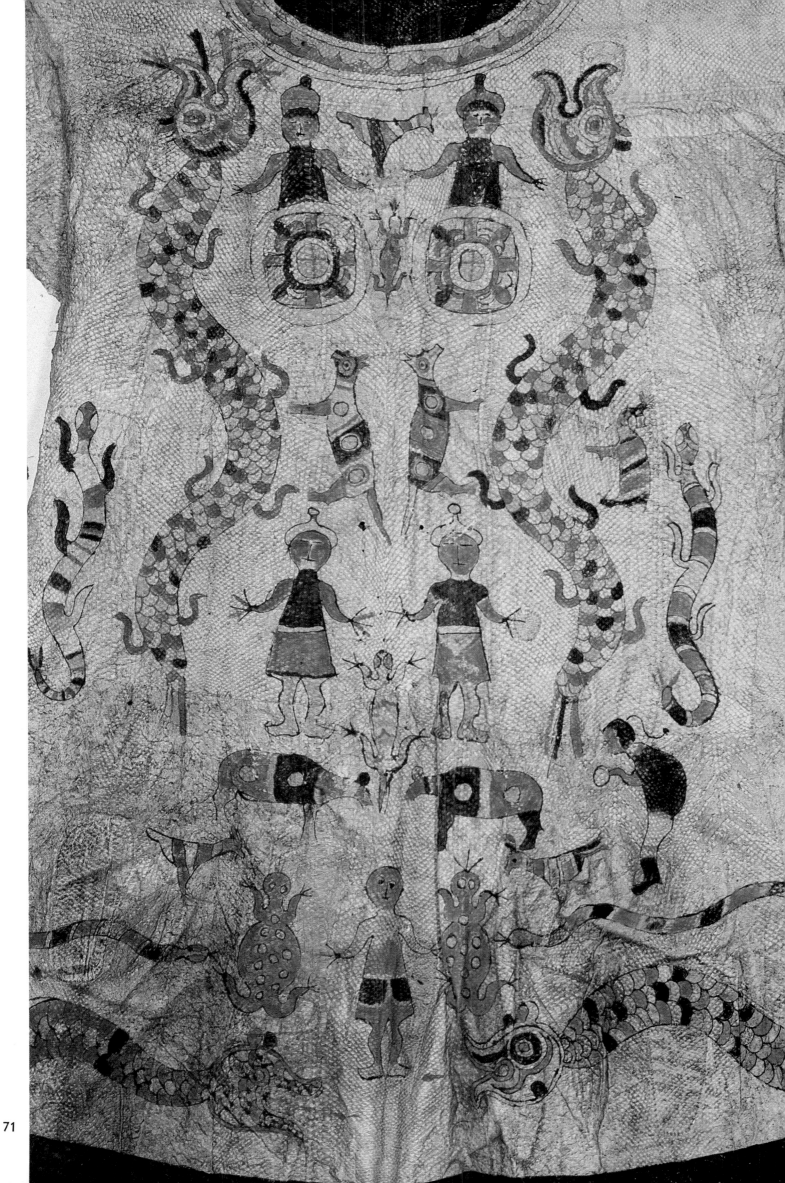

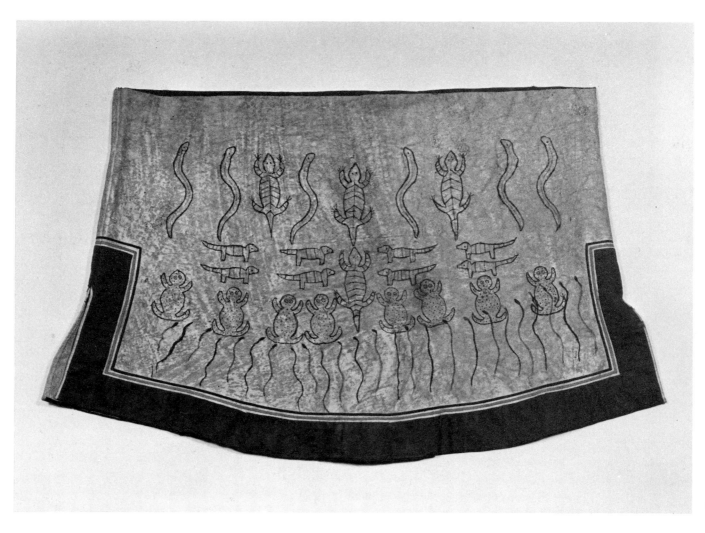

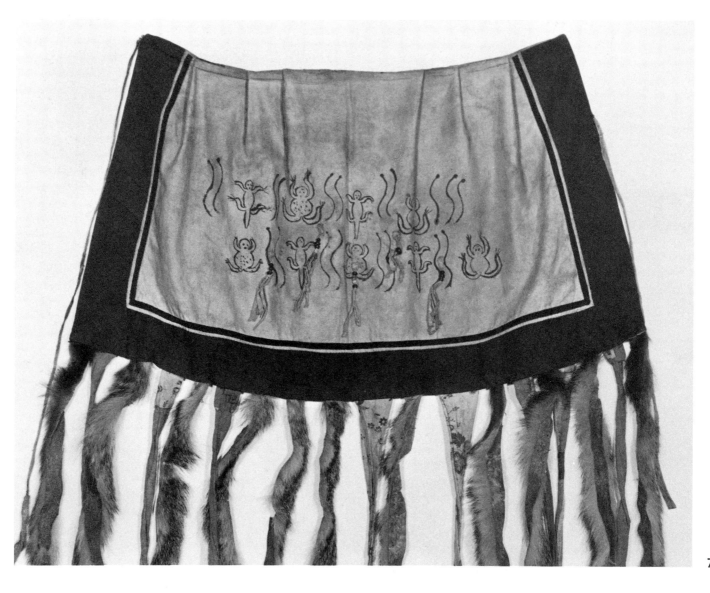

The ornament consisted of a wave-line or a diagonal net. A stamped pattern of lozenges inscribed one inside the other was also common, as were squares and triangles.

Various ornaments were cast in metal: cruciform and ribbed plaques and intricately shaped

pls. 143–145 buckles, sometimes of open-work type. The abundant decoration of the belt with plaques symbolized the high social standing of their owners and served to identify outstanding warriors and leaders. The minute bronze fishes served the same purpose: they were an indication of official rank. The Jurchen, like their predecessors the Bo-hai, learned a lot from the farmers of Eastern Asia, and also from their neighbors in the steppes, since the boundless steppe, with its nomadic population of Turks and Mongols, was close by. As before, earrings with pendants, belts richly ornamented with plaques, buckles, and many other things, were widespread; this shows that the Jurchen culture was related to that of the steppe cattle-breeders and mounted warriors.

The architecture and building techniques of the Jurchen were distinctive and original. The fortified Jurchen settlements, called into being by the uneasy political situation—at first intertribal warfare, and later wars with Korea and the Sung China—were real eyries, inaccessible fortresses. The settlement on Golubinaya hill on the Artiomovka River was bounded on one side by a vertical limestone wall and the deep river, and on the other by the steep slope of the hill and a massive rampart of stones and earth. The Jurchen architects took advantage of the relief of the terrain and adapted their fortifications to it. This is shown by such impressive constructions as the Krasnoyarovskaya hill fortress, whose ramparts and ditches follow the contours of the hill. Another distinguishing feature of Jurchen architecture is the building of houses on cleverly designed ledges or platforms. Their *kans*—smoke-pipes placed under the floor to heat the houses—have come down to us. The *kan*, which was later taken over from their northern neighbors by the peoples of Northern China and Southern Manchuria, was already in existence among the tribes of the Early Iron Age Krounovka culture in the Primorye. It was the ingenious invention of the aboriginal inhabitants of these areas, dictated by their severe climate. The *kan* was passed on by the Jurchen to their lineal descendants—the contemporary Amur tribes, Nanai and Olcha—together with the entire set of principles on which the system of construction was based.

However much the Jurchen surpassed their ancestors and predecessors in economical, political, and spiritual development, in their culture we can see traces of the age-old culture of the Amur peoples. One of the most important is the spiral decoration. The spiral motifs on the bronze and silver ornaments recall the predominance of spirals on the earthenware vessels from the island of Suchu or from Kondon. The earrings with discs made of white jade—the sacred stone of the forest hunters—also go back to ancient traditions. Those objects, like the belts with variously shaped plaques, which form part of the traditional folk art of the Amur tribes, were in everyday use not only among the Jurchen but also among the related tribes on the northern outskirts of the former Jurchen state, which survived the Mongol invasion. We must conclude that it was precisely these tribes (the ancestors of the Nanai, Olcha, and Nivkh) who used the ancient style of ornamentation. No longer suitable for pottery, because of the new techniques of production, it was probably used to decorate objects of wood, birch-bark, and bone, and fish-skin clothing, which have not survived in the damp Amur soil; these are just the materials on which nineteenth-century ethnographers found the ancient patterns.

After the fall of the Jurchen state, the aboriginal tribes of the Amur region and the Primorye territory were left without a state power. They were still subject to no authority when they were found in the seventeenth century by the first Russian explorers to make their way from the Urals to the Pacific Ocean. Since then the lot of the Far East has been indissolubly linked with Russia and the Russian people. It fell to Russians to lead this region out of its centuries-old isolation, and to facilitate the rebirth of a culture whose foundations, as we have been able to convince ourselves on the basis of ethnographical finds, lie in the most ancient traditions of the native peoples. It is these traditions that determine the characteristic color, the vital currents of national individuality in the art of the Amur peoples.

96

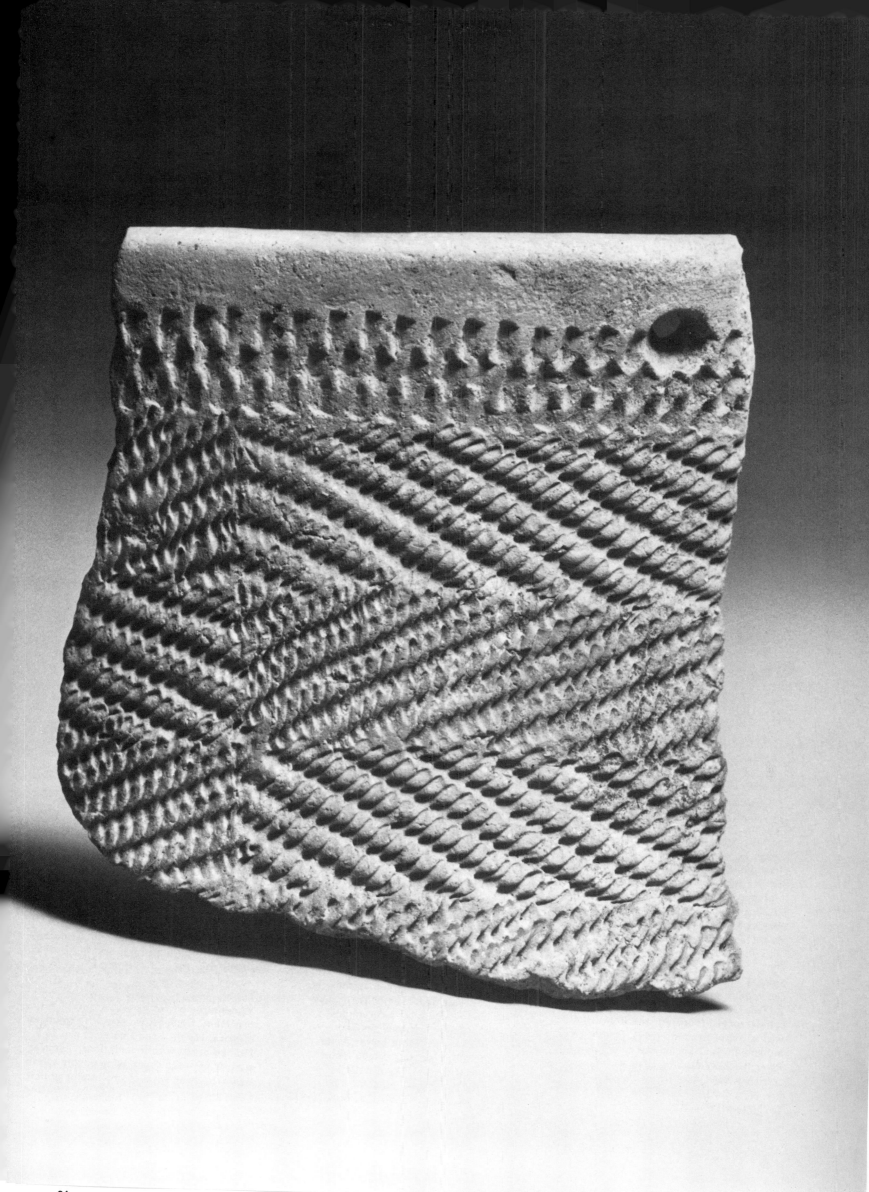

96

Two wide-mouthed vessels. Brown clay. Height 19, 9.3; diameter of rim 23, 12. Vertical zigzag, impressed with a comblike stamp. Third millennium B.C. Voznesenskoye, Amursk district, Khabarovsk territory. FEAE, 1968, MIHPP, Inv. No. B-68/77 (left). Kondon, Solnechny district,

77
Grain-muller. Dark grey sandstone.
Length 24. Spiral ornament. Fourth–third
millennium B.C. Mramornaya River,
Dalnegorsk district, Primorye territory.
FEAE, 1956. MIHPP, Inv. No. ДВ-56/411.

78

(top and center). Dalnegorsk, Primorye
territory. FEAE, 1958. MIHPP,
Inv. No. ДП-132 (bottom).

84
Vessel ornamented with horizontal bands.
Reddish-brown clay. Height 32, diameter
of rim 18.5. The pattern impressed with
comblike stamp. Shape and ornamentation

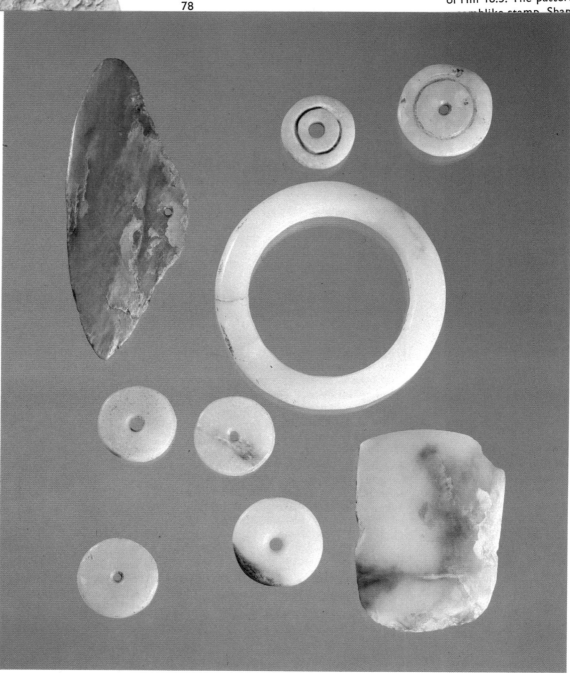

78

79

80, 81

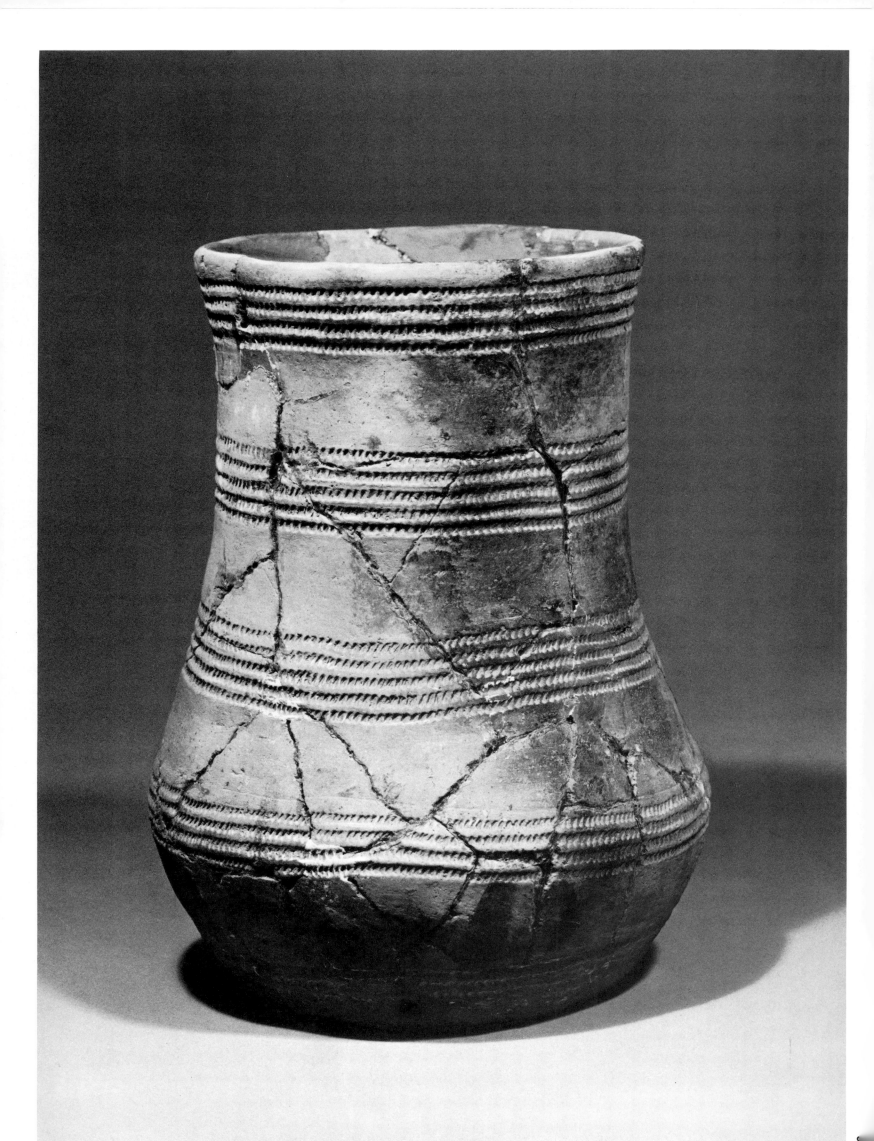

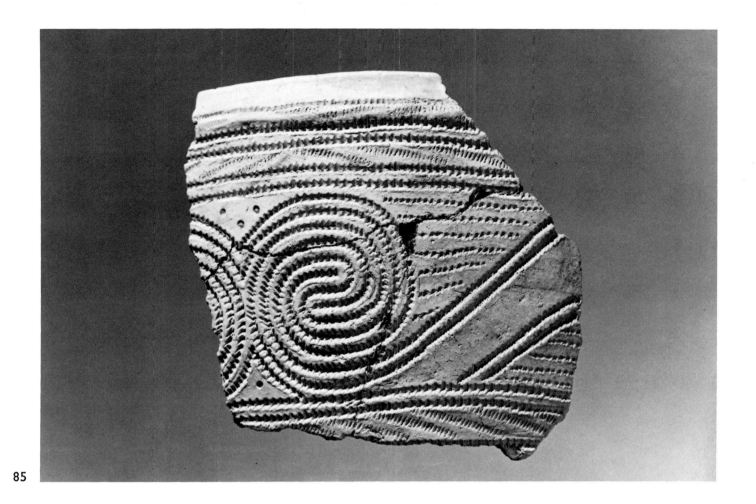

85

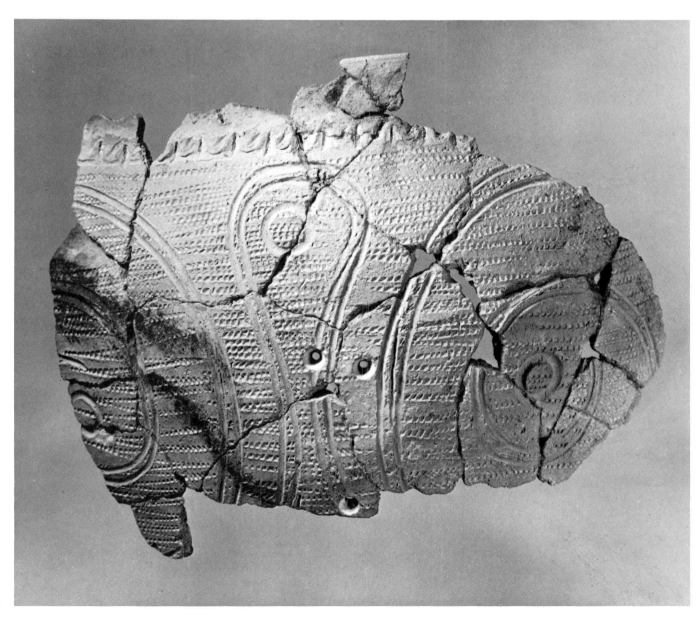

86

87 →

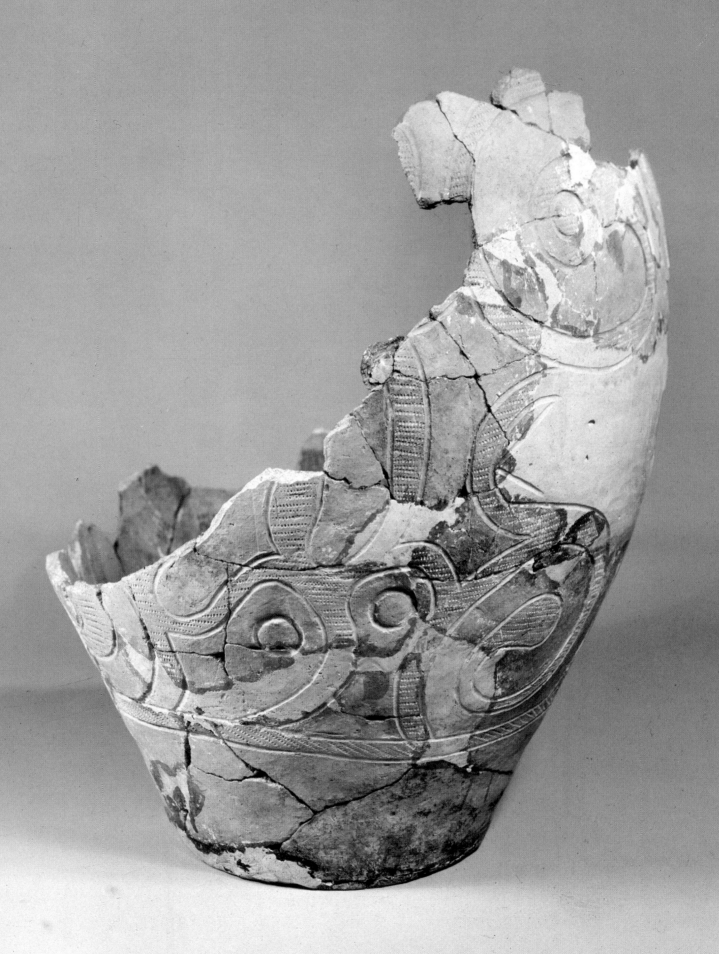

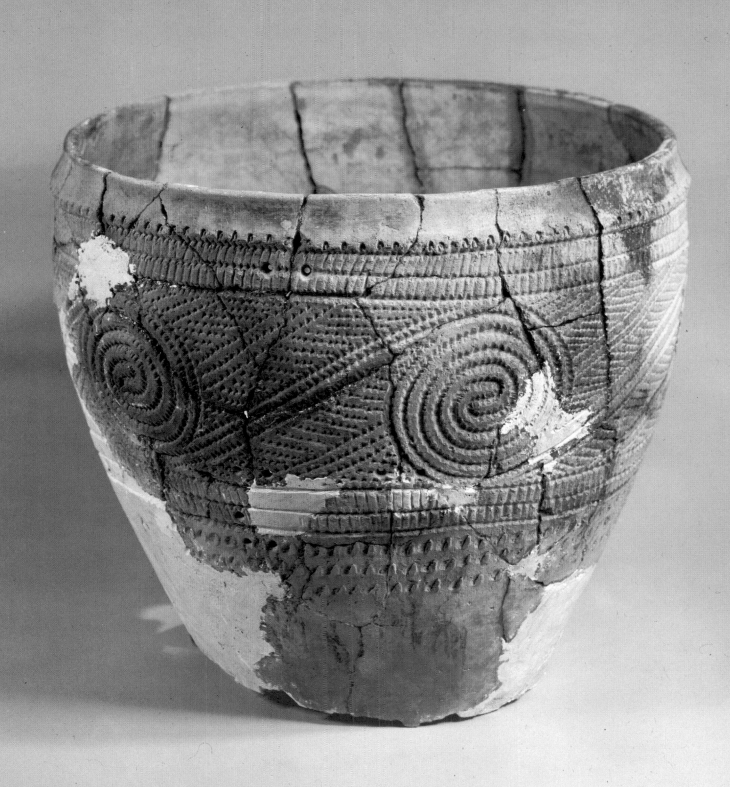

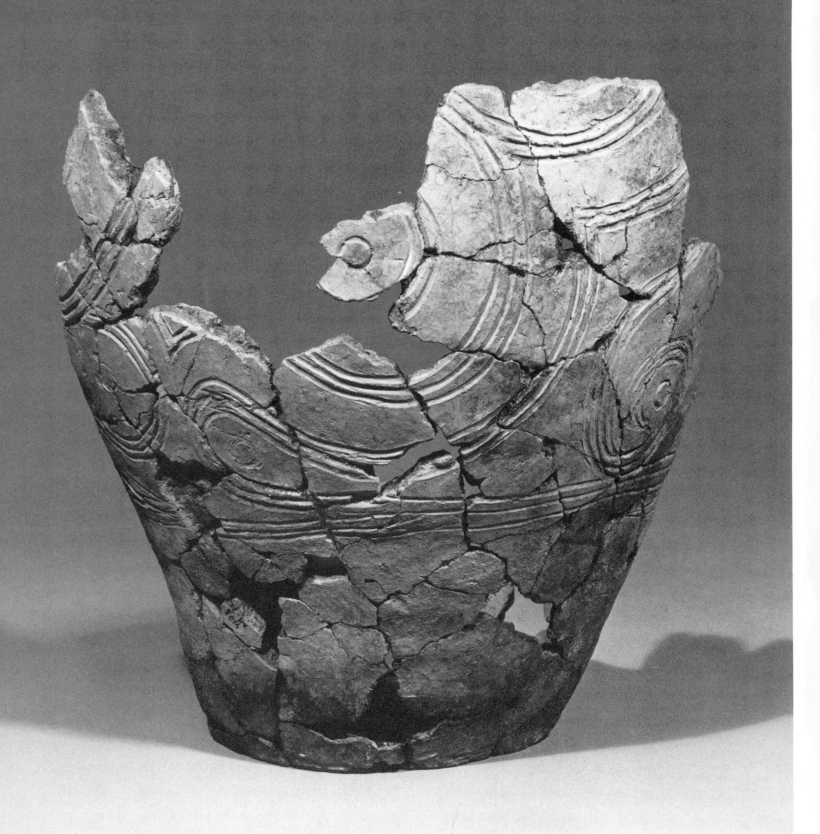

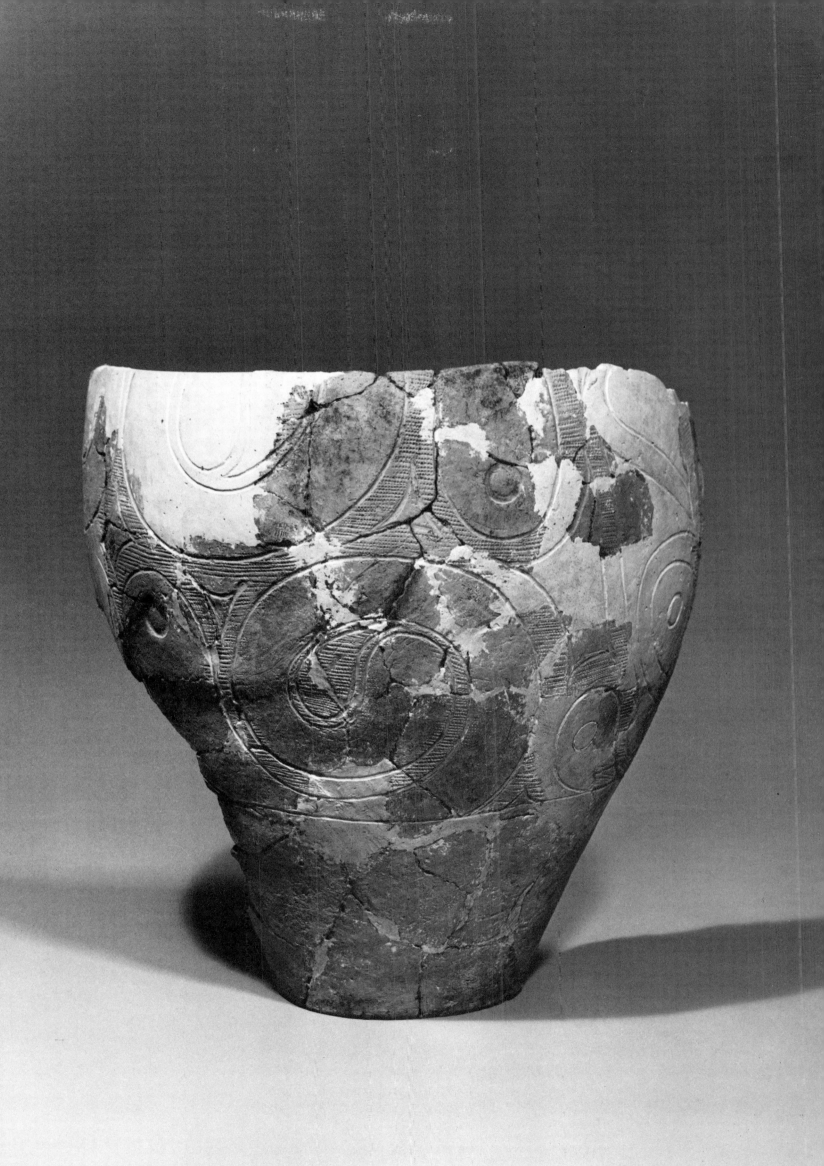

1

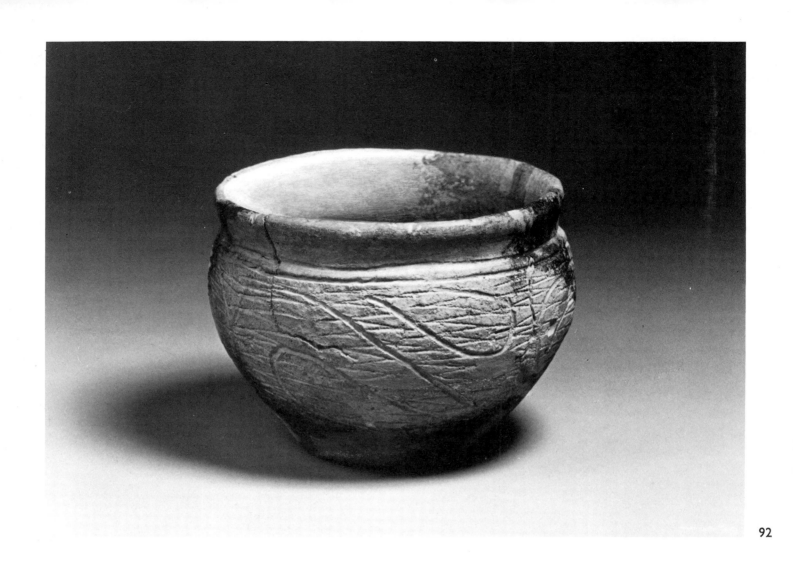

92

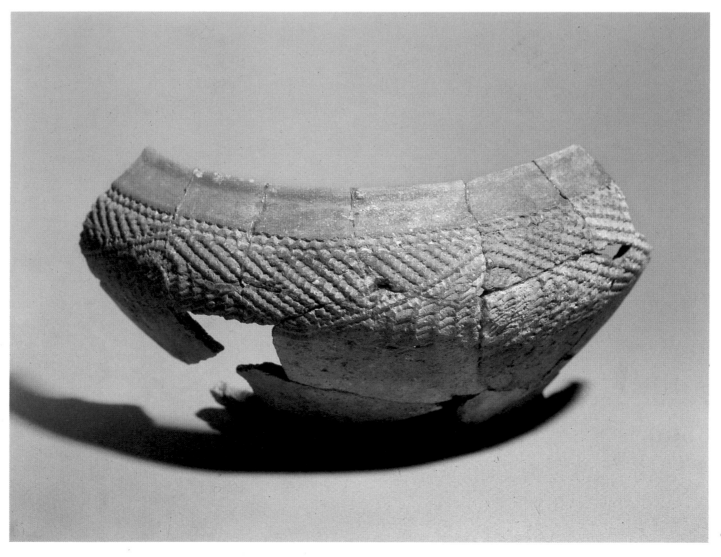

93

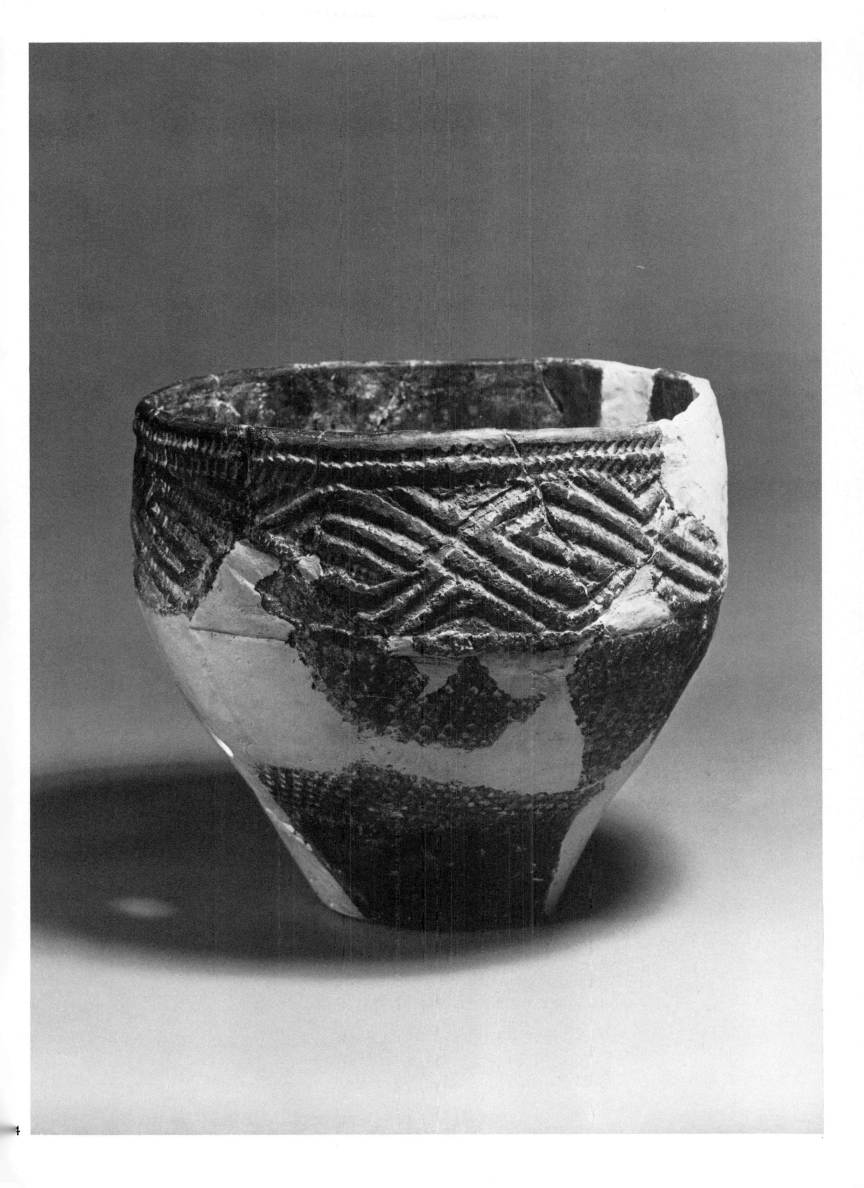

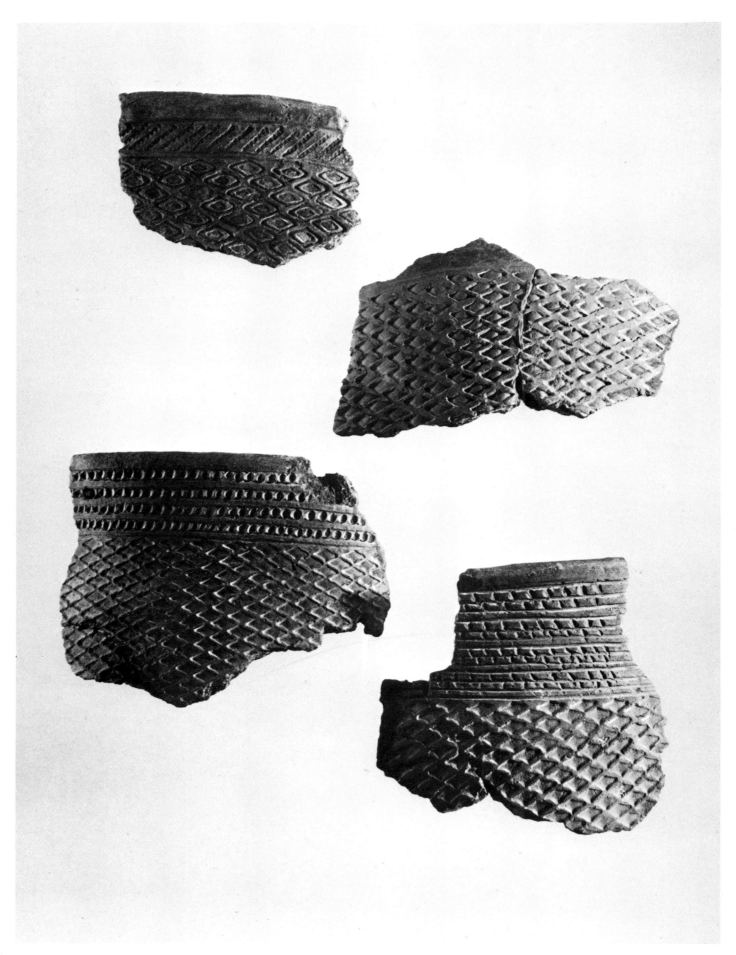

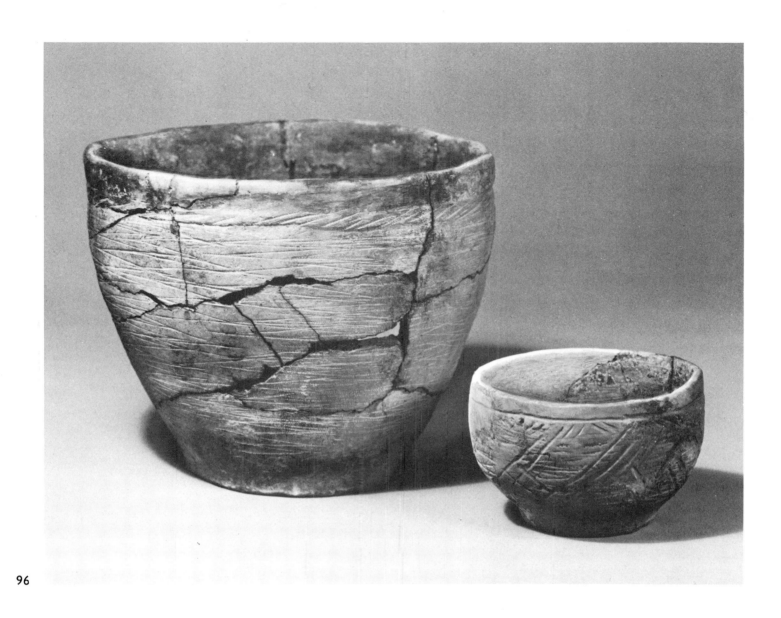

96

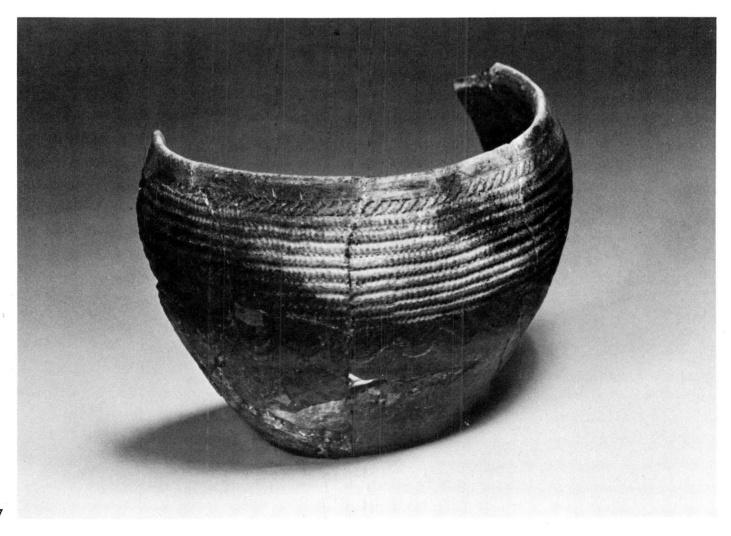

97

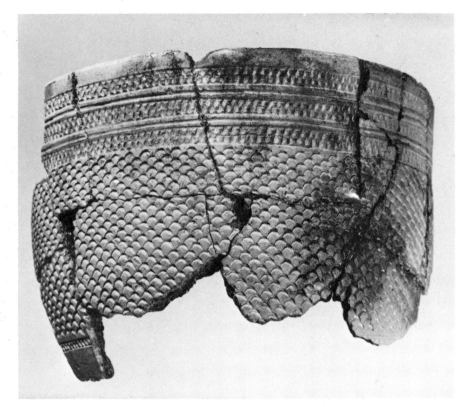

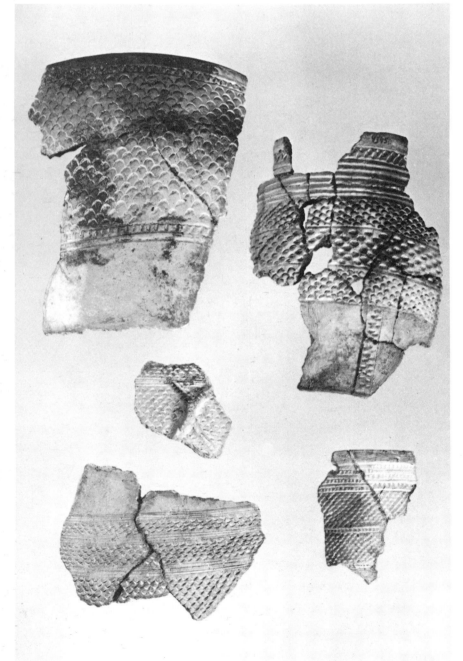

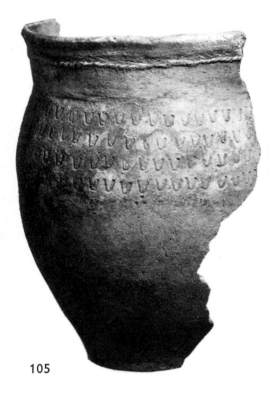

105

105

Potsherd. Yellow-brown clay. Height 23.8, diameter of rim 17.8. Ornamented with a molded band and four horizontal rows of stamped chevrons. Second half of the first millennium B.C. Kukelevo, Leninskoye district, Jewish Autonomous region. FEAE, 1964. MIHPP, Inv. No. Ky-64/237.

106

Thin-walled segmented vessel. Flat surfaces of red clay, impressions in yellow-brown clay. Height 6.5, diameter of body 8. Ornamented with stamped triangles, filled in with impressions of slanting and spiral lines. Fourth–third millennium B.C. Suchu island on Amur River, Ulchsky district, Khabarovsk territory. NACAE, 1974. MIHPP, Inv. No. Cy-74/10210.

107

Wide-mouthed vessel with broad body, ornamented with spiral scrolls. Brown clay. Height 16.5, diameter of mouth 16.3. Fourth–third millennium B.C. Suchu island on Amur River, Ulchsky district, Khabarovsk territory. NACAE, 1974. MIHPP, Inv. No. Cy-74/2121.

108

Two thin-walled vessels. Light-brown clay; the right-hand vessel with black smudges. Height 13.4, 14.5; diameter of rim 17 (left). The left-hand vessel ornamented with a design of zigzags and slanting lines, applied with a denticulated stamp; the same technique used to decorate the right-hand vessel, which has a pattern of lozenges on the neck and bands of slanting lines on the body. Fourth–third millennium B.C. Suchu island on Amur River, Ulchsky district, Khabarovsk territory. NACAE, 1973, 1975. MIHPP, Inv. Nos. Cy-73/P2E2, Cy-75/13641.

109

Fragmented wide-mouthed vessel with broad body. Light brown clay. Height 16.2, diameter of body 26.3, diameter of mouth 15. On the body, a pattern of stamped meanders and red burnished figures in the form of "ram's horns." Above it, an unornamented band painted red. Fourth–third millennium B.C. Suchu island on Amur River, Ulchsky district, Khabarovsk territory. NACAE, 1975. MIHPP, Inv. No. Cy-75/11998.

110

Two wide-mouthed vessels. Dark-brown clay. Height 20, 6.4; diameter of body 23 (left), diameter of rim 9.5 (right). Ornamented with stamped elements of meander and zigzag. Fourth–third millennium B.C. Suchu island on Amur River, Ulchsky district, Khabarovsk territory. NACAE, 1972. MIHPP, Inv. No. Cy-72/5987 (left). Kondon, Solnechny district, Khabarovsk territory. FEAE, 1962. MIHPP, Inv. No. K-18/80 (right).

111

Box. Birch-bark. Height 28, diameter 24. Cylindrical in shape, ornamented with a geometrical design in black pigment. At the upper edge, tying thongs. Nanai, 19th–20th century. Khabarovsk. Collected by D. Solovyov in 1910. SME, Inv. No. 1928-225.

112

Wide-mouthed vessel with two ornamented bands. Yellow-brown clay, with black smudges. Height 29; diameter of rim 28.5. The upper band ornamented with a one-armed meander of two incised lines. The lower one ornamented with spirals done in the same manner. The bands divided by incised lines. The background filled in with impressions of a comblike stamp. Late fourth – early third millennium B.C. Voznesenskoye, Amursk district, Khabarovsk territory. FEAE, 1966. MIHPP, Inv. No. B-66/63.

113

Skin scraper. Bone. Length 26. The upper part ornamented with incised scrolls. Nanai, 19th – early 20th century. Viazemsky district, Khabarovsk territory. Collected by P. Solovyov in 1910. SME, Inv. No. 1998-321.

114

Sewing box. Birch-bark. Height 21, diameter 9. Carved geometrical design on the lid. Udeghe, late 19th – early 20th century. Nikolaevsk district, Khabarovsk territory. Collected by E. Schneider in 1931. SME, Inv. No. 5656-86аб.

115

Box for spoons (left). Birch-bark. Height 29, diameter 6. Rectangular at the bottom, round at the top; ornamented with scrolls. The design carved and painted black and red in the upper part, and impressed in the lower part. Nanai, 19th–20th century. Khabarovsk, Collected by D. Solovyov in 1910. SME, Inv. No. 1998-219. Box for chopsticks (top right). Birch-bark. Height 25, diameter 8.5. The surface covered with a spiral design. Orochi. 19th – early 20th century. Mukhtukhu campsite on Samarga River, Ternei district, Primorye territory. Collected by V. Arsenyev in 1911. SME, Inv. No. 1870-66. Box (bottom right). Birch-bark. 7 × 20 × 14. In the upper part, a spiral design embroidered with birch-bark on a black, pink, and blue background. Stiches of unbleached cotton thread in the walls. Orochi, 19th–20th century. Tumnin campsite on Tumnin Uska River, Sovietskaya Gavan district, Khabarovsk territory. Collected by B. Vasilyev in 1927 (Tungus expedition). SME, Moscow holdings, Inv. No. 9499аб.

116

Festive robe (detail). Fish-skin. 43 × 29. Ornamented with stylized masks. Nanai, 19th century. Kondon, Solnechny district, Khabarovsk territory. FEAE, 1971 (collected by V. Timokhin). MIHPP, Inv. No. МИИФ-584.

117

Hat. Birch-bark. Diameter 38. The impressed spiral ornament filled in with blue and black pigment. Olchi, 19th century. Ulchsky district, Khabarovsk territory. Collected by V. Avrorin in 1963. MIHPP, Inv. No. МИИФ-210.

118

Wall hanging. Cotton cloth. 200 × 135. Curvilinear appliqué design of varicolored cloth. The edges of the insets machine-sewn. Blue border, width 9.5. Twelve loops along the edges. Made by A. Onenko, a Nanai woman, in 1967. Bolon, Nanaisky district, Khabarovsk territory. Acquired by the purchasing board in 1968. SME, Inv. No. 7798-1.

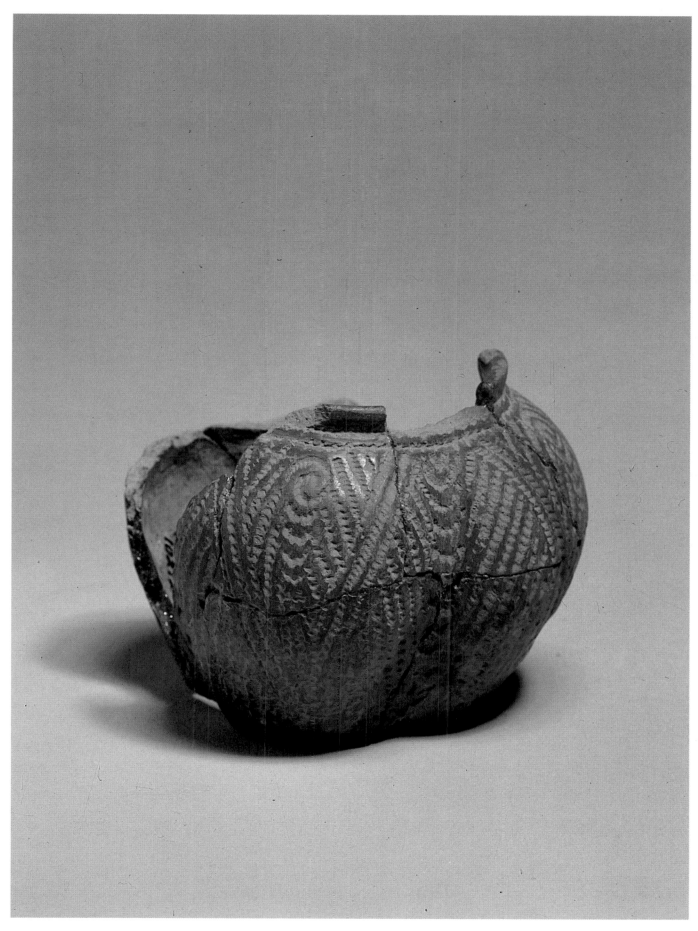

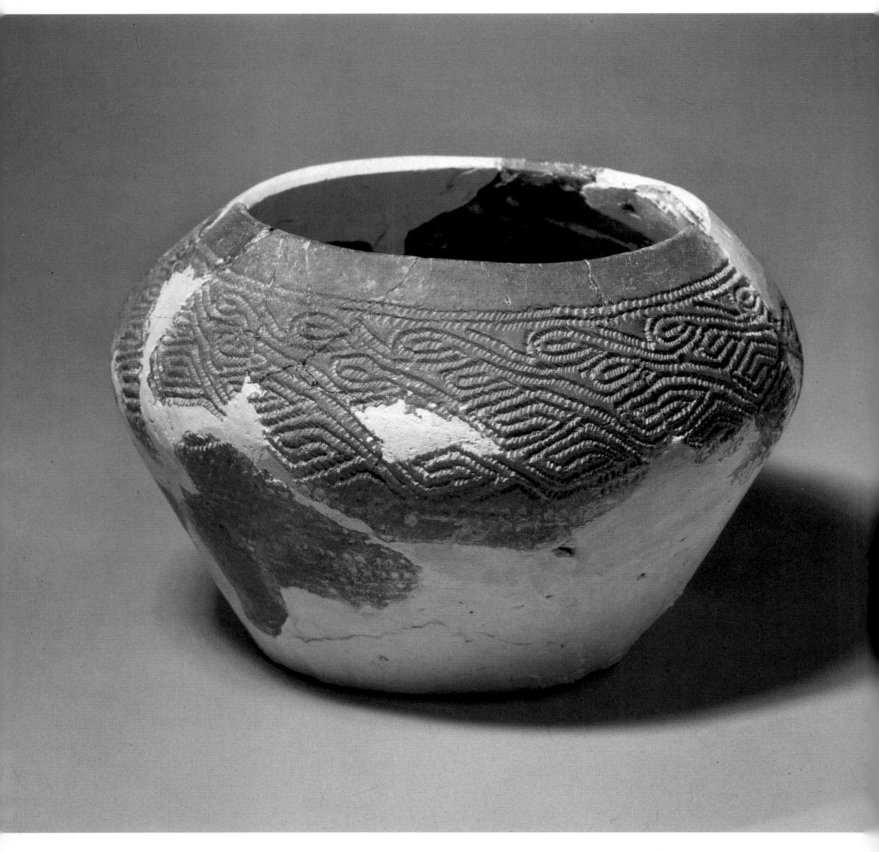

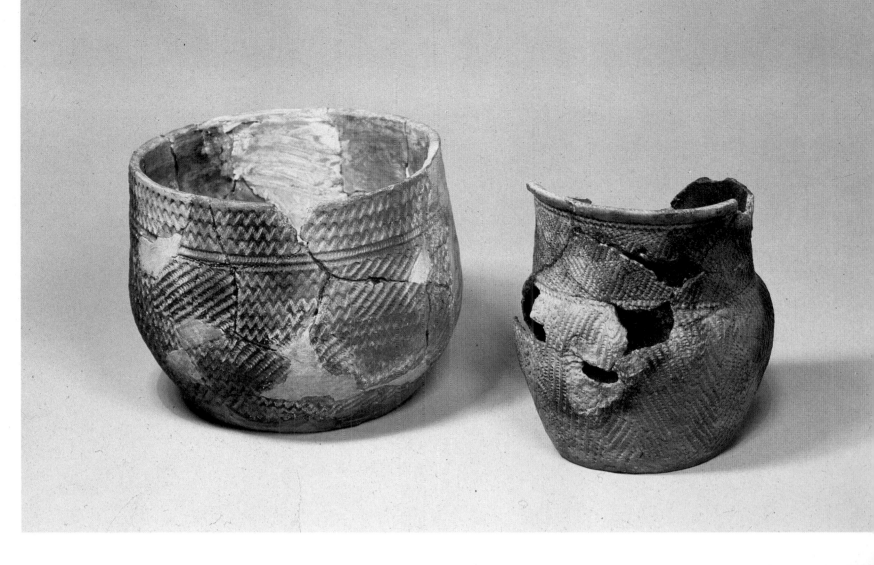
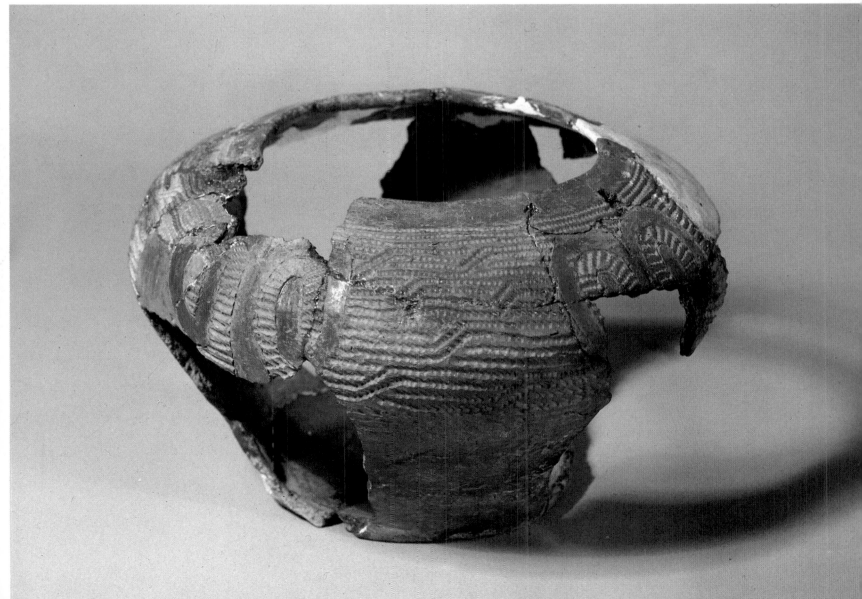

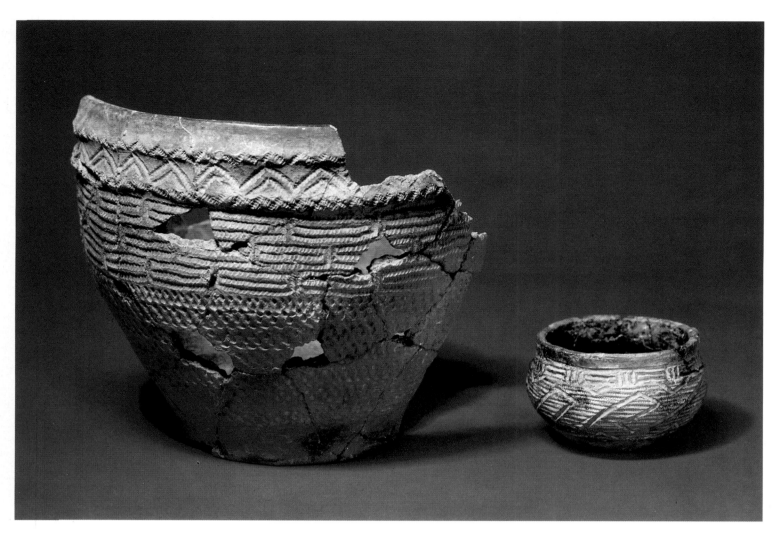

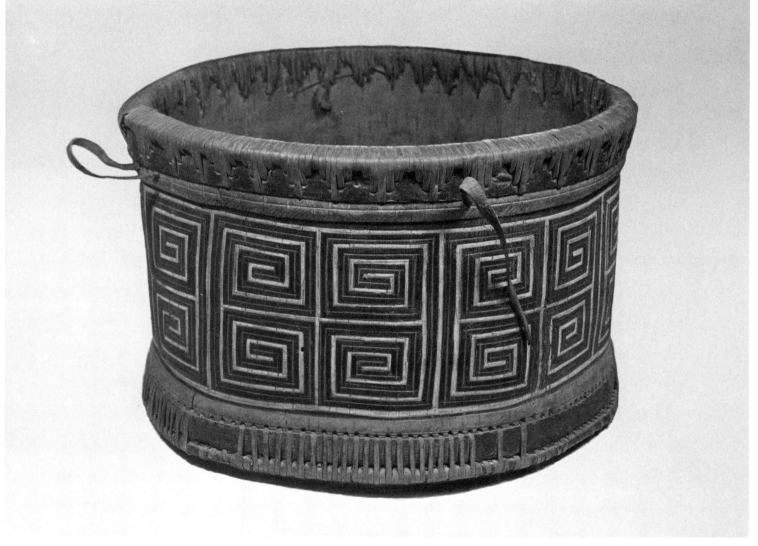

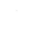

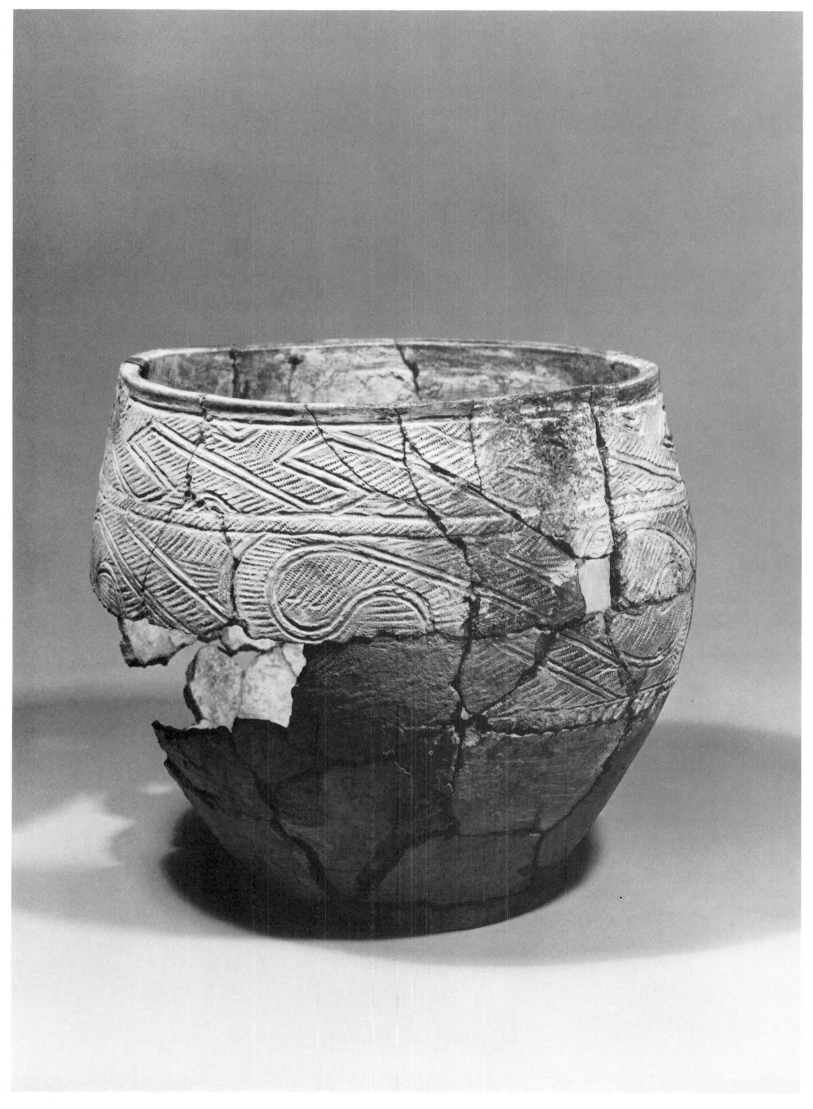

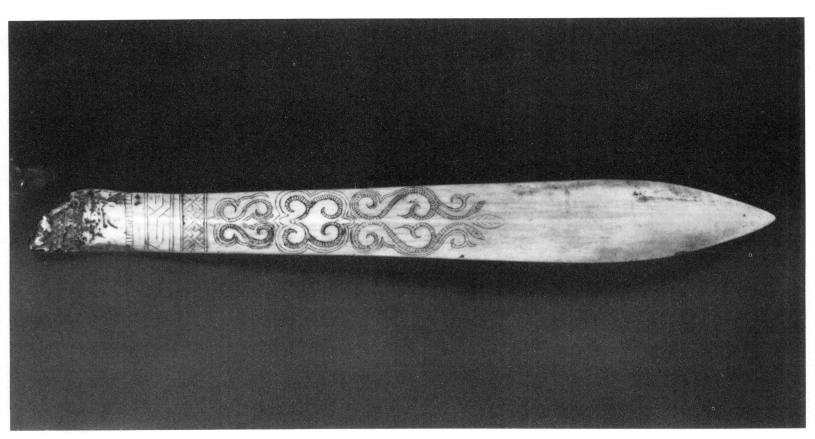

11

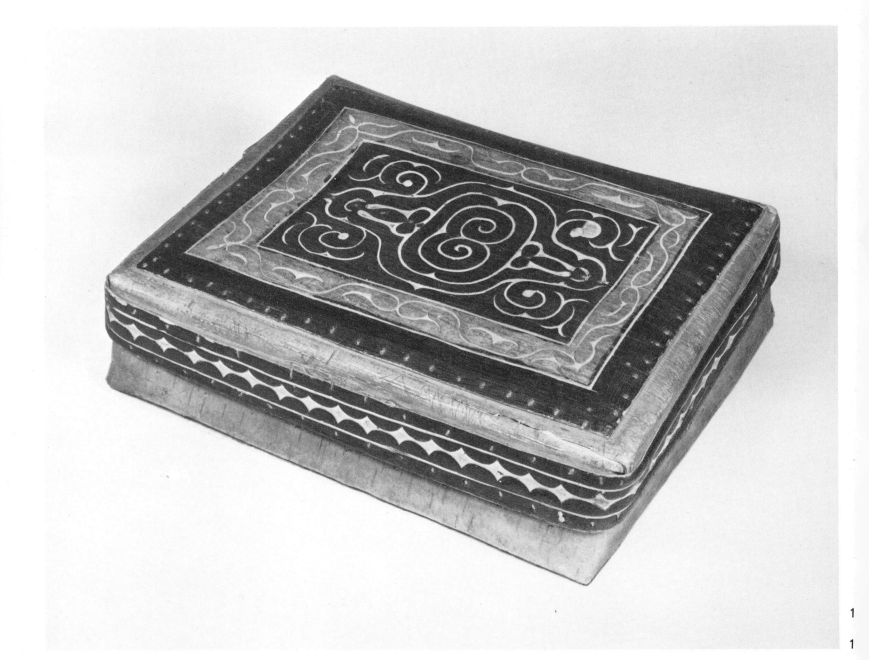

1

1

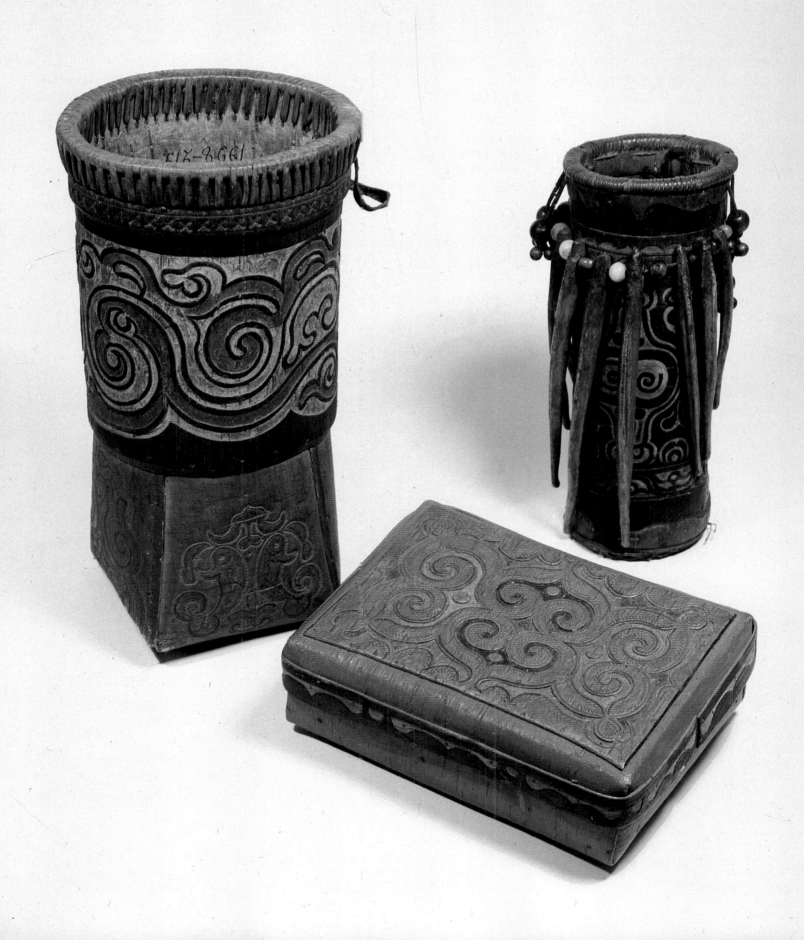

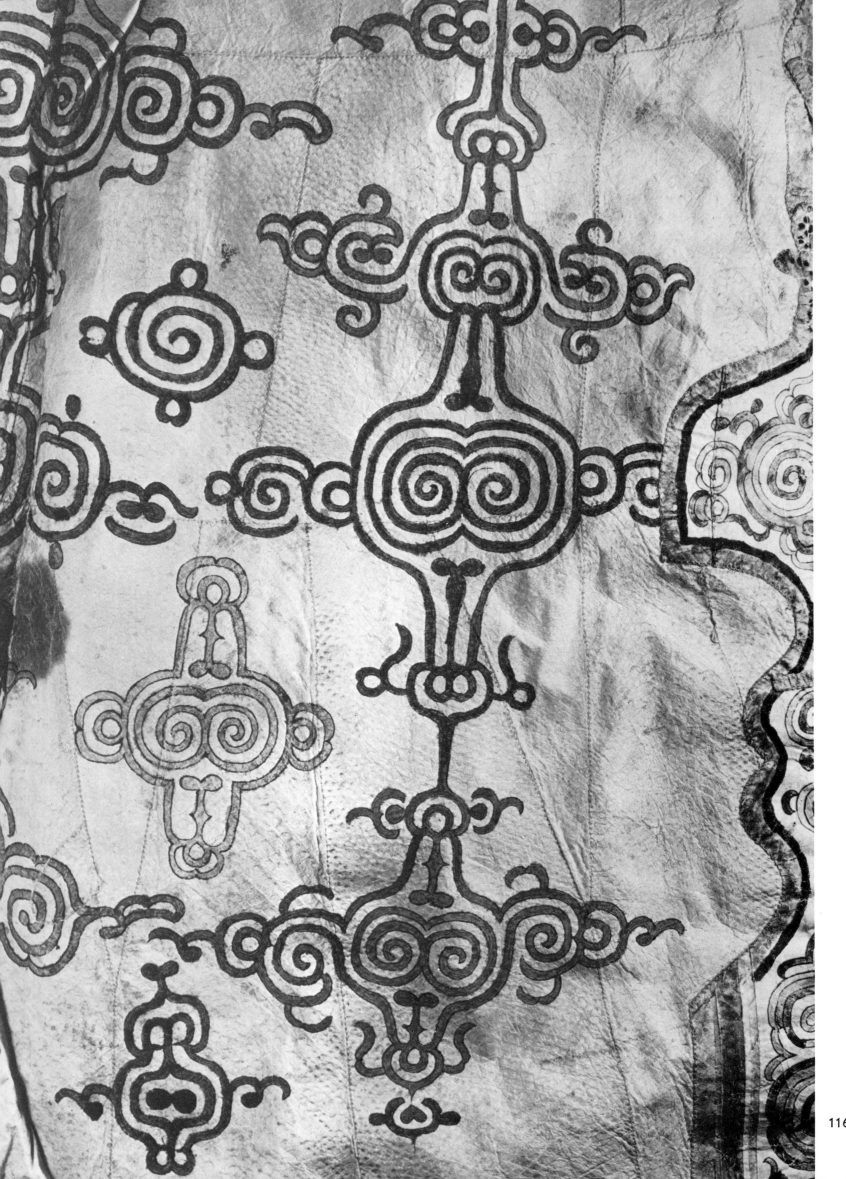

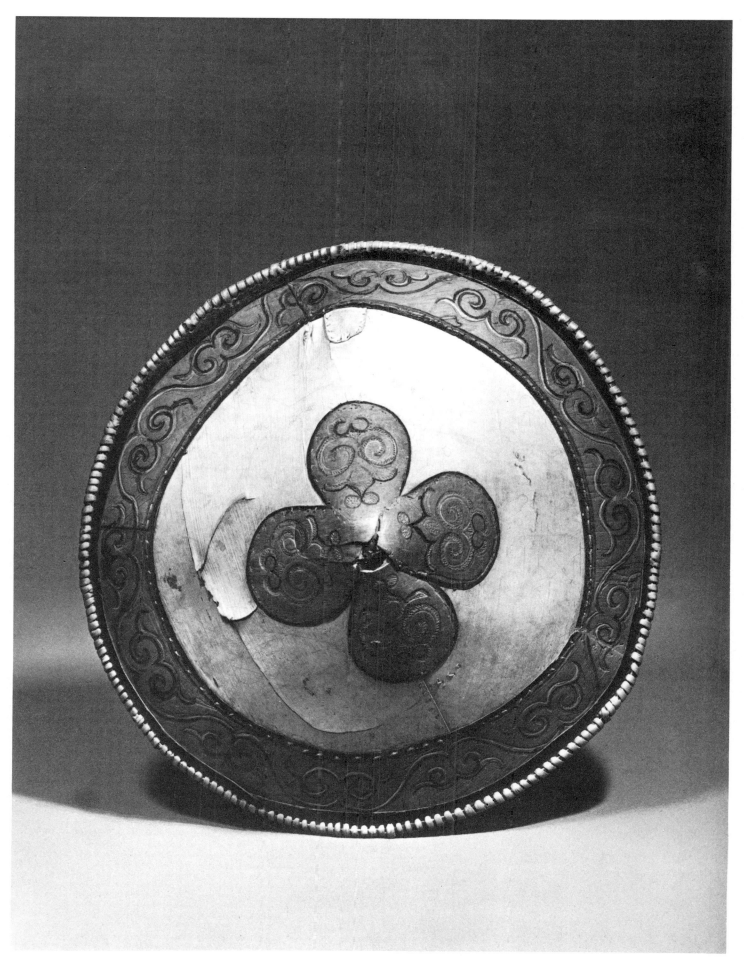

118→

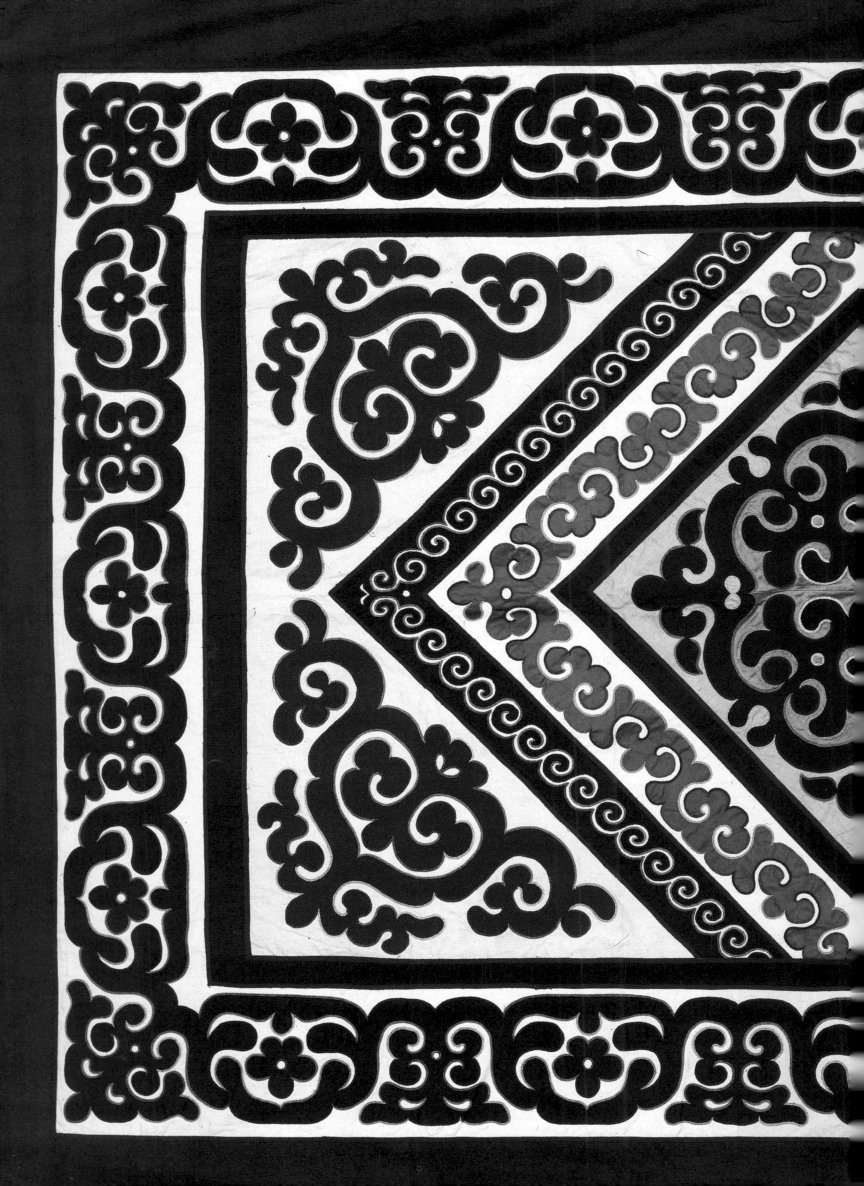

127 →

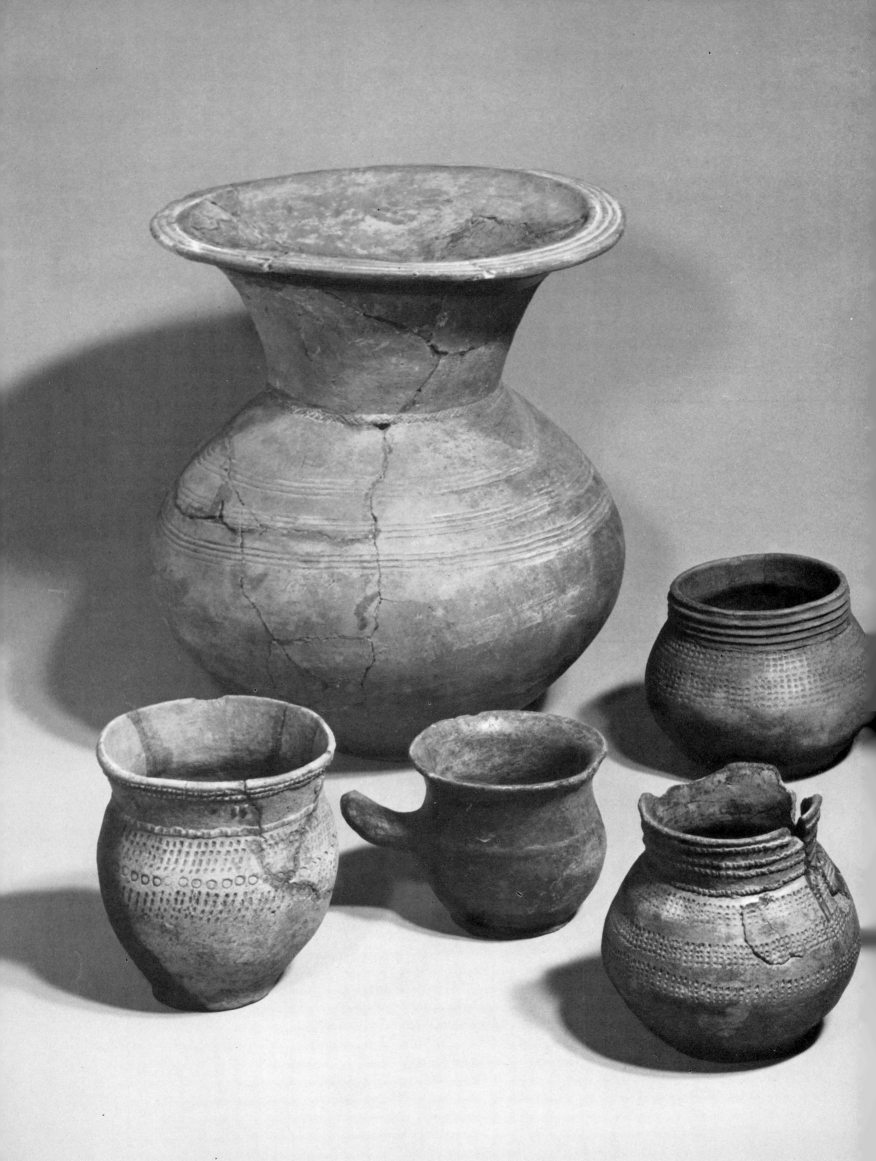

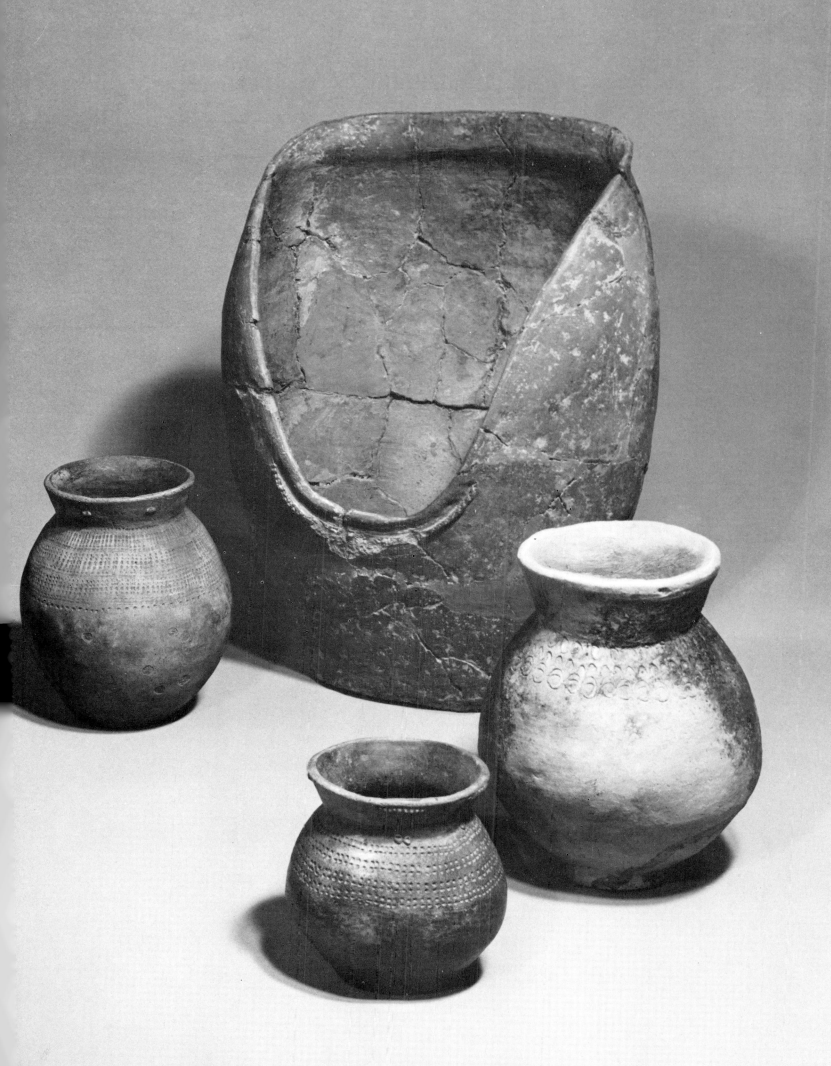

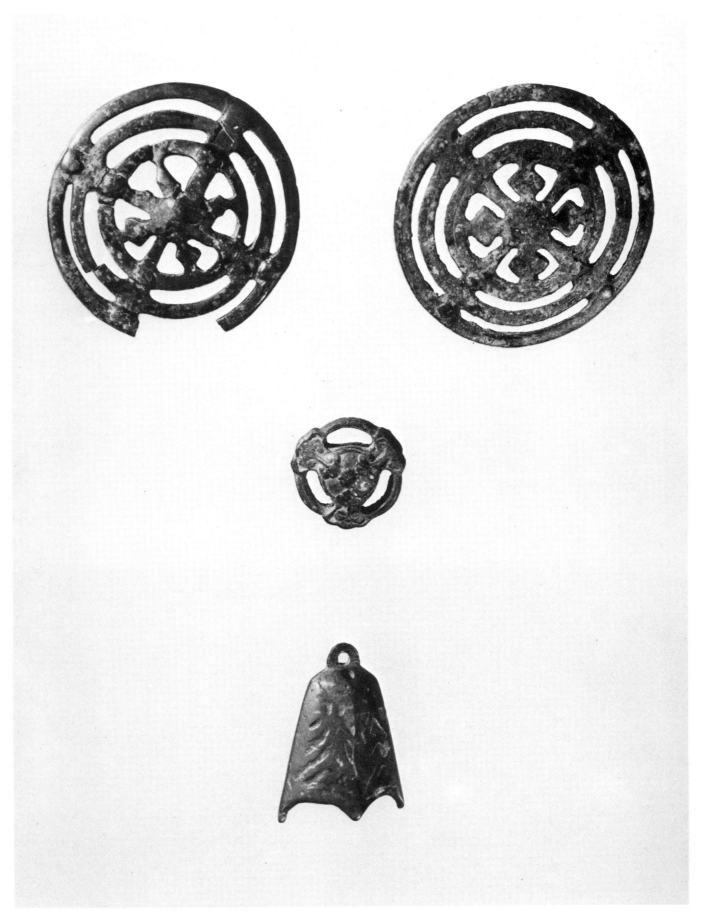

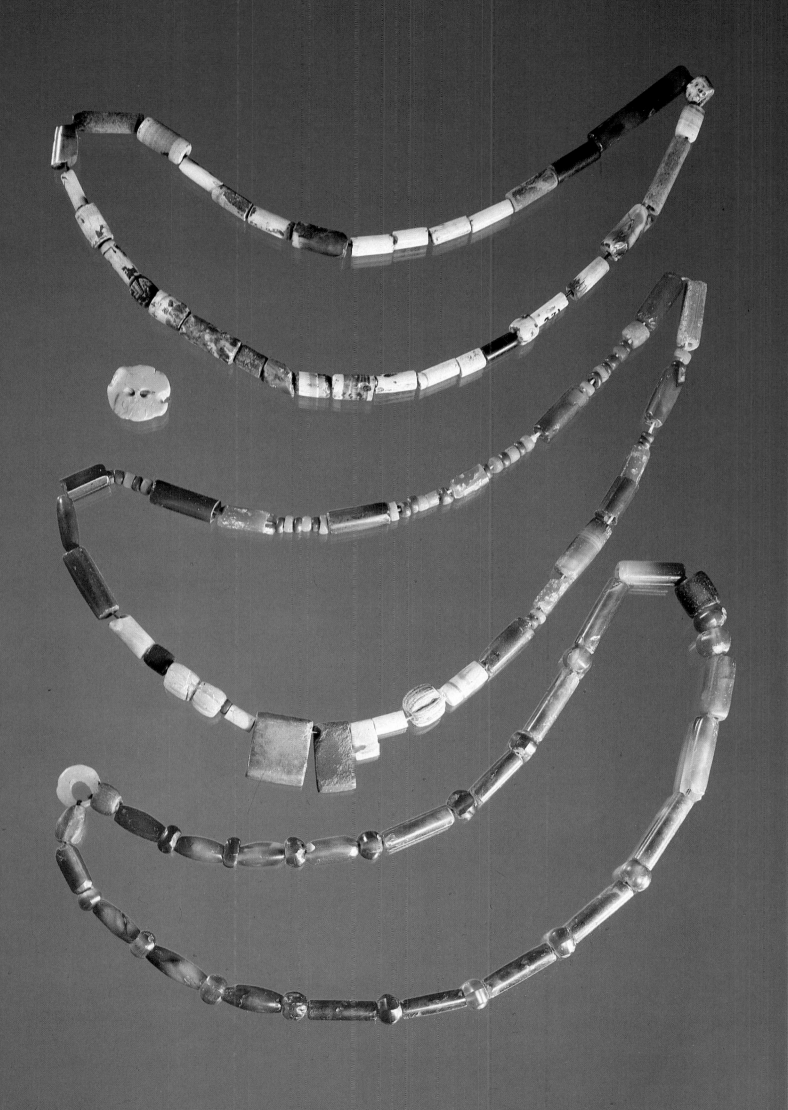

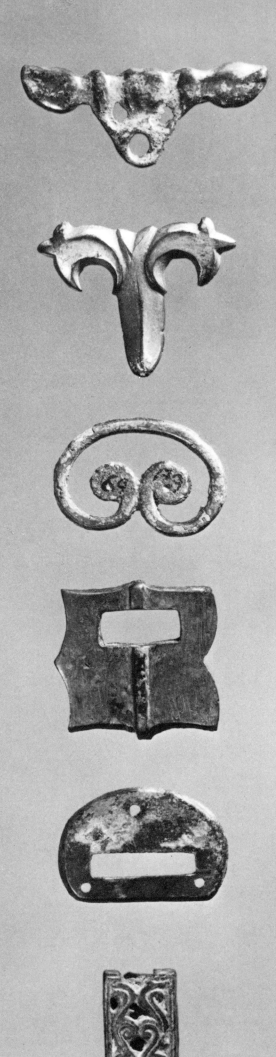

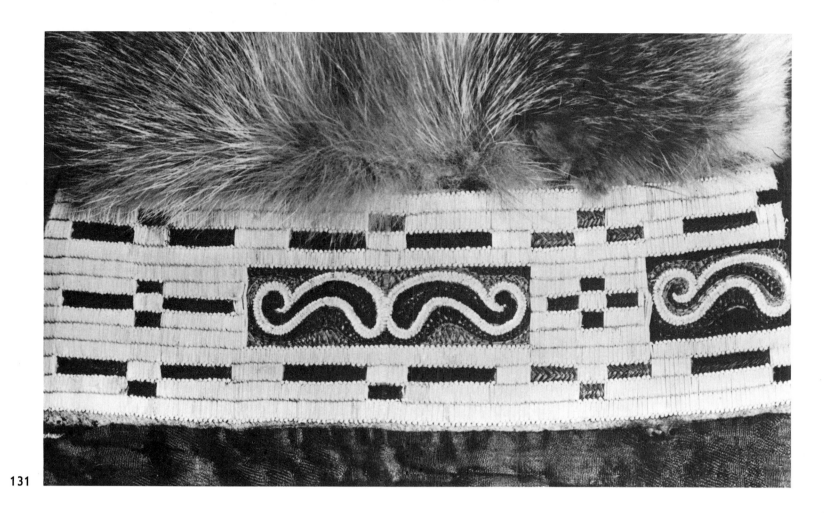

131

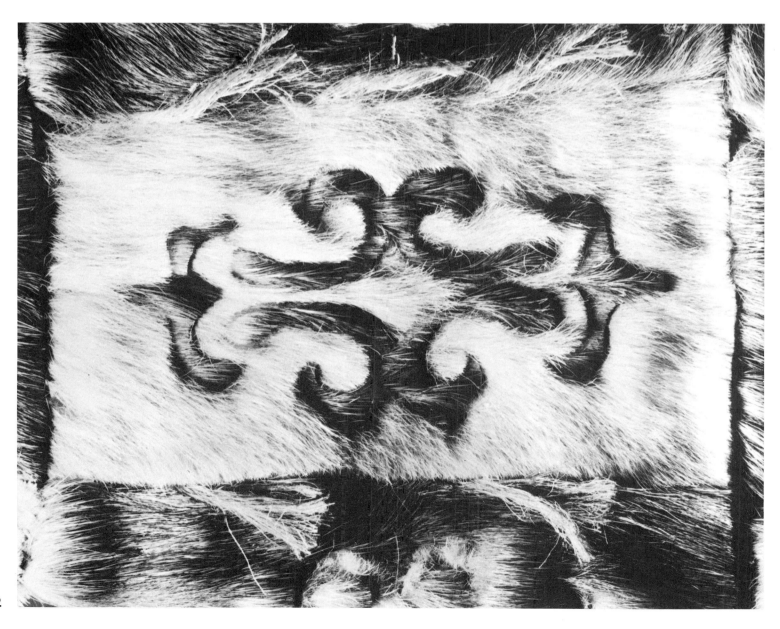

32

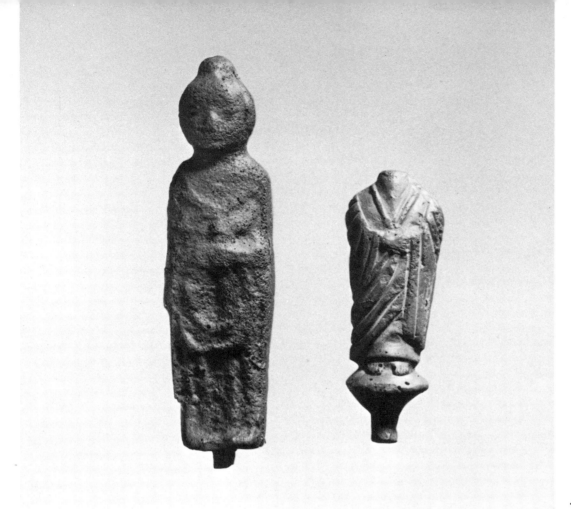

133

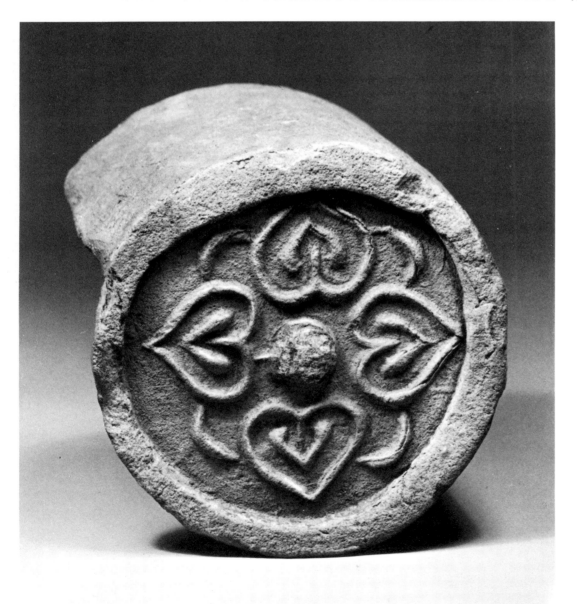

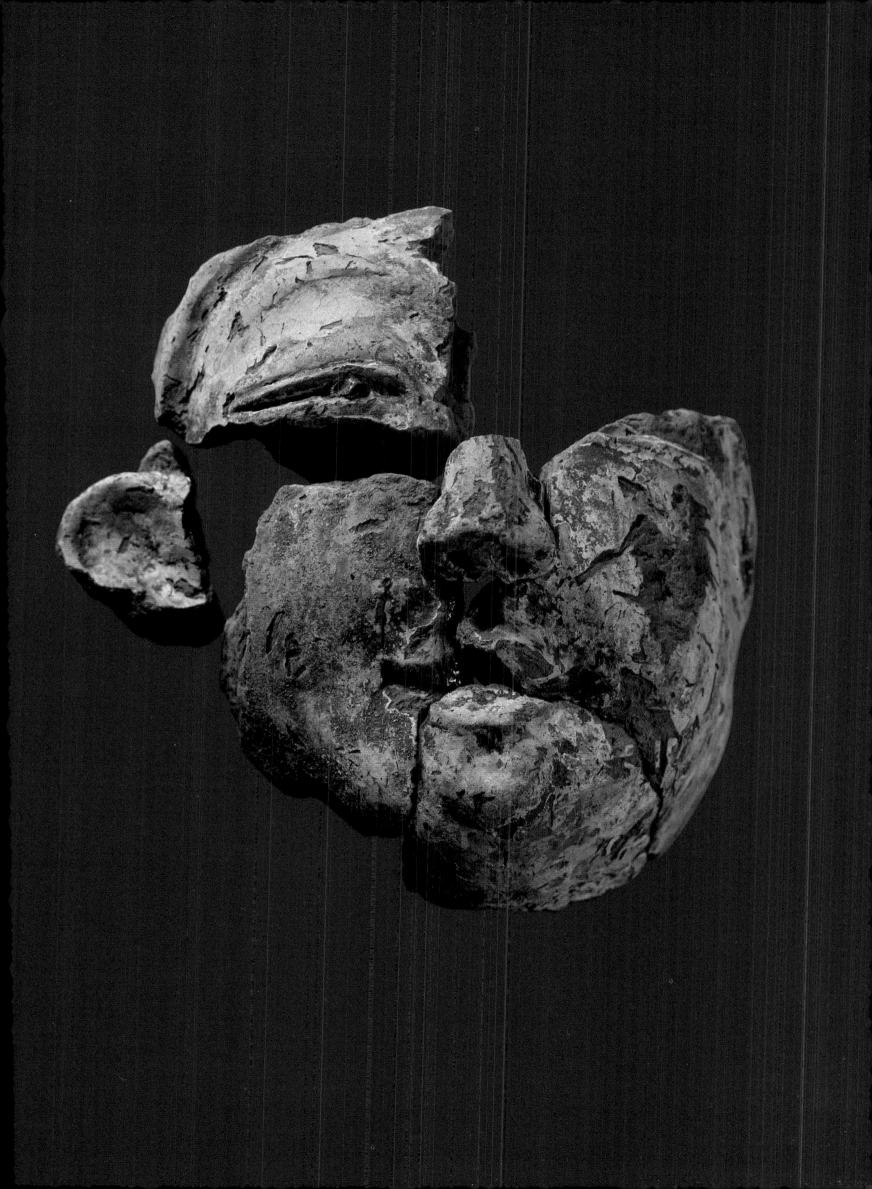

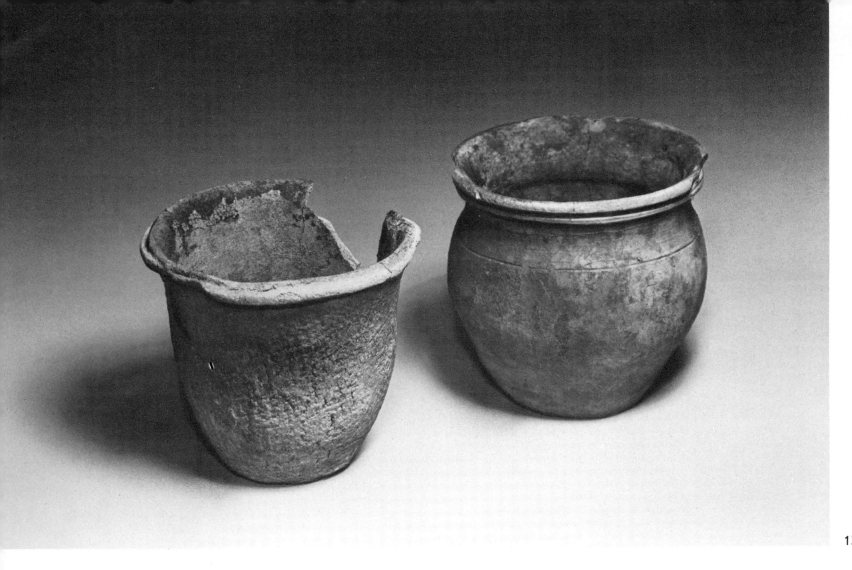

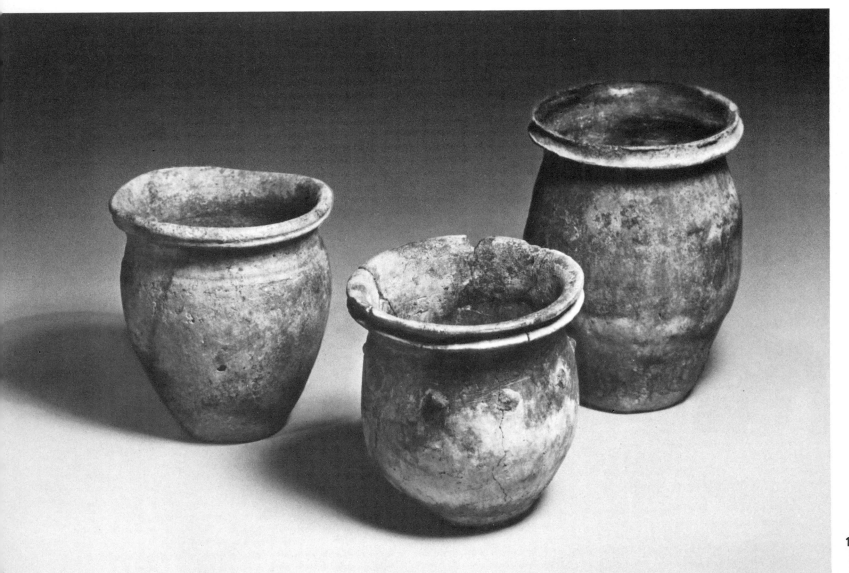

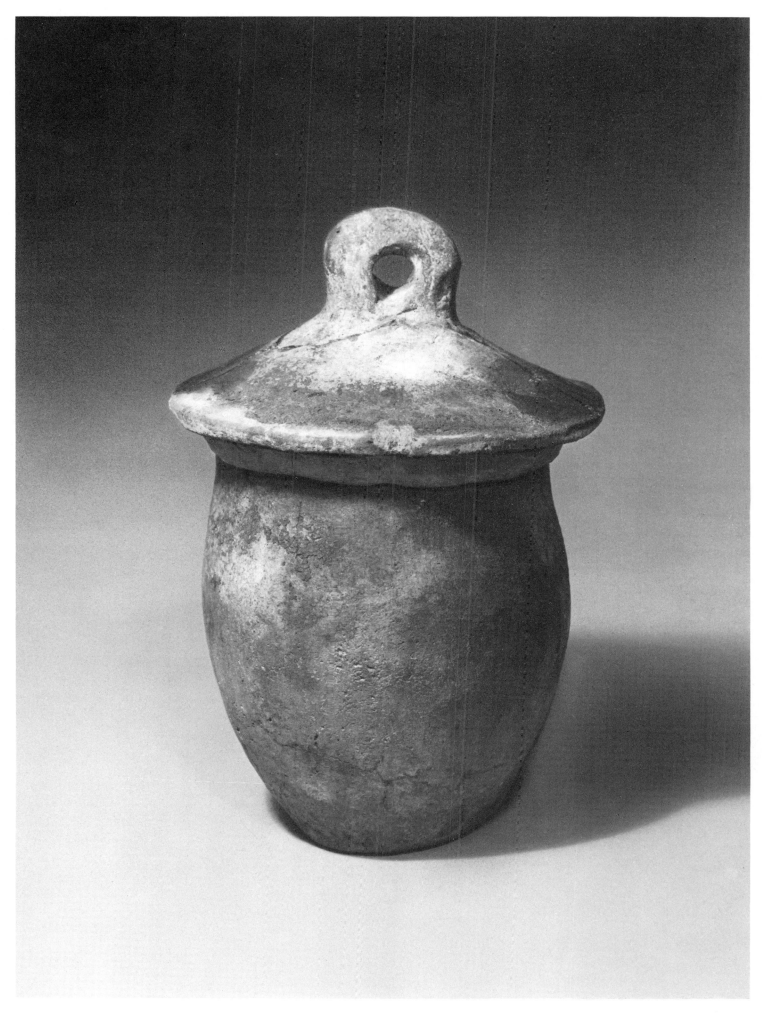

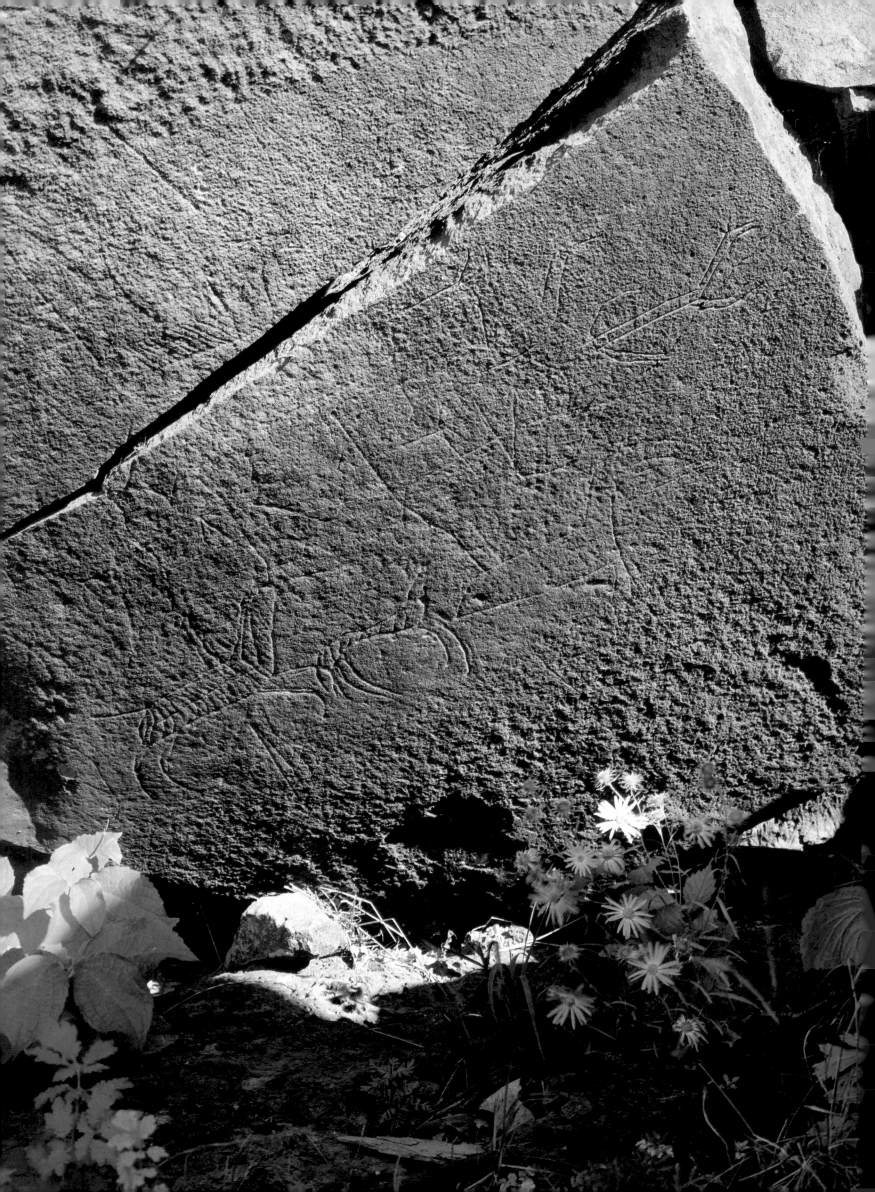

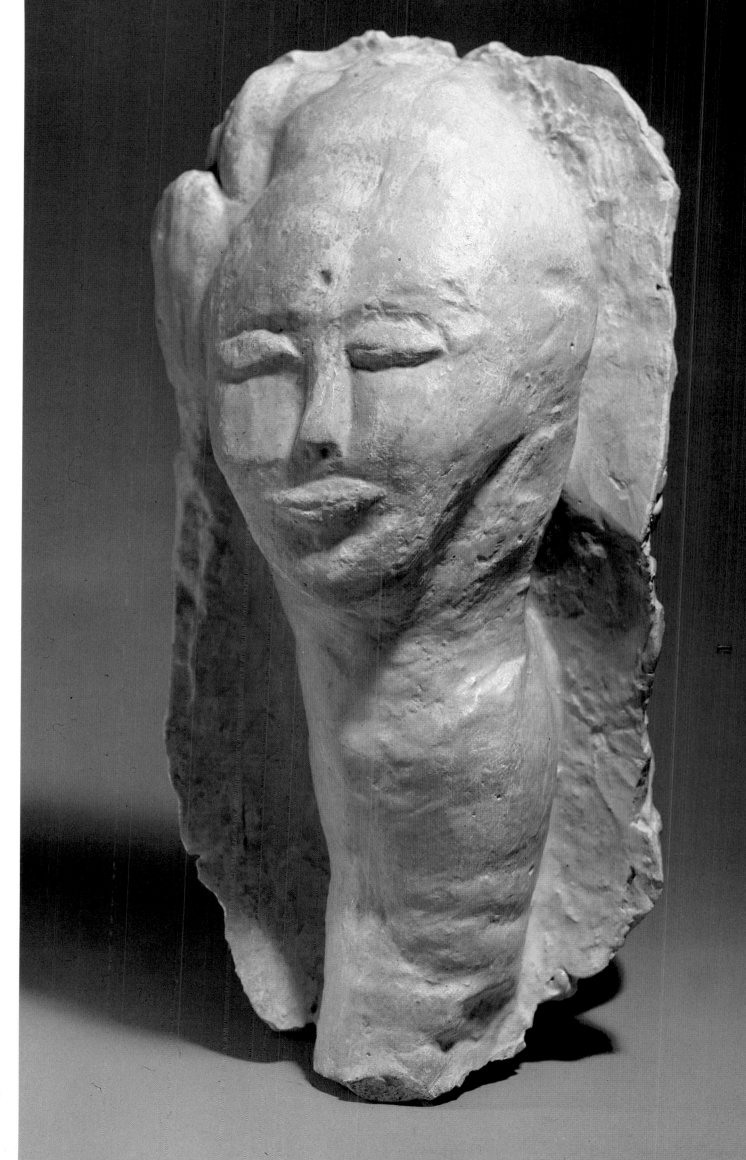

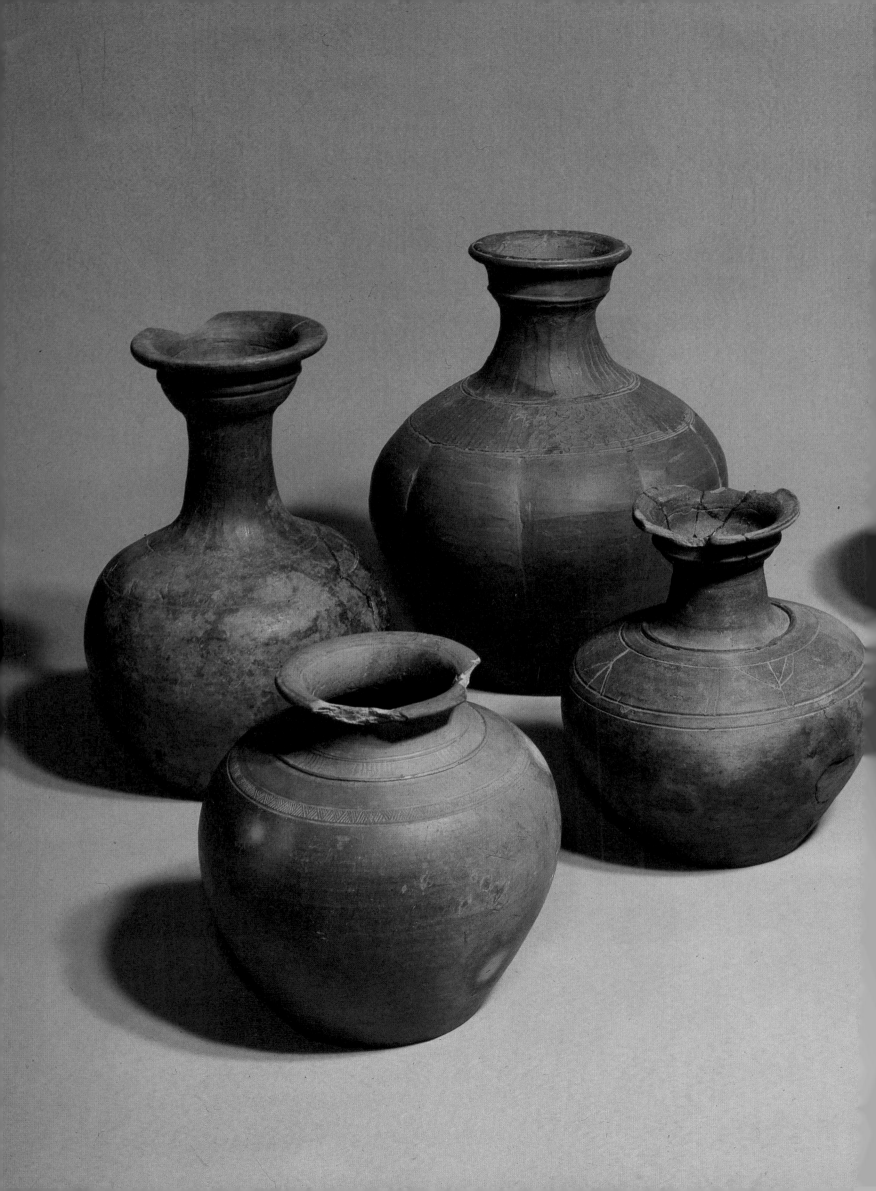

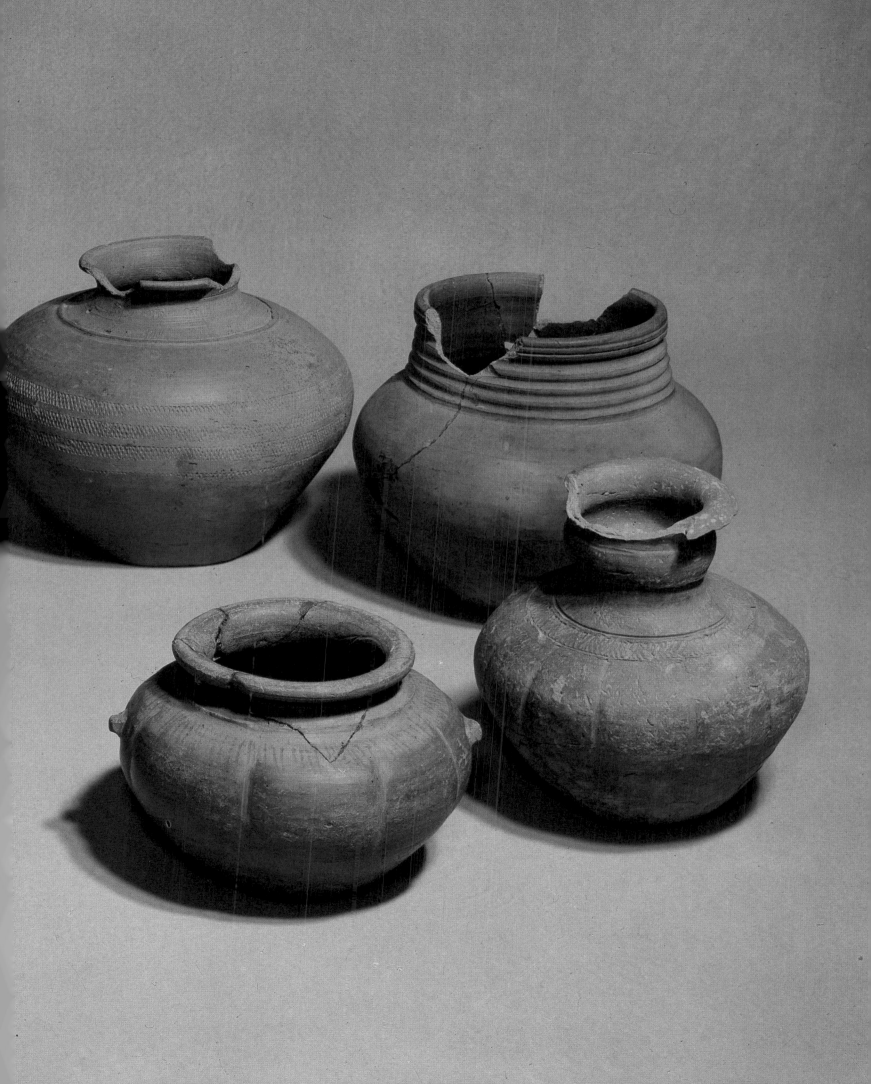

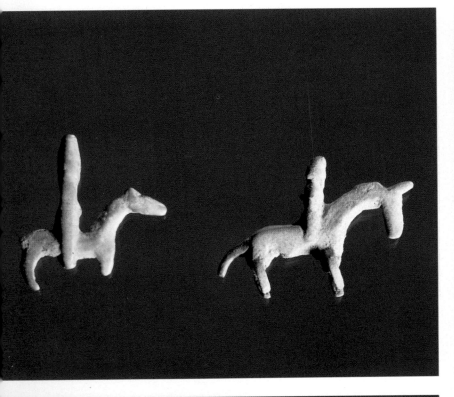

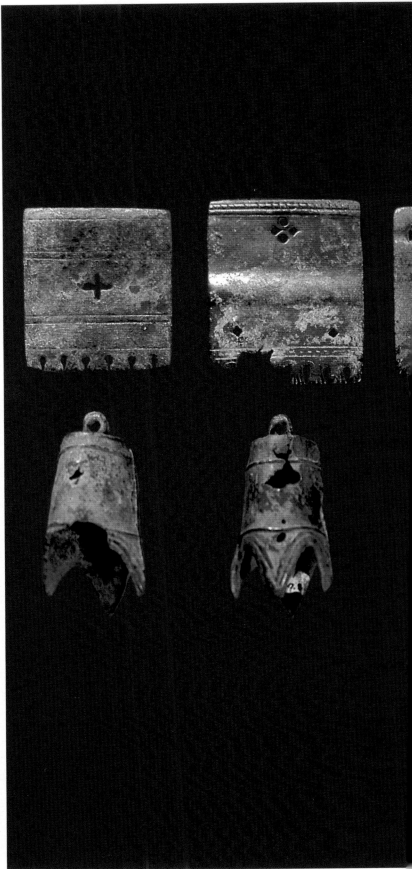

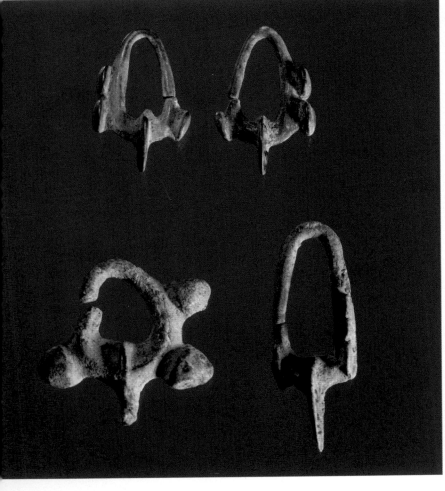

142, 143

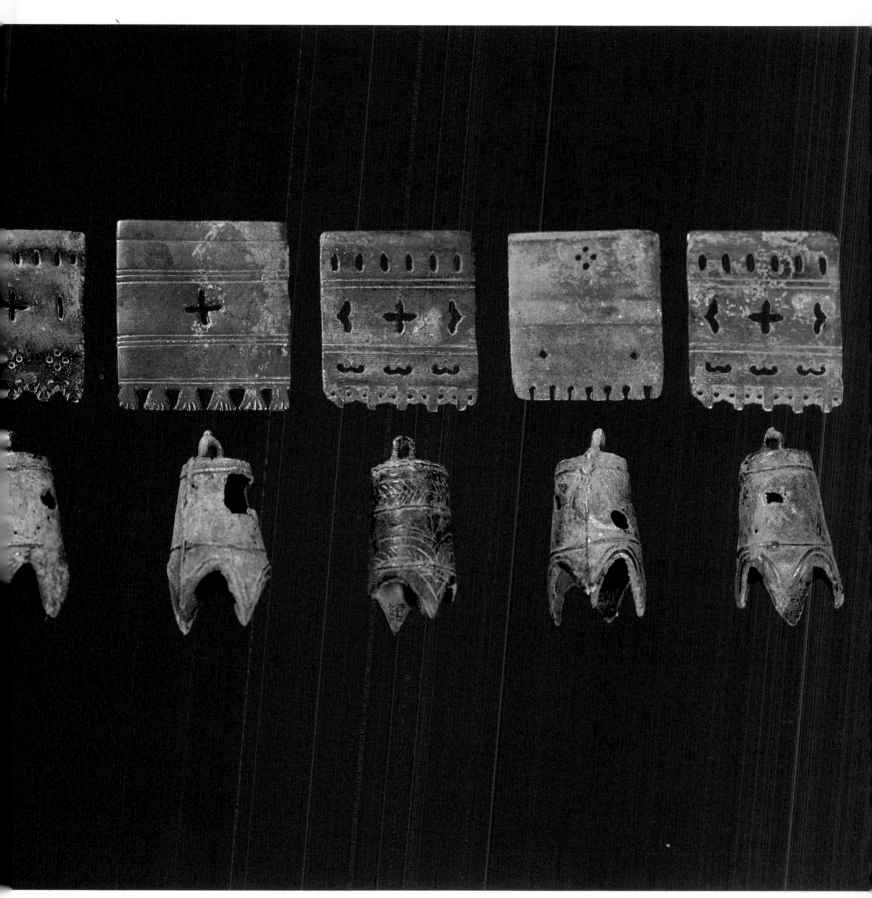

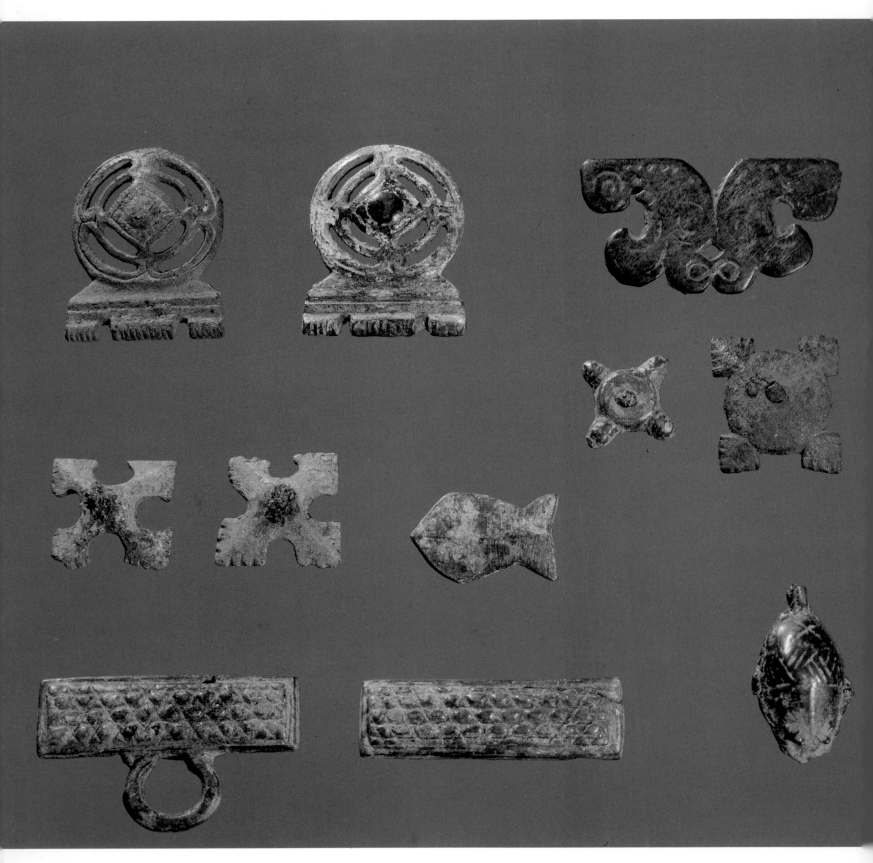

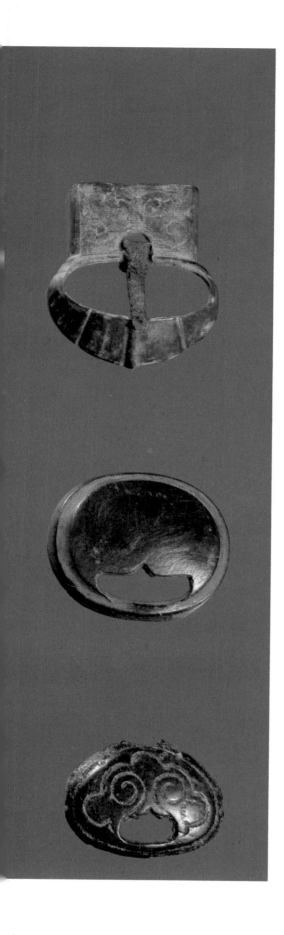

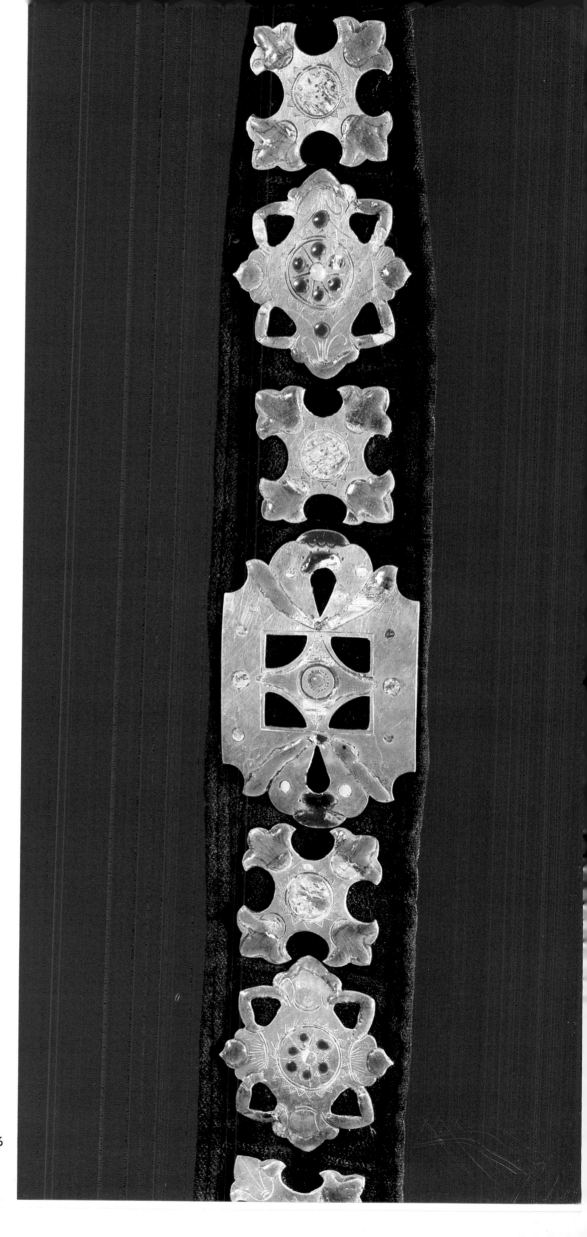

ДРЕВНЕЕ ИСКУССТВО ПРИАМУРЬЯ

Альбом (на английском языке)

Издательство „Аврора“. Ленинград. 1981
Изд. № 2732

Printed and bound in Hungary